5-17-63

Anglais

*THE TRADITIONAL THEORY OF LITERATURE*   ❧   ❧   ❧

# THE TRADITIONAL THEORY OF LITERATURE

BY  RAY LIVINGSTON

*University of Minnesota Press, Minneapolis*

N
8375
.C6 L5
1962

PUBLISHED IN GREAT BRITAIN, INDIA, AND PAKISTAN BY THE
OXFORD UNIVERSITY PRESS, LONDON, BOMBAY, AND KARACHI
AND IN CANADA BY THOMAS ALLEN, LTD., TORONTO

Quotations from Ernst Robert Curtius's *European Literature and the
Latin Middle Ages* (copyright 1953) are used by permission of Bollingen
Foundation, New York; from Coomaraswamy's "Two Passages in Dante's
Paradiso" (*Speculum*, XI, July 1936) by permission of the Mediaeval
Academy of America, Cambridge, Massachusetts; from Coomaraswamy's
*The Transformation of Nature in Art* (copyright 1934) by permission of
Harvard University Press, Cambridge, Massachusetts.

*To my friend, Ira Rubel*

# Preface

*Authority is the source of knowledge, but our own reason remains the norm by which all authority must be judged.* JOHN SCOTUS ERIGENA

THIS BOOK IS AN INTRODUCTION to the Traditional doctrine of the nature and function of literature. Although over-simple and imprecise, it is not intended to be a popularization. At best it may serve as a primer whose very imperfections will increase the reader's desire to consult the authoritative works it cites in abundance. If these purposes are not served there may be little excuse for meddling with Ananda Coomaraswamy's writings, which serve as the primary source of the ideas here set forth.

What may appear as intransigence in this work stems from the conviction that one must decide to let his communication be yea, yea; nay, nay. With due regard for the especial claims of Christian orthodoxy, I have said yea to a venerable Tradition that has persisted for millennia. To all that is contrary to this Tradition, I voice my nay, to the degree that it is ignorant of Traditional claims or that it perverts Traditional forms for malign purposes. Whatever appears to be heterodox, syncretic, or eclectic is put down unwittingly and not wilfully.

Let it be noted at the outset that Coomaraswamy cannot be lumped with those swamis East and West, or like types, who peddle a bogus "spirituality" that is vague, delusory, and deceitful. I believe further that Coomaraswamy had no designs on us in the West except to return us to the sources of our own wisdom. In essence his message is this: "Drink waters out of thine own cistern, and running waters out of thine own well" (Prov. 5:15).

And if we go here to an outlander, Coomaraswamy, for aid, it is because it has been stated, "As cold waters to a thirsty soul, so is good news from a far country" (Prov. 25:25). The good news brought from far countries corroborates our own Good News, which seems in our time to be much staled by custom and muddied by ignorance.

To the many who have helped me I am grateful. The offices of several benefactors I wish especially to acknowledge: Mr. DeWitt Wallace, who gave generously to Macalester College so that it could grant research monies to ready a dissertation for publication; Professor David White, who turned me to Coomaraswamy; Professor Donald Swanson, who checked (at one stage) the Greek and Sanskrit words; Professor Herbert Slusser, who read the manuscript with the charity that inspires; Miss Sara Hunter, who typed the final draft with rare diligence; and Miss Marcia Strout, who edited the work with good cheer, tact, and devotion.

I wish also to express my gratitude to Mr. and Mrs. Ira Rubel whose manifold kindnesses have done much to make this work possible. At the last I must mention the one who is first, my wife Claire, without whom I would not have conceived or written this book.

RAY LIVINGSTON

*Macalester College, St. Paul, Minnesota*

# Table of Contents

*THE TRADITIONAL THEORY OF LITERATURE* ❋ ❋ ❋

For enquire, I pray thee, of the former age,
And prepare thyself to the search of their fathers:
For we are but of yesterday, and know nothing,
Because our days upon earth are a shadow:
Shall they not teach thee, and tell thee,
And utter words out of their heart?

*Job 8:8–10*

I

# *Prologue*

*If the deep learning and strong will of one man can avail anything to
lift the curse of Babel today, Dr. Coomaraswamy deserves the gratitude
of mankind.* GRAHAM CAREY

C RITICISM IN OUR DAY," it has been said with some truth, "is a
sort of tower of Babel."[1] Even more truly one could state that not
only literary criticism but also the whole "house of intellect" is a
tower of Babel. Assuming this, one must ask the important ques-
tion: How can we escape the confusion of voices? The answer is
to be found in the very metaphor of Babel with its manifold impli-
cations. Clearly one should try to quit the tower and learn anew
"the one language and one speech" that prevailed before the curse
was laid upon men.[2] For the practicable means of liberation, we
can turn in our extremity to the account in Genesis, which in the
manner of primordial myths is timely as well as timeless in import.[3]
Preposterous though such a proposal may seem, it is worth study-
ing, if only by those oppressed by the murmuring but still hopeful
of the "pure language" anciently promised.

Persons qualified to interpret Scriptures parabolically [4] will ob-
serve that the "one language" of Genesis is, in a certain sense, a
clear expression of the one Divine Word which is the source of form
and intelligibility in every order of manifestation. This "language"
is essentially the Logos, the creative wisdom of God, common to all
men, most of whom live without awareness of it.[5] Forgetfulness of
this Word causes confusion of tongues; recollection restores under-
standing and communication. So far as this wisdom has not been

3

lost to men, the "one language," in many linguistic forms, is still understood by some and used in discourse.[6]

Because direct intellectual intuition of the Word is beyond most persons, who are unwilling or unable to rectify their natures, we must search for another version of the Truth that we can grasp. In another age this might be found in the inspired Scriptures. Now, however, we receive or deduce all too little from this source, largely because we are not of the spirit of those who set them down originally. The best then that most of us can do is to consult lesser writers whose works are so far as possible congruent with Holy Writ and accommodated to our condition.

There are some in our time who in their search for authoritative doctrine on a variety of subjects can repair to the works of St. Thomas Aquinas, which are impressive in their cogency, clarity, and strict coherence to superior principles. There are others, though, who find that their minds however much informed by the Angelic Doctor are not completely amenable to his particular idiom. These few, still hoping to hear a clear voice above and beyond the noise of Babel, must look elsewhere.

They can well turn to the great modern expositors of the perennial Tradition, especially to René Guénon, Frithjof Schuon, and Ananda Coomaraswamy. These scholars, who read the great myths and scriptures of mankind with reverence and penetration, have discerned a common metaphysical language in all the diverse cultural forms. Whatever their shortcomings, they have been conscious of their obligation to ground their many works — so far as they are able — on the "one language" that is the vehicle of truth in every place and age. Although all have written about many phases of Traditional thought, it is Ananda Kentish Coomaraswamy who has studied more than the others the whole subject of art in the perennial Tradition. It is his works that one can best study for a hint at least of the doctrine of art that existed (and still exists) before the confusions of Babel. And those who first wish to abandon the quarters in the tower that are reserved for the practitioners of literary criticism can profitably examine Coomaraswamy for suggestions of escape. This we propose to do here.

Coomaraswamy, pre-eminently a Doctor of the Tradition, has written many works dealing with metaphysics, mythology, religion, folklore, philology, philosophy, politics, sociology, and the natural sciences.[7] He has, moreover, written so copiously and well on the art of the world that his works probably comprise the most comprehensive and unimpeachably orthodox statement of the doctrine of art according to the universal Tradition. And although he was concerned for years largely with the visual arts, he does set forth a theory of art that in its more universal form is a calculus that can be interpreted in terms of any art, be it agricultural, political, musical, or literary.[8] This doctrine of the arts is one that prevailed for millennia in a more or less pure form until recently.

By coupling Coomaraswamy's many specific statements on literature with his doctrine of art, one can reconstruct, *mutatis mutandis*, a theory of literature supported by the perennial Tradition, ordered by first principles, and quite free from both the limitations of individualism and the fatal concessions to modernity often found in writers otherwise sound. The materials are at hand, gathered by unremitting industry and discrimination and interpreted by inspired intellection. One could organize these materials into a treatise that would discover a theory of literature radically different from, and more satisfying intellectually than, many now current. This precisely is what we will do here, as others have made studies of the aesthetic theories of St. Augustine and St. Thomas Aquinas whom Coomaraswamy resembles intellectually.

Although this study will be based upon Coomaraswamy's works, the doctrine of art and literature that will emerge will not be an individual one, for it was Coomaraswamy's intention to set forth only those ideas that reflect in various forms the principial truths of the Primordial Tradition. Even for those persons who have little sympathy for this mode of thought, this doctrine may have some interest because it will represent a polar position, for them possibly a *terminus a quo* happily abandoned for more sensible beliefs. For others it could reveal an extraordinary theory echoed in many ways, though often coupled with incompatible elements, in diverse works in the history of Western thought. Its doctrines

will be consistent with a whole view of God, man, and the universe, long enduring and still not dead. They will resemble those of Plato, St. Augustine, Meister Eckhart, and William Blake, whose writings still possess fructifying energy.[9] If we turn to the works of one man, it is not only because he has gathered a treasure of Traditional wisdom such as few could ever find by themselves, but also because we find in Coomaraswamy a grand type of the philosopher and critic whose thought is enlightening and whose life and work are exemplary.

❈   ❈   ❈

Despite our intention to consider Coomaraswamy as exemplar for scholar, critic, and teacher, it would be contrary to the Tradition by which he lived to write much about his life and personality.[10] Enough has probably been written,[11] though nothing has been said quite so appropriate to him as the words of the Chorus on Oedipus dead at Colonnus: "He lived his life." More than this one need not say except possibly to add with Antigone: "He did as he wished." What Coomaraswamy intended to do is what is of interest here. And because he was like some others in large measure what he thought, this study dealing with his thought may well treat of his essential nature more than would a biography. What he thought has, moreover, seemed extraordinary to many persons. Among those who have eulogized Coomaraswamy, Eric Gill could say, "I believe that no other living writer has written the truth in matters of art and life and religion and piety with such wisdom and understanding."[12] On the other hand, scholars who have followed him in writing much less well on the subjects he treated with immense authority and learning have again and again failed even to mention him in their bibliographies. It may be helpful, therefore, to say a few words about the nature of his work and his attitude toward it.

Generally deprecating concern with the original and the personal as heretical in a radical sense (from αἱρεῖν "to choose," i.e., for oneself), Coomaraswamy was in spirit like the *rishis* or seers of old whose names are unknown or mythical at best. He believed that

what he wrote – or much of it, at least, in the great productive period of his last three decades – was not his own in an individual sense. Feeling no proprietorship, he often quoted the saying of Walt Whitman, "These are really the thoughts of all men in all ages and lands, they are not original to me."

Shortly before his death, at his last public appearance, Coomaraswamy spoke in a rarely personal vein to those honoring him:

I should like to emphasize that I have never built up a philosophy of my own or wished to establish a new school of thought. Perhaps the greatest thing I have learned is never to think for myself; I fully agree with André Gide, that "Toutes choses sont dites déjà!" and what I have sought is to understand what has been said, while taking no account of the "inferior philosophers." Holding with Heraclitus that the Word is common to all, and that wisdom is to know the Will whereby all things are steered, I am convinced with [Alfred] Jeremias that the human cultures in their apparent diversity are but dialects of one and the same language of the spirit, that there is a "common universe of discourse" transcending the difference in tongues.[13]

For the task of understanding what has been said, Coomaraswamy in his generation was uniquely equipped by the fact of his birth, education, and natural endowments. Born of a Tamil father and an English mother, educated in England from an early age, he was fortunate in returning to his native land as a geologist to head its first mineralogical survey. In the following years in Ceylon and India he became more and more aware – as many Indians were not – of the greatness of the heritage of India, long scorned by Westerners. There began the process of winning back his birthright as an Oriental; in this he responded as few men ever have to the Faustian challenge:

What from your fathers' heritage is lent,
Earn it anew, to really possess it.

Born as he was of two cultures and educated in the liberal arts as well as in the sciences, each with its own claims, he was presented with a challenge that evoked from him a response equal to his powers. To become who he was, to become a man and not a creature caught (like many Indians) between two worlds, he had to

7

transcend the limiting claims of both worlds by encompassing the truth of each in an organic synthesis. This he did and was thus enabled to spend his life earning back his eternal birthright with its claims and privileges beyond the national and cultural.

Coomaraswamy was one of those fortunate men graced with a genuine vocation. In his life the truth of the *Bhagavad Gītā*'s dictum on vocation was borne out: "Man reaches perfection (or success) by his loving devotion to his own work." Having the nature of a great scholar, he found the work that suited him. From the earliest writings to the last, one senses the initiatic progress typical of hereditary callings; with sureness and inevitability he moved step by step from the study of the art of medieval Ceylon to the mastery of the most profound metaphysical speculations. And so complete and sure was his dedication to the work at hand that, despite the astonishing breadth of his knowledge, he seems to have been little given to accumulating learning for the sake of show or diversion. His powers were so drawn forth by his vocation that his writings display an authority and vigor, not personal, that is unmistakable even to those who cannot agree with much in the Traditional thought.

Coomaraswamy's natural endowments are difficult to analyze, so much does he seem an integral man in his writings. Most important for his work, besides his great intelligence, was a catholicity of vision and a magnanimity toward many modes of thought; conversely, he lacked the prepossessions that limit, the parochialism and fearfulness that engender the bigotry and the *odium theologicum* tainting much religious thought, especially in the West. He knew with St. Ambrose that "the truth by whomever it is spoken is of the Holy Spirit." Despite his generosity, he was never a syncretist given to easy eclecticism. An examination of his mature works will show a transcendental orthodoxy and rigor of thought shared by thinkers like Plotinus, Dante, and Eckhart.

As even a brief glance at his works will reveal, Coomaraswamy was one of the most keen and indefatigable trackers of the spoor that leads to God, one of whose names is Truth, for he saw the *vestigia pedis* in folklore, mythology, religion, poetry, theology,

philosophy, metaphysics, and art from all over the world. All the tracks, however effaced and worn by time, he knew led to the same lair; as he wrote in a notable essay, "All paths lead to the same summit."[14] He agreed with Edgar Dacqué that myth represents the deepest knowledge that man has[15] and with Mircea Eliade, who in his study of folk tales says that "la mémoire collective conserve quelquefois certains détails précis d'une 'théorie' devenue depuis longtemps inintelligible . . . des symboles archaïques d'essence purement métaphysique. . . ."[16] In this he was poles apart from a common type of modern scholar, Sir J. G. Frazer, who spent a lifetime collecting examples of folk beliefs only to remark that he had been "led on, step by step, into surveying, as from some specular height, some Pisgah of the mind, a great part of the human race" and to say, "I was beguiled, as by some subtle enchanter, into inditing what I cannot but regard as a dark, a tragic chronicle of human error and folly, of fruitless endeavor, wasted time and blighted hopes."[17]

Thanks to the generosity of his mind and the security of his knowledge Coomaraswamy was able to discover not only the eternal truths of myths and folk thought but also those set forth by the great writers of the past. In another of his rare personal statements he said, "No day passes in which I do not read the Scriptures and the works of the great philosophers of all ages so far as they are accessible to me in modern languages and in Latin, Greek and Sanskrit. I am wholly convinced that there is one truth that shines through them all in many shapes, a truth greater in glory by far than can be circumscribed by any creed or confined by the walls of any church or temple."[18] To what extent he discovered the truth, often hidden even from those in whose culture he found it and all the more from foreigners, can be revealed in an understanding reading of some of the larger writings like *The Transformation of Nature in Art, Figures of Speech or Figures of Thought, Time and Eternity, A New Approach to the Vedas, Hinduism and Buddhism,* or even some of the smaller pieces like the two-page article, "The 'E' at Delphi." All these works attest to a truly catholic perception and an enormous learning and skill both

9

in the reading of myths and in the parabolic interpretation of scriptures.

Coomaraswamy was aided in his labors by being, in every good sense, a believer.[19] With St. Augustine, St. Anselm, and nearly everyone else who has really learned anything, he could say, "I believe that I may understand" and "I understand that I may believe." His approach to the many ways of thought and life he studied was never profane or merely tolerant. He was a Platonist, Hindu, Muslim, Buddhist, Hermetist, Christian — simultaneously but not exclusively — when he wrote of these world-views; hence he knew whereof he spoke more than the nonbelievers who are wont to take some at least of the names of the Lord in vain. Yet, in a rigorous sense, he was much more than a believer. Belief may be helpful and even necessary to some stages of understanding, but the knowledge to which he aspired is beyond belief and opinion in the realm of certitude. Coomaraswamy was that type called in Sanskrit *jñani*, one whose path to realization is primarily intellectual. Like Śaṅkarâcārya he knew that "there is no other means of obtaining complete and final deliverance except knowledge";[20] hence his greatest interest in his later years was in metaphysics whose higher reaches are ineffable, being beyond discursive thought and the dualities inherent in language. This does not mean that he was not religious, for that he undoubtedly was; it does mean that his intellect flourished latterly more in the realms beyond religious forms. It seemed always with him as with his beloved Eckhart who cried, "What is truth? If God could backslide from the truth, I would fain cling to truth and let God go."[21]

The written results of the labors of this man, who was a true polymath with a comprehensive grasp of modern thought and an unparalleled command of the Traditional thought of the world, are impressive in their bulk and richness. Merely to search his writings out, much less to read them, would demand considerable effort so scattered are they in books and periodicals all over the world. They form a body of over five hundred and fifty books and articles, some two hundred book reviews, and a mass of unpublished manuscripts. "All the essays written by Ananda Coomara-

swamy," it has been said, "are linked together like the pillars and girders in a beautifully constructed edifice, though he never wrote a philosophical 'system' in the usual sense."[22] Taken together they seem to embody a respectable synthesis of many phases of Traditional knowledge. And if they do not constitute the "Summa of the Philosophia Perennis (et Universalis) based on all orthodox sources whatever, not excluding those of 'folklore' "[23] that Coomaraswamy himself thought would have to be written, they undoubtedly will by their example and accumulated learning enable the writer of the Summa — supposing there will be such — to bring his task properly to completion.

If the resources of Coomaraswamy's writings are rich enough to supply many of the materials for such a summa, they are, a fortiori, a vast mine of ideas and information that can be exploited in the studies of the epigoni — scholars and students in many fields. It may well be as Mr. Langdon Warner has said "that our true debt to Ananda Coomaraswamy will not be appreciated during his lifetime and that a century may elapse before art critics and historians of religions and philosophers will turn to his writings for source material."[24] Since a century seems to be an impossibly long time in this age, it may be well to go into debt now, specifically by borrowing heavily from Coomaraswamy's numerous and lucid insights into the literature of the world.

❋     ❋     ❋

A natural order for a study of Coomaraswamy's theory of literature readily suggests itself. Since the superior principles in Traditional thought always dictate the nature of the inferior, it will first be necessary to set forth briefly the doctrine concerning the nature and final end of man (all sciences and activities properly being arranged to that end), the nature and purpose of the social order, and the nature and function of art.[25] In the light of these principles, which form the bases of Coomaraswamy's thought, a statement of his theory of literature can be organized by gathering together, summarizing, and explicating some of his many dicta on literature specifically and by analyzing several of his works of literary criti-

cism. Because a complete theory with all parts treated with the same degree of fullness will not be found in Coomaraswamy's writings, it will be necessary in some cases to interpret his calculus of art in terms of literature and to deduce in more detail the implications of some of his briefer statements on literature. Lastly, the fruitfulness of his ideas in affording insights, the uses of his theories in explaining certain problems of literary study, and the general worth of his efforts can be assessed.

Although the order of this study presents no difficulties, the nature of the material creates a problem of method. For several reasons, frequent and extensive quotations beyond the ordinary from both Coomaraswamy and his sources will be necessary. Coomaraswamy, it has been observed, avows that his thoughts are not his own in any individual sense and this he constantly demonstrates by quoting from others, not so much at great length as in nearly incredible profusion. His works seem to be the quintessential distillate of thousands of writers who on one occasion or another reveal elements of Traditional thought. In the first place, then, one is faced with a plenitude of material that makes selection difficult. Coomaraswamy's citations are so cogent, apposite, and authoritative and so economically employed that many can be omitted from an account of his theory only at the cost of reducing the clarity and vigor of his argument which, in the main, is quite alien to most contemporary modes of thought. Extensive quotation from Coomaraswamy and his sources will also serve to reveal the extraordinary richness and suggestiveness of his work as well as his characteristic method of writing.

Secondly, summary in some cases will be difficult, if not impossible, because a relative outsider cannot express many aspects of Traditional thought without distortion. Hence, honesty, if not piety, will dictate frequent quotation of material that cannot be summarized by those not properly qualified. The principle of St. Bonaventura's dictum is applicable to most of us who examine Coomaraswamy's writings: "Non enim potes noscere verba Pauli, nisi habeas spiritum Pauli." Thirdly, Coomaraswamy himself writes in such a style — lucid, mathematical in its precision and brevity,

quite adequate to his thought — that one must often hesitate to paraphrase or summarize. It has been stated, "His pen was an instrument of precision. His closely and tightly woven fabric of thought was the very model of explicit denotation. . . ."[26] Selection and summary there will be, of course, since this is intended to be a work of exposition and not an anthology.

In the main, only the Western versions of Coomaraswamy's theory will be noted and discussed herein, except in cases where he draws almost entirely upon Eastern sources. Despite the fact that such an emphasis will falsely represent Coomaraswamy's total thought and persistent orientation, it will better suit our limited purposes for which the idiom of Western thought is generally more intelligible — for most of us, at least. However, enough of Eastern sources will be included both to suggest the widespread occurrence of the doctrine and to elucidate, as only unfamiliar formulations sometimes can, ideas that frequently only *seem* to be well known and clearly understood. To some degree this will accord with the prospect envisaged by the rigorously orthodox Christian philosopher, Josef Pieper, who speaks of the "wisdom of the East [which is] ready for and apparently in want of absorption into the intellectual structure of Christian philosophical interpretation and the Christian way of life — or it may also be that it is we who need enrichment through this wisdom, in a quite particular manner."[27]

Because Coomaraswamy's method of exposition, imitated to some extent below as well as illustrated by quotations, has certain features generally eschewed in most modern academic scholarship, it may be necessary to add a final word to disarm those who are more interested than he was in historical scholarship, matters of provenience, the tracing of influences, and the particular idiom and strict denotation of the writings he cites and explicates. Coomaraswamy is much like the Schoolmen; he cites whatever expresses well the truth as he understands it. As he frequently quoted, "Omne verum a quocumque dicatur, est a Spiritu Sancto." Since it is stated with even greater authority, "Spiritus ubi vult spirat," it is easy to understand that Coomaraswamy knew that the truth can be expressed in many places, even in the midst of other words less

clearly reflecting it. For example, he quotes from Plato or St. Thomas Aquinas that which serves his purpose; the rest, though possibly relevant to his topic, he ignores. He never, it seems, falsifies; he merely develops arguments (from *arguere*, "to make clear," as he himself would observe) with whatever material he finds in the thinkers he generally respects.[28]

Despite the amplitude of the quotations that follow, we must admit that the profundity and richness of Coomaraswamy's thought — even that concerned specifically with literature — will only be suggested. Enough, however, will be set down to reveal a coherent and pure doctrine (relatively uncontaminated by unorthodox elements), fragments of which are imbedded in much of the critical and imaginative writing of the West. And if only a few of these fragments are here noted, it is because our purpose is to discover the archetypal theory of art and literature and not to explore its manifestations in particular writers.

## II

# *Man, Society, and Art*

*The order of the parts of the universe to each other exists in virtue of the order of the whole universe to God.* ST. THOMAS AQUINAS

COOMARASWAMY'S WRITINGS on art and literature can best be understood in the light of the rest of his mature work, which belongs to a venerable tradition rooted in remote antiquity. This Tradition,[1] sometimes called that of Philosophia Perennis, is also labeled primordial, universal, unanimous; it is "always and everywhere fundamentally the same, whatever form it may take."[2] The Tradition in all its aspects can be considered a clear expression of the "wisdom that was not made, the same now that it was and ever shall be," as Saint Augustine has it.[3] So far as anything created is intelligible, it is informed by this divine wisdom, the Son (Logos, Word), who is the exemplar of all the creation. So far as human existence, in whatever form, is conducted in accord with this essential wisdom it is Traditional.

Despite the great variety of cultural forms, there is to be discovered an astonishing agreement in the metaphysical bases of the life and thought of diverse peoples around the world. It has been said that "human culture is a unitary whole and its separate cultures are dialects of one and the same language of the spirit." Again, "If Ultimate Truth is one and only, the language of Truth necessarily consists of many dialects, adapted to the needs of different races and individuals."

Certain cultures and the works of particular men at various times are clearer, less degenerate manifestations of the one lan-

15

guage of the Spirit; their particular dialect or mode of expression is a more intelligible vehicle of the Truth. It is these cultures and these works especially that the Traditionalists of our day have studied with such acumen and devotion that the essential, unanimous, and perennial bases of human existence have shown forth, it would seem, as never before. Following Coomaraswamy, whose every work is founded upon ultimate principles, we must try to adumbrate some of those doctrines that underlie the perennial theory of literature that we propose to delineate. These doctrines treat of the nature of God, the world, and man; stated another way, they deal with the problem of the One and the many — how the One becomes many and how multiplicity returns to unicity. Especial emphasis must be placed upon the doctrines that define the nature and final end of man, the order of the "normal" or traditional society, and the place of art in that society. However elementary and imprecise will be our formulations here, they will still serve not only to orient Coomaraswamy's thought in the context of the Tradition but also to suggest the enormous difference between familiar and frequently profane notions and essential Traditional doctrines, which in their way are not completely unknown to those who have some knowledge of the great religions and the main intellectual tradition of the West.

Initially there must be set down some hint of two fundamental principles which are familiar to those who are aware of the doctrine of the Divine Ground (Godhead), which is the source of all that is, and the doctrine that the Logos is the paradigm of all created things. The first deals with the Supreme Identity of both non-being and all orders of being in the Godhead. The deity, who in a manner of speaking can be said to have one essence and two natures, in reality comprises all. From a certain point of view, there is nothing truly different from or outside of God, despite appearances to the contrary. To realize this in a state of non-differentiated awareness, when the knower and the known are one, is the end and perfection of man. The second doctrine is correlative; it affirms the analogical correspondence between the intellectual and sensible orders, the former being the paradigm of the latter. These two

16

doctrines, merely sketched out in more or less familiar terms for reference, treat of the problem of unity and multiplicity, which is the major one the Tradition is dedicated to solving, not mentally or scientifically, but both intellectually and existentially, as it were. All the proper activities of man — the production of works of art and literature among them — are ultimately means for the supreme realization in which the many becomes One in us as it is in Him.

The next doctrine, which is most significant immediately for our purposes, deals with the nature and end of man, that "great amphibium," who differs from all creatures in living in two worlds. "From the first God created two worlds, the visible and the invisible, and has made a king to reign over the visible who bears within himself the characteristic features of both worlds."[4] All forms of the Tradition (inwardly, if not always outwardly) maintain that there are two in man — an individual self (psyche or soul) and the divine Self (pneuma or spirit) who is the Self of all selves. (So stated this metaphysical doctrine may give offense to the faithful because it may appear to smack of heresy. Nevertheless, its truth and universal orthodoxy — demonstrated incontrovertibly by Coomaraswamy and others, who ought to be consulted by the dubious — is here assumed without argument.)

❧     ❧     ❧

Man, then, is composed of conjoint principles, divine and human. About this dual nature of man, Coomaraswamy has written often, as, for example, the following:

Of these two "selves," the outer and inner man, psychophysical "personality" and very Person, the human composite of body, soul and spirit is built up. Of these two, on the one hand, body and soul (or, mind) and on the other, spirit, one is mutable and mortal, the other constant and immortal; the one "becomes," the other "is," and the existence of the one that is not, but becomes, is precisely a "personification" or "postulation," since we cannot say of anything that never remains the same that "it is." And however necessary it may be to say "I" and "mine" for the practical purposes of everyday life, our Ego in fact is nothing but a name for what is really only a sequence of observed behaviors.[5]

As long as man does not know who he ultimately is and continues to identify himself with the congeries of powers composing his earthly nature, he lives the life well described in the familiar words — almost Buddhist in their starkness — of a foe of the Tradition, Thomas Hobbes. In his unregenerate state man believes that "the felicity of this life consists not in the repose of a mind satisfied" but in the "continual progress of the desire, from one object to another; the attaining of the former, being still but the way to the latter."[6] Men are continuously drawn toward objects of desire and repelled from objects of aversion; this ceaseless shuttle seems to make up the sum of their existence. Possessed by a "perpetual and restless desire of power after power that ceases only in death," man seems never to know his immortal Self.

When Boethius in prison was asked by Philosophia what man is, he answered (much as Hobbes would have), "I know that he is an animal, reasoning and mortal; that I know and that I confess myself to be." To this Philosophia retorted, "Now I know the cause or the chief cause of your sickness. You have forgotten who you are."[7] When this amnesia is overcome and man really becomes and knows who he is, he is aware that he and God are one and that there is no other. To overcome one's ignorance, to uncover the knowledge that lies within, to rid oneself of illusion, to be receptive to the grace flowing from the Holy Spirit who will teach all things and will bring all things to remembrance — this is the true concern of all men. If man does discover who he really is, he will know that he is the Son of God, as Christ is. Following Plato, in another manner of speaking that is translatable into Christian terms, Plotinus daringly puts it: "Ceasing to be man, he soars aloft and administers the kosmos entire: restored to the All he is the maker of the All."[8]

This conception of man has been widespread, though now it is forgotten or not understood even by the adherents of those religions whose scriptures enunciate it. In the Orient it is, of course, found everywhere. The *Māṇḍūkya Upanishad* describes it thus: "There are two birds, two sweet friends, who dwell on the self-same tree, the one eats the fruits thereof, and the other looks on in silence, the first is the human self who resting on that tree, though active,

feels sad in his unwisdom. But on beholding the power and the glory of the higher Self, he becomes free from sorrow."[9] In one of his many great and inexhaustible essays Coomaraswamy has written of that Self who goes through the world with us:

Only, indeed, if we recognize that Christ and not "I" is our real Self and the only experient in every living being can we understand the words "I was an hungered. . . . I was thirsty. . . . Inasmuch as ye have done it unto one of the least of these my brethren, ye have done it unto me" [Matt. 25:40]. It is from this point of view that Meister Eckhart speaks of the man who knows himself as "seeing thy Self in everyone and everyone in Thee" . . . ; as [the *Bhagavad Gītā*] speaks of the unified man as "everywhere seeing the same Lord universally hypostasised, the Self established in all beings and all beings in the Self" . . .[10]

Coomaraswamy, who has found this doctrine of the two selves set forth in an amazing number of works from all over the world throughout the ages, nicely sums up the Buddhist expression of the condition and true nature of man in a characteristic passage:

The first step is to acknowledge the predicament, the second is to unmask the self whose sole liability it is, the third to act accordingly; but this is not easy, and a man is not very willing to mortify himself until he has known these appetitive congeries for what they are, and until he has learned to distinguish his Self and its true interest from the Ego, his self and interests. The primary evil is ignorance; and it is, in fact, by the truth that the self must be tamed. . . . Only "the truth shall make you free!" The remedy for self-love . . . is Self-love . . . and it is precisely in this sense, in the words of St. Thomas Aquinas, that "a man, out of charity, ought to love himself more than any other person, more than his neighbor" (*Sum. Theol.*, II.–ii. 26.4). In Buddhist terms "let no man worsen welfare of himself for others' weal however great; if well he knows the Self's true interest, let him pursue that end." . . . In other words, man's first duty is to work out his own salvation, — from himself.[11]

The higher Self is the one Boethius forgot, the existence of which men like Hobbes do not admit. This is the Self that Socrates was adjured to know — the immortal Soul, the daimon. Socrates in the *Phaedrus* prays that these two selves may be united: "Beloved Pan, and all ye other Gods who haunt this place, give me beauty in the

19

inward soul; and may the outward and inward man be at one." The lesser or outward self — "le moi haïssable" of Pascal — is the one that must be lost, for Christ says, "Whosoever would save his life [psyche] shall lose it." To lose his soul, a man must deny its claims and assert the lordship of the immanent Christ; then he can say with St. Paul, "I live; yet not I, but Christ liveth in me."

The Bible, of course, contains many references to the nature of man who is first mentioned as made in the image and likeness of God. In the Psalms we read, "I have said, Ye are Gods; and all of you are children of the most high." In the Book of Wisdom are these words: "For God created man incorruptible and to the image of his own likeness he made him." It is evident that the means for realizing his true nature are considered to be somehow within man's reach, for it is stated in the New Testament that "the kingdom of God is within you." But it is further noted that "except a man be born again, he cannot see the kingdom of God."

According to the Tradition the problem of rebirth in the spirit is the greatest one of life. Throughout the Tradition it is recognized that the ignorance of man in his mortal soul is responsible for his troubles. Patanjali in his *Yoga Sutras* says that the cause of bondage to life is first the universal ignorance which covers the face of reality. From this ignorance of the divine nature of all, there arises the sense of ego. Then comes attachment to pleasant things and aversion for the unpleasant things of the world; lastly, the blind lust for life consumes man.[12] Because the passible part is of the world, it strives to become more deeply immersed in its element, for like is drawn to like. The powers with which man is endowed are dissipated in the fixations to created things or imaginings. The Tradition therefore generally decries concern with created things ("creatures") taken separately and apart from the whole because they draw one from the Creator who is man's final end. "The creature is vanity in so far as it comes from nothingness, but not in so far as it is an image of God."[13] The creation, however, as God's work of art or as theophany is universally praised.

It is generally held that atonement (literally at-one-ment) with the Father or union of the two selves is obtainable while man is yet

alive. Plotinus writes, "'Let us flee then to the beloved Fatherland': this is the soundest counsel. But what is this flight? How are we to gain the open sea? For Odysseus is surely a parable to us when he commands the flight from the sorceries of Circe or Calypso — not content for all the pleasure offered to his eyes and all the delight of sense filling his days. The Fatherland to us is there whence we have come, and there is the Father." As he writes elsewhere, "Our concern is not merely to be sinless but to be God."[14]

Christ's injunction, "Be ye therefore perfect even as the Father which is in heaven is perfect," was directed at living men. This spiritual height which is man's perfect destiny is the realization that "Thou art That" (Upanishads), the knowing that is being (Parmenides and Plato), the imitation of the divine activity of contemplation (Aristotle), and the awareness in direct experience of the Supreme Identity beyond all dualism. (Although these ends, so described, may not be identical, they are enough alike to indicate the transcendent end and perfection of man's existence.) As Nicholas of Cusa writes, "The wall of the Paradise in which thou dwellest is composite of the coincidence of contraries, and remains impenetrable for all who have not overcome the highest Spirit of Reason who keeps the gate."[15] The first stage of the unitive vision is described by Dante who saw "ingathered, bound by love in one volume, the scattered leaves of all the universe" before he was absorbed into the Godhead.[16]

One of the noblest statements of this ideal, much like the earlier Hermetic version and Pico della Mirandola's later and more familiar *Oration on the Dignity of Man*, is from the writings of Al-Ghazali, the great Muslim theologian:

You ought to know yourself as you really are, so that you may understand of what nature you really are and whence you have come into this world and for what purpose you were created and in what your happiness and misery consist. For within you are combined the qualities of the animals and the wild beasts and also the qualities of the angels, but the spirit is your real essence, and all beside it is, in fact, foreign to you. So strive for knowledge of your real origin, so that you may know how to attain to the Divine Presence and the contemplation of the Divine Majesty and Beauty, and

21

deliver yourself from the fetters of lust and passion. For God did not create you to be their captive, but that they should be your thralls, under your control, for the journey which is before you, to be your steed and your weapon, so that you may therewith pursue your happiness, and when you have no more need of them, then cast them under your feet.[17]

To these few scattered quotations about the nature and destiny of man, one could add hundreds by consulting many of Coomaraswamy's writings which, whatever the subject, are always grounded upon principial knowledge concerning God and man.[18] Enough has been said to suggest the Traditional doctrine which, as Guénon remarks, "is always and everywhere the same." Although there are more than nuances of difference to be detected in the several statements made here, it is nonetheless clear that the doctrine of the dual nature of man and his transcendent perfection in the rediscovery of his divine origin and last end is always maintained in one form or another. Whatever the formulation, it is even more evident that these doctrines are far removed from profane and merely humanistic notions which apparently underlie many theories of art and criticism.

✾   ✾   ✾

The Traditional view of man implies a concomitant theory of society and government, for all aspects of being are governed by correspondences among the various orders.[19] If divided man is to become whole, he is more likely to accomplish this in a social order designed to give him maximum guidance and support in an undertaking that even at best has always been difficult. There have been integral societies whose institutions have been more or less efficient means for the self-realization of their members. Some of these exist today, though they decline apace, many changing radically in the last century. India's seems to have been a typical Traditional society. The theory of this striking — virtually archetypal — hieratic society is intrinsically interesting and useful to study here as an example of a social order wherein all activities are ordered to the end of justice and the perfection of men.

Since Coomaraswamy has written more about Indian theory than

about any other, India can serve as a type of the Traditional society to be discussed briefly, for it is in the light of a comprehensive doctrine of man and society that Coomaraswamy's theory of art has been conceived.[20] Hinduism, of course, is not unique principially; hence, many of its doctrines lend themselves to easy (though not always exact) translation into other idioms.[21] Many likenesses, for instance, to Plato's theories in the *Republic* and *Laws*, the Stoic and Christian doctrines of natural law, and the concept of social hierarchy described by Shakespeare and Burke will be readily apparent.

A traditional social order, like that of India, is not a haphazard development but imitative of a body of principles or values that are understood to have been revealed and of which the truth is taken for granted. Institutions represent an application of metaphysical doctrines to contingent circumstances, and take on a local color accordingly, changing with the times, but maintaining throughout a high degree of stability, comparable to that of a living organism in which, by the repeated process of death and rebirth that we call "becoming" or "life," an existing order preserves a recognizable identity and produces order from order.[22]

The important metaphysical principle that underlies the Indian theory of government and, as a matter of fact, all of life, asserts the primacy of the intellectual or spiritual function over all the others and the gradation of all orders of existence in a hierarchy.

To the degree that the hegemony of the Spirit and the just subordination of all elements of the hierarchy are maintained, the social order flourishes. In the life of an individual man — his work, worship, marriage, and conduct — as well as in the collective life of the people, the intellect, which is always considered masculine and active, is the ideal ruler and director of the powers and activities of a psychophysical individual who is considered feminine. This principle is inherent in the very structure of the universe on all levels — God is male to his creation, the Sky to the Earth, the Self to the self, Inner Man (Spirit) to outer individuality (soul and body), Priest (Sacerdotium) to King (Regnum), the king to his kingdom, contemplative function to the operative, patron to artist, the art in the artist to the work, husband to wife, and wife

to her husband's estate. All of these are types of the marriage from whose harmonious conjunction comes the fruit of right action. Coomaraswamy observes that throughout a series like this "it is the noetic principle that sanctions and enjoins what the aesthetic [i.e., sensitive] performs or avoids; disorder arising only when the latter is distracted from its rational allegiance by her own ruling passions and identifies this submission with liberty."[23] This doctrine is always one of the characteristic marks of the Tradition in whatever mode it manifests itself; it is found in many contexts — e.g., *Tao Te Ching*, Buddhist scriptures, Plato, the New Testament, the Muslim tradition of esoterism, Marcus Aurelius, and Philo Judaeus. All actions whatever are referred to the norm (dharma, Lex Aeterna, synteresis, Tao, etc.) which dwells potentially in each man and actually in those men who have become perfected. The dharma in Hindu theory works through the Sacerdotium to insure the right rule of the Regnum on all levels — politics, marriage, art, conduct, and the like.

Because the world of becoming was formed by God who, according to the perennial myth, sacrificed his essential unity by proceeding into existence, it falls upon men to imitate God in their lives by forsaking multiplicity to realize unity, the sacrificial operation here being a reflection and hence the reverse of the sacrifice there. Properly organized, the social institutions, which are themselves images of those in the realm of the gods, will be an efficient means of man's self-integration. It is recognized that each man, in his mortal vehicle (the "chariot" of Plato and the *Bhagavad Gītā*) must move toward the final end by traversing so far as he is able the field of becoming. Even if he does not achieve the end, he will have bettered himself and become a more harmonious member of society. As the Book of Wisdom states about each who lives and works in his station, "They will maintain the fabric of the world; and in the handy work of their craft is their prayer."

Concerning the Hindu view of life as a progress, Coomaraswamy writes, "On the one hand, the purposes of life are the satisfaction of desire (*kāma*), the pursuit of values (*artha*), and the fulfillment of function (*dharma* in the sense of duty); on the other

hand, the final, and in this sense the whole purpose of life is to attain liberation (*mokṣa*), from all wanting, valuation and responsibilities."[24] These mediate and final ends listed in order of their place in the hierarchy are not independent or opposed to each other; indeed it is the final end that dictates the nature of the others which are generally necessary to it.

The institutions devoted to the fulfillment of both lives — the "ordinary" in the world and the "extraordinary" apart from it — are the "Four *Āśramas.*" "An *āśrama* . . . is a state or station of life to be regarded as a workshop, or a stage of a continuous and always arduous duty; the *āśramas* are so many 'sojourns,' not in the sense of places of rest but in that of places of activity; the refrain of an ancient pilgrim song is always to 'keep on going.' . . ."[25] The four *āśramas* are those of the student, the householder (married and practicing his trade), the forester ("living much as Thoreau did at Walden"), and the last one, the crown of the others, is that of the abandoner (*sannyāsī* or "Truly Poor Man" who has no possessions and no social responsibilities and for whom the funeral rites have been performed). Life then is a pilgrimage toward freedom or the realization of the Self.[26] The rate of the journey is according to one's nature: some get an early call to abandon all, but most need to advance slowly along the path. Not all men will realize their final end in this life but they will, in theory, advance as far toward perfection as possible with the support of the institutions and the ideals of Hindu life.

The state in which a man usually stays the longest is that of the householder practicing his art. This he practices in accordance with the Traditional doctrine of art and work: all occupations are priesthoods; they are holy and sanctifying service born of one's sacrifice. The actions and products of all true callings are the fruit of the harmonious marriage of the Intellect (Spirit) and psychophysical individuality. As Coomaraswamy often notes, "All of our sources [of Traditional doctrine] are conscious of the fundamental identity of all the arts."[27] He points out that "Indian literature provides us with numerous lists of eighteen or more professional arts and sixty-four avocational arts; and these embrace

25

every kind of skilled activity, from music, painting, and weaving to horsemanship, cookery, and the practices of magic, without distinction of rank, all being equally of angelic origin."[28] Only that work which is mindless or devoted solely to physical ends is not an art; those who perform such work are not responsible members of society, being low caste or outcaste.[29]

If the dharma (justice, law) is to be made effective in a man's life, he must work in an occupation to which he is called by his own nature. The concept of vocation recognizes that each one in his natural vehicle must follow Nature — that is, *natura naturans*, God — in his life, because God endows most men with a certain constitution or congregation of powers which are exercised most economically as a means to self-realization in the practice of particular arts. If a given work harmoniously employs a man's various powers more than others, and if, practiced diligently, it attenuates his ego, it may be said to be the work to which he is called by his nature and by God. Since a true marriage realizes the best potentialities of the pair, it is necessary that the outer feminine part consent to the guidance of the Inner Man who, being the immanent deity and hence intelligent, will ask her to perform that for which she is best suited, *dharma* then becoming *svadharma*, "one's own law or duty."

The *locus classicus* for the doctrine of the active life is the *Bhagavad Gītā* in which, as Coomaraswamy observes, it is stated that "the division of castes is from God and made according to men's natural . . . diversity of qualities and corresponding functions."[30] Coomaraswamy translates the Sanskrit as follows:

Man reaches perfection (or success) by his loving devotion to his own work. . . . And now hear how it is that he who is thus devoted to his own task finds this perfection. It is inasmuch as by this work that is his own he is praising Him from whom all beings (or, all his powers) are projected, and by Whom all this (Universe) is extended. More resplendent is one's own law (*svadharma*), however imperfectly fulfilled, than that of another, however well carried out. Whoever does not abandon the task that his own nature imposes upon him incurs no sin. One's hereditary . . . task should never be forsaken, whatever its defects may be; for every business is clouded with defects, as fire is clouded by smoke.[31]

Commenting on this passage Coomaraswamy writes, "Herein, of course, 'perfection' or 'success' does not mean the accumulation of a fortune; . . . in old age a man looks forward, not to economic independence, but to a being independent of economics. What is meant by 'success' is self-integration and Self-realization of the man who is Emeritus, one who has done what there was to be done . . . and now is 'Brahma-become.' "[32]

The *āśrama* in which one works is that in which most must remain all of their lives because circumstances and obligations — to gods, ancestors, society, and family — as well as their own condition preclude their retreat. Work in this stage, however, advances a man far on the path of freedom even if it does not render him a *jivan-mukta* (freed in this life). The efficacy of the path of works (*karma-yoga*) as a means to spiritual growth depends partly upon natural vocation and partly upon the will with which actions are performed. All work is sacramental; laborare est orare. His are the powers and He is the director; so, if a man does not consider that he — or that congeries of powers he regards as a person — is the worker, his work will be sacrificial, for he will deny himself for his true Self.[33] According to the *Gītā*, only "he whose soul is bewildered by egotism thinks, 'I am the doer.' "

Concerning right action Coomaraswamy comments,

The literal meaning of the word *karma* is "action," "work," or "making." Now just as in Latin *facere* and *operare* had an original reference to ritual performance and so implied a "making sacred," or "making holy," ( *sacra facere*, "sacrifice") so the primary reference of *karma* (never entirely lost) is to the performance of sacrificial rites that are the paradigms of all operations. This is a point of view of the most far-reaching significance: it implies in the comprehensor a reduction of the whole distinction of sacred from profane and the opposition of spirit to matter, a perception of all things at the same time in their temporal and their eternal significance; it makes it possible to provide for the needs of the body and soul at one and the same time, as in savage societies, and as demanded by Plato for the ideal Republic.[34]

Of primary importance for the doctrine of art is the teaching of the *Gītā* regarding the fruits of labor. One must not be attached to the results of his work; he must merely perform it properly and

27

leave the issue with God.[35] Coomaraswamy writes, "The world is enchained by whatever is done, unless it be made a Sacrifice, and offered up as such in the fire that is kindled by gnosis; better so than to sacrifice any concrete things. So, then, we are to do whatever Nature bids us do, whatever ought to be done; but without anxiety about the consequences, over which we have not control."[36] This renunciation of the fruits of action serves to insure not only an attitude of obedience to the will of God but also the correct performance of the action.

As Coomaraswamy writes, "The essence of traditional politics amounts to this, that 'Self-government' (svarāj) depends upon self-control . . ." "The whole of this science (be it politics or any other science or art) has to do with a victory over the powers of perception and action."[37]

The Hindu social and political doctrine resembles the familiar theories of Plato and the Christian Middle Ages; each conceives of institutions as "means to the perfectibility of the individual." Each holds that justice obtains when the component parts of both men and the social order perform their proper and natural work under the direction of the superior part. A society living by these doctrines is the true "open society"; that is, it is open for men to become who they are, for the opening is above, so to speak, and the whole movement of man and society is designed to be upward and not lateral. Such a society is a complex of compensations; many of the supposed goods that the average sensual man, for example, seems to cherish are relinquished in an existence that orders life toward the acquisition of both the natural goods truly necessary for man's life and the imperishable goods that are ultimately the more valuable.

The universal Tradition, as we have seen, maintains the fundamental identity of all the arts in principle and practice. In various cultures there may be different hierarchies of the arts but there is no real and essential distinction to be made between practical and fine arts. Plato gives a well-known formulation of this doctrine in the *Symposium*: "The productions of all the arts are kinds of

poetry and their craftsmen all are poets." [38] Commenting on this passage Coomaraswamy writes,

"Demiurge" and "technician" are the ordinary Greek words for artist (artifex), and under these headings Plato includes not only poets, painters, and musicians, but also archers, weavers, embroiderers, potters, carpenters, sculptors, farmers, doctors and above all those whose art is government, only making a distinction between creation (δημιουργία) and mere labor (χειρουργία), art (τέχνη) and artless industry (ἄτεχνος τριβή). All these artists, in so far as they are really makers and not merely industrious, in so far as they are musical and therefore wise and good, and in so far as they are in possession of their art (ἔντεχνος cf. ἔνθεος) and governed by it, are infallible. The primary meaning of the word σοφία wisdom, is that of "skill," just as Sanskrit kauśalam is skill of any kind, whether in making, doing or knowing.[39]

The various arts, generally believed to have been discovered by a mythical hero or revealed to men, are, as Meister Eckhart says, "'The artist in the artist,' (that is, in the man so-called)."[40] The arts are innate; the ones appropriate to each man's nature must be discovered and developed.[41] "All the arts have been given to man but not in immediately recognizable form; he must discover them by learning"[42] — that is, primarily by learning who he is, so the art appropriate to him may operate. Similarly William Blake writes, "Man is Born like a Garden ready Planted & Sown."[43] And Plato remarks, "For all well-governed peoples there is a work enjoined [by Nature] upon each man, which he must perform."[44] Each man then who is not an idler, mere brute, criminal, or emeritus has his art in a Traditional society which he is to practice in the manner prescribed.

All true Traditional arts are imitative of the art of the Divine Artificer. As St. Thomas Aquinas states it (though not in the mythical idiom) in a sentence that Coomaraswamy frequently quotes, "Art imitates nature in her mode of operation."[45] The nature designated here, as Coomaraswamy has pointed out, is Mother Nature (natura naturans, God, creatrix universalis) rather than created nature (natura naturata) which is itself God's work of art. In Indian writings it is stated, "We must build as did the Gods

29

in the beginning."[46] The divine creator is conceived as having shaped the universe from its ideal archetype (e.g., "the perfect Word, not wanting in anything, and, so to speak, the art of God," according to St. Augustine).[47] God embodies in the realm of multiplicity the perfect universe that He beholds, as it were, in His intellect.

The human artist imitates the divine artificer by copying in the appropriate material the image interiorly conceived. For him, the creative act falls into two phases, respectively, contemplative (intellectual) and operative. As the artist perfects his means, he reduces both the gap between intellection and execution and the discrepancy between the form in his intellect and the aspect of his work; more and more he will approach the divine spontaneity and perfection. From another point of view, as he becomes emptied of individuality, he works as an instrument of the Divine Artificer — i.e., his true Self — in His creation of the universe that goes on eternally.

The art produced in a Traditional social order is not a naturalistic art that attempts to reproduce the outward aspects of things and to evoke in men responses similar to those they have to natural objects. For one thing, "true art, pure art, never enters into competition with the unattainable perfection of the world"[48] and, for another, it must be a means — symbolic and anagogic — to draw men's powers and attention away from attachment to the changing phenomenal world (experienced as such because incompletely illuminated by the light of gnosis) so that men can conceive the real world in its intelligible aspect, always abiding without essential change. A naturalistic art does not generate this impetus; it tends to emphasize the aesthetic rather than the intellectual or formal nature of things.

The practice of any art usually serves a two-fold purpose both for the artist and the patron. The artist needs to work to discharge his social responsibilities and to gain his livelihood. He will, furthermore, dedicate his art in praise of the gods and use it as a means to his self-realization. A man becomes who he is by doing what the gods gave him to do. The artist then satisfies his material needs

as well as his spiritual needs by laboring in his vocation, because in the words of St. Thomas Aquinas, "The last end of every maker, as such, is himself."[49]

The patron or consumer likewise receives a two-fold benefit. The work of art will serve to satisfy some natural indigence of everyday life which is usually the immediate cause of its being fashioned. And if the work genuinely fits into the economy of his life and does not present occasions for divagation (sin, as we have seen, is basically dissipation of one's powers and wandering from the most direct route to the end of life), it will serve an intellectual (or spiritual) purpose and its use will be helpful to his perfection. The very aspect as well as the form of a Traditional work of art — be it plow, poem, sword, house, statue, loaf of bread, or piece of pottery — will suggest its proper use and also serve as a support to contemplation, a reminder of the true nature of things. Referring to Plato, Coomaraswamy notes that he "has always in view an attainment of the 'best' both for the body and the soul, 'since for any single kind to be left by itself pure and isolated is not good, nor altogether possible' . . . ; 'the one means of salvation from these evils is neither to exercise the soul without the body nor the body without the soul.'"[50]

In a passage devoted to a discussion of the intellectual ends of the arts, Coomaraswamy, drawing largely upon Plato, writes as follows:

What Plato says is that "we are endowed by the Gods with vision and hearing, and harmony was given by the Muses to him that can use them intellectually ($\kappa\alpha\tau\grave{\alpha}$ $\nu o\hat{\nu}\nu$), not as an aid to irrational pleasure ($\dot{\eta}\delta o\nu\acute{\eta}$ $\ddot{\alpha}\lambda o\gamma o s$), as is nowadays supposed, but to assist the soul's interior revolution, to restore it to order and concord with itself. And because of the want of measure and lack of graces in most of us, rhythm was given us by the same Gods for the same ends"; and that while passion ($\pi\acute{\alpha}\theta\eta$) evoked by a composition of sounds "furnishes a pleasure-of-the-senses ($\dot{\eta}\delta o\nu\acute{\eta}$) to the unintelligent, it (the composition) bestows on the intelligent that heartsease [$\epsilon\dot{\upsilon}\phi\rho o\sigma\acute{\upsilon}\nu\eta$, translated "higher sort of delight" by Jowett and "intellectual delight" by R. G. Bury] that is induced by the imitation of the divine harmony produced in mortal motions."[51]

The arts in a Traditional social order are vocational priesthoods

31

dedicated to the perfecting of both artist and patron or consumer (who is himself an artist both in his work and in his life as he uses artifacts). More than any activity (except perhaps the participation in rites) the practice of arts orders a man's life to his proper end. The artifacts produced serve to *remind* men of the Truth, which is not abstract but real, timeless and timely. What Blake has said can be applied essentially to any Traditional society: "The Whole Business of Man Is The Arts. . . . The unproductive Man is not a Christian. . . ."[52]

And as Blake, following Dante and Milton, who were also conscious of their high calling, wrote of his own practice of the arts, "It is an Endeavour to Restore what the Ancients call'd the Golden Age."[53] This is what Plotinus called "that archetypal world . . . , the true Golden Age, age of Kronos, who is the Intellectual-Principle [νοῦς] as being the offspring or exuberance of God."[54] It is in that age, as Blake observes, that "all had originally one language and one religion . . . the Everlasting Gospel."[55] Walter Andrae, the Assyriologist whom Coomaraswamy often quotes with approval, has put it thus: "To make the primordial truth intelligible, to make the unheard audible, to enunciate the primordial word, such is the task of art, or it is not art."[56]

In the context of this Traditional doctrine concerning the nature of God, man, and the universe, and in the light of a comprehensive theory of the function of art in the economy of the whole of life, Coomaraswamy's absolute and intransigent attitude and theories will be somewhat more intelligible, if not more credible.

# The Creative Process

*In making a thing the very innermost Self of a man comes into out-wardness.* MEISTER ECKHART.

As ABOVE, SO BELOW: this metaphysical principle is clearly exemplified in creative activity. Because of the correspondence of the two orders — heavenly and earthly — all human life is said to be patterned after the divine existence.[1] And since creation is one of the most godlike activities,[2] the human artist must be especially aware of modeling his art on that of the divine artificer. A Hindu work has it, "We must do what the Gods did first."[3] Referring to Meister Eckhart as one of the great proponents of the Tradition, Coomaraswamy observes that "it runs through all his thought that man is an artist in the analogy of the 'exalted workman' and his idea of 'sovran good' and 'immutable delight' is that of a perfected art."[4] As man labors in his vocation and approaches perfection in his work, he will become more like God in spontaneity and efficacy. It is to approach this perfection that each person traditionally practices the art best suited to him.

Coomaraswamy has written at length in many essays about the creative process. The theory he sets forth is clear, though possibly somewhat alien to modern attitudes and thought. In general it is the familiar doctrine of Plato and the Scholastics. It is essentially the same as that sketched out by William Blake, whose theories much informed his practice.

In a late essay, "Athena and Hephaistos," Coomaraswamy makes a typical analysis of the creative process according to the Tradi-

tion; here he employs Greek sources almost exclusively in explicating the myth of the goddess of wisdom and the artificer-god. He writes,

In the production of anything made by art, or the exercise of any art, two faculties, respectively imaginative and operative, free and servile,[5] are simultaneously involved; the former consisting in the conception of some idea in imitable form, the latter in the imitation (*mimesis*) of this invisible model (*paradeigma*) in some material, which is then informed. The distinctive character of all the arts is, accordingly, twofold, on the one hand the work of the intellect (*nous*) and on the other of the hand (*cheir*). These two aspects of the creative activity correspond to the "two in us," viz. our spiritual or intellectual Self and sensitive psychophysical Ego, working together (*synergoi*). The integration of the work of art will depend upon the extent to which the Ego is able and willing to serve the Self, or if the patron and the workman are two different persons, upon the measure of their mutual understanding.[6]

To insure the cooperation of the two selves, the artist must prepare himself by various techniques designed to subject the psychophysical nature to the intellectual, for, as St. Thomas Aquinas writes, "Art is an intellectual virtue."[7] The fact that the artist has accepted a commission after due consideration should imply the rectitude of his will toward his project.[8] Once he undertakes a work, the Traditional artist labors rightly not for fame, money, beauty, or the personal satisfaction of himself or others — not even for the glory of God — but only for the perfection of the object he intends to create. St. Thomas Aquinas observes, "Every artist intends to give his work the best disposition"[9] and "a craftsman is inclined by justice . . . to do his work faithfully." In performing his work properly, the just craftsman satisfies the strict requirements of his art and the legitimate needs of his patron. This purity of intention and dedication to the work characterizes the first step in the subjection of the outer to the inner man; it will help the artist to utilize his art and his powers in their highest and most concentrated form.

Granted the dedication, the artist must further strive to minimize creature behavior. The relatively uncontrolled race of thoughts in the conscious mind and the unconscious "knots of the heart" need

somehow to be controlled and loosened if the contemplative authority within is best to direct the executive powers. To clear the mirror of the intellect and to recruit his scattered powers for the act of creation, the Traditional artist often practices such disciplines as fasting, prayer, and meditation.[10] "The whole process [of preparation] is one of worship,"[11] which, in one manner of speaking, is an effort to make one's will and intellect consonant with that of God.[12] The purpose of this practice is to prepare the instrument (the artist) to pursue the divinely appointed work most perfectly.[13]

Once the psychophysical nature has been subjected to the limit of the artist's ability to the inner controller, the contemplative or intellectual phase of the creative process can begin. This phase is called variously *actus primus*[14] in Scholastic terminology, intuition, act of imagination, and act of interior or contemplative vision. "The whole purpose of contemplation . . . is to reach that state of being in which there is no longer any distinction of knower from known, or being from knowing."[15] The contemplative state is considered throughout the various forms of the Tradition to be the one factor, beside practice and the skill that is learned, necessary for the production of the best works of art. Only by the contemplation of an interiorly conceived image and not by direct observation are the required results to be obtained.[16] "The man incapable of contemplation cannot be an artist, but only a skilful workman."[17] As Coomaraswamy states, "The emphasis that is laid upon the strict self-identification of the artist with the imagined form should be noted. Otherwise stated, this means that he does not understand what he wants to express by means of any ideas external to himself . . . Per contra, the distinction of subject from object is the primary condition of ignorance, or imperfect knowledge, for nothing is known essentially except as it exists in consciousness, everything else is supposition . . . The artist must really have been whatever he is to represent."[18] If the artist does not concentrate his attention in an intense focus clear of irrelevancies and free from awareness of himself, he will only partially "be" that which he proposes to represent by his art. That is, he will be conscious of himself to a greater or lesser degree as a knowing

35

and creating *subject* contemplating a mental *object* which he must imitate in the material of his art. Any artist so divided will not be able, on the one hand, to conceive the intelligible idea clearly nor, on the other, to imitate it properly.[19]

From no other writer of classical antiquity does Coomaraswamy draw so extensively as he does from Plato, whom he reveres as one of the great figures in the perennial Tradition. Plato's view of artistic creation, it is well known, is that the only true art is based upon imitation of archetypal forms. In a passage often quoted by Coomaraswamy Plato writes, "The work of the creator [δημιουργός, an artificer], whenever he looks to the unchangeable and fashions the form and nature of his work after an unchangeable pattern, must necessarily be made fair and perfect, but when he looks to the created only, and uses a created pattern, it is not fair or perfect."[20] Speaking of the *polis*, which should be constructed according to the "royal art" of politics (the type of all human art and life), Plato writes, "The city can never otherwise be happy unless it is designed by those painters who follow a divine original."[21] Again he states, "Law and art are children of the intellect (νοῦς)."[22]

Plato censures human action that is based upon illusion or opinion and he condemns naturalistic art.[23] "And may we not fairly call the sort of art, which produces an appearance and not an image, phantastic art?"[24] As Coomaraswamy observes, "Art is iconography, the making of images or copies of some model (παράδειγμα), whether visible (presented) or invisible (contemplated). . . ."[25] For Plato, the goodness of an imitation is to be determined by its truth and its adequacy in rendering the thing imitated according to quantity and quality[26] and not by the pleasure it gives or its success in reproducing appearances.

In a composite quotation Coomaraswamy cites several other passages in which Plato iterates his fundamental conception of the nature of veridical knowledge. "The realities are 'seen by the eye of the soul' (*Republic* 533D), 'the soul alone and by itself' (*Theatetus*, 186, 187), 'gazing ever on what is authentic' (πρὸς τὸ κατὰ ταὐτὰ ἔχον βλεπών ἀεί *Timaeus* 28A) . . . and 'thus by inwit (intuition) of what really is' (περὶ τὸ ὂν ὄντως ἐννοία *Philebus* 59). Just

as in India, where it is only when the senses have been withdrawn from their objects, only when the eye has been turned around . . . and with the eye of gnosis . . . that the reality can be apprehended."[27]

Others in the Platonic tradition — especially Plotinus, Hermes Trismegistus, Dionysius the Areopagite, St. Augustine, St. Bonaventura, and Meister Eckhart — Coomaraswamy cites copiously in support of his theory. Plotinus, who Coomaraswamy believes "ought much rather to be called a Platonist than a 'Neo-' Platonist,"[28] has written that "music is the earthly representation of music that there is in the rhythm of the ideal world"[29] and that the "crafts such as building and carpentry take their principles from that realm and from thinking there."[30] He has given a concise description of the intellectual state characteristic of the first phase of the creative process, "In contemplative vision, especially when it is vivid, we are not aware of our personality; we are in possession of ourselves, but the activity is towards the object of vision with which the speaker becomes identified; he has made himself over as matter to be shaped; he takes ideal form under the action of the vision, while remaining potentially himself."[31]

From the Judaic tradition Coomaraswamy often quotes Exodus 25:40, in which God instructs Moses concerning the building of the temple and its furniture, "And look that thou make them after their pattern, which was shewed thee in the mount."[32] Following the hermeneutics of St. Bonaventura which equates *mens* and *mons* here he quotes, "Ascendere in montem, id est, in eminentem mentis."[33] He also cites with approval Philo Judaeus's exegesis of the text in Exodus respecting the

tabernacle . . . the construction of which was set forth to Moses on the mount by divine pronouncements. He saw with the soul's eye the immaterial forms (ἰδέαι) of the material things that were to be made, and these forms were to be reproduced as sensible imitations, as it were, of the archetypal graph and intelligible patterns . . . So the type of the pattern was secretly impressed upon the mind of the Prophet as a thing secretly painted and moulded in invisible forms without material; and then the finished work was wrought after that type by the artist's imposition of those impressions on the severally appropriate material substances.[34]

For Coomaraswamy this is a type of all true creativity; the artist copies in his material the image he beholds in his intellect.

From Patristic and Scholastic sources Coomaraswamy draws frequently, especially from the works of St. Augustine, St. Thomas Aquinas, St. Bonaventura, and Meister Eckhart. These Christian thinkers all accept the doctrine that God created the universe through the Word (Logos) or Christ, through whom all things were made — and are now being made, for the creation is conceived as everlasting.[35] The Logos or Son, who is God's understanding of Himself in Himself (His intelligible aspect), is the exemplar of all creation, individual creatures as well as the whole.[36] The universe is an epiphany taking form from the eternal paradigm.[37] At best the human artist who lets Christ or the immanent deity work for him imitates the forms or ideas of things as they are in God. The exemplar, paradigm of all things, is within (virtually at least), and comes into outward manifestation in whatever is made, the more perfectly as the individual is dead to himself and allows Him to work.

St. Thomas Aquinas writes, "God is the cause of things made by His intellect and will, just as the craftsman is the cause of the things made by his craft. Now the craftsman works through the word conceived in his intellect,[38] and through the love of his will toward some object. So, too, God the Father made the creature through His Word, which is His Son; and through His Love, which is the Holy Ghost."[39] Again, "Now the knowledge of the artificer is the cause of things made by his art from the fact that the artificer works through his intellect. Hence the form in the intellect must be the principle of action. . . ."[40] Similarly in St. Bonaventura, "Agens per intellectua producit per formas."[41]

Concerning the Scholastic use of the word "form" Coomaraswamy writes explicitly in a passage that, though abbreviated below, must be quoted at some length:

A clear grasp of what is meant by "form" (Lat. *forma* = Gk. εἶδος) is absolutely essential for the student of mediaeval aesthetic. In the first place, form as coincident with idea, image, species, similitude, reason, etc., is the purely intellectual and immaterial

cause of the thing being what it is as well as the means by which it is known; form in this sense is the "art in the artist," to which he conforms his material, and which remains in him and this holds equally for the Divine Architect and for the human artist. This exemplary form is called substantial or essential, not as subsisting apart from the intellect on which it depends, but because it is like a substance. Scholastic philosophy followed Aristotle rather than Plato, "who held that ideas existed of themselves, and not in the intellect." . . .

In the second place, over against the essential form or art in the artist as defined above and constituting the exemplary or formal cause of the becoming of a work of art (*artificiatum, opus,* that which is made *per artem,* by art) is the accidental or actual form of the work itself, which as materially formed (*materialis efficitur*) is determined not only by the idea or art as formal cause, but also by the efficient and material causes; and inasmuch as these introduce factors which are not essential to the idea nor inevitably annexed to it, the actual form or shape of the work of art is called its accidental form.[42]

To the extent that anything is known, it is known formally. Knowledge, however, as the Scholastic maxim has it, is according to the mode of the knower. Even if an artist intends to create a naturalistic work of art, he will copy some kind of interior image; this image may be only a phantasm of his imagining but nevertheless it will be within him because he cannot know or sense things as they "are" in the world of becoming, such is their impermanence. The true artist, however, wishes to apprehend the *real* or essential forms of things he plans to embody in his work.[43] He will create according to the word (or conception) in his intellect; to the degree that his copy imperfectly expresses the imitable form he will fail. "Artificial things are said to be false absolutely and in themselves, in so far as they fall short of the form of the art; whence a craftsman is said to produce a false work, if it falls short of the proper operation of his art." [44]

Although Coomaraswamy drew heavily from the works of St. Thomas Aquinas and St. Bonaventura, he never made a single detailed study of their doctrine of art as he did of Meister Eckhart's. His essay, "Meister Eckhart's View of Art,"[45] is significant in the present context not only because Eckhart's thought has a particular

affinity to Coomaraswamy's, but also because it demonstrates, as Coomaraswamy observes, "the spiritual being of Europe at its highest tension."[46] This difficult and profound essay, which makes few concessions to the reader, is composed in large part of Eckhart's scattered obiter dicta on art, organized with brief commentaries by Coomaraswamy. The insights into the creative process that it affords are particularly illuminating.

For Eckhart as for the other Scholastics the contemplative phase is properly devoted to concentrating upon and apprehending the intelligible form of that which is to be embodied in the material. "These pre-existing forms are the origin or principle of creation of all creatures [that is, all created things] and in this sense they are types and pertain to practical knowledge."[47] These forms, types, patterns, or ideas, whether those of natural species (e.g., of a rose) or of artificial things (e.g., of a house) live eternally in the "divine mind," the "hoard" which "is God's art."[48] "There is a power [like this divine hoard] in the soul called mind . . . ; it is her storehouse of incorporeal forms and intellectual notions."[49] Coomaraswamy comments, "The ideas in this storehouse of the soul may seem either to be new or to be remembered . . . , but in either case are as it were recollected . . . for 'all the words of his divine essence flow into the word in our mind in distinction of Persons [that is, as the Logos, Son, or Exemplar, the intelligible aspect of the deity, as distinct from the Father who cannot be known except through the Son] just as memory pours out treasure of images into the powers of the soul.'"[50]

The problem for the artist is to perceive these ideas, which are for Eckhart not Platonic ideas external to intellect but rather "types of activity, principles of work or becoming, living and particular."[51] The invention (finding) of the artist, whether of the ideas of natural species or factibilia, is "a discovery amongst 'the sum of all the forms conceived by man and which subsist in God himself, I having no property in them and no idea of ownership.'"[52] These ideas are not God's essence for that cannot be known as particular or universal but only as Sameness. For St. Bonaventura writes, "Idea does not denote essence as such but essence as imitable."[53] This

40

"imitable essence," Coomaraswamy observes, is in this sense "the same thing as 'nature' (*'natura naturans, creatrix, Deus'*) in the very important dictum, 'Ars imitatur naturam in sua operatione.'"[54] Knowledge of all things is potentially within all men. "The doctrine of recollection is explicit in Meister Eckhart, who says: 'If I knew my Self as intimately as I ought, I should have perfect knowledge of all creatures,' for 'the soul is capable of knowing all things in her highest power,' viz. 'as a clear mirror sees all things in one image.'"[55]

Eckhart further states, "Work comes from the outward and the inner man but the innermost man takes no part in it. In making a thing the very innermost Self of a man comes into outwardness."[56] This is no contradiction. The psychophysical outward man is the instrument of the inner man or Self, which is immortal and change-less, an unmoved mover, the witness of life. That the vision of the inner man may best come into outwardness without accruing ad-ventitious features imposed on it by the personality, the artist must both quiet and quit himself. "Let go thyself," says Eckhart, "and let God act for thee."[57]

"The arising of the image" of that which is to be imitated or ex-pressed outwardly, Coomaraswamy observes, "is not by an act of will . . . but of attention . . . when the will is at rest."[58] The creative process often referred to by Eckhart is three-fold: "The arising of the idea in germ, its taking shape before the mind's eye, and outward expression in work."[59] In the words of Eckhart, what I say "springs up in me, then I pause in the idea and thirdly I speak it out."[60] Again he states, "First when a word [or idea] is conceived in my mind it is a subtle intangible thing; it is a true word when it takes shape in my thought. Later, as spoken aloud by my mouth, it is but an outward expression of the interior word."[61] This act of attention when the will is quiet is described by Eckhart, who relates the case of the master who "was once questioned by his pupil about the angelic order. He answered him and said, Go hence and withdraw into thyself until thou understandest: give thy whole self up to it, then look, refusing to see anything but what thou find-est there. It will seem to thee at first as though thou art the angels

with them and as thou dost surrender to their collective being thou shalt think thyself the angels as a whole with the whole company of angels." [62] When this contemplative act finds the knower assimilated to the known, the artist fulfills the primary condition of all true artistic endeavor, as the Tradition maintains.[63] Commenting on this passage Coomaraswamy writes, "So far, the process is identical with the Indian imager's *dhāyana-yoga* [visual contemplative union]; and had an actual picture [or verbal description] of the angels been required, it might have been added *dhyātvā kuryāt*, that is, 'Having thus seen and surrendered to the presented form, begin the work.'" [64]

From Dante, contemporary of Eckhart, Coomaraswamy several times quotes passages about the need for the artist's identification with the form of the work to be done. "He who would paint a figure, if he cannot be it, cannot paint it," and "No painter can portray any figure, if he have not first of all made himself such as the figure ought to be." [65]

The Traditional doctrine of the imitation of contemplated forms in artistic creation has been widespread throughout the ages in the Orient.[66] Characteristically, Coomaraswamy refers often to works from the East and translates many passages relating to imitation.[67] From the Sanskrit are the following: "It is in imitation . . . of the divine forms that any human form . . . is invented here"; "There is this divine harp, to be sure; this human harp comes into being in its likeness . . . "; "We must do what the Gods did first." On these passages Coomaraswamy comments, "*This* is the 'imitation of Nature in her manner of operation,' and like the first creation the imitation of an intelligible, not a perceptible model." [68]

In his essay "The Theory of Art in Asia" [69] Coomaraswamy, basing his doctrine upon a Sanskrit text, writes as follows about imitation:

The formal element in art represents a purely mental activity, *cittasaññā*. From this point of view, it will appear natural enough that India should have developed a highly specialized technique of vision. The maker of an icon, having by various means proper to the practice of Yoga eliminated the distracting influences of fugitive emotions and creature images, self-willing and self-thinking, pro-

ceeds to visualize the form of the *devatā*, angel or aspect of God, described in a given canonical prescription, *sādhana*, *mantram*, *dhyāna*. The mind "pro-duces" or "draws" . . . this form to itself, as though from a great distance. Ultimately, that is, from Heaven, where the types of art exist in formal operation; immediately, from the "immanent space in the heart" . . . , the common focus . . . of seer and seen, at which place the only possible experience of reality takes place. The true-knowledge-purity-aspect ( *jñāna-sattva-rūpa* ) thus conceived and inwardly known . . . reveals itself against the ideal space . . . like a reflection. . . . The imager must realize a complete self-identification with it . . . , whatever its peculiarities, even in the case of the opposite sex or when the divinity is provided with terrible supernatural characteristics; the form thus known in an act of non-differentiation, being held in view as long as may be necessary . . . , is the model from which he proceeds to execution in stone, pigment, or other material.[70]

On this passage he comments: "This procedure on the part of the imager implies a real understanding of the psychology of aesthetic intuition. To generalize, whatever object may be the artist's chosen or appointed theme becomes for the time being the single object of his attention and devotion; and only when the theme has thus become for him an immediate experience can it be stated authoritatively from knowledge."[71]

Always and everywhere in the Tradition the same formula for artistic creation is present. Still another Sanskrit work, "the *Śukranītisāra*, IV. 70–71, defines the initial procedure of the Indian imager; he is to be expert in contemplative vision ( *yoga-dhyāna* ), for which the canonical prescriptions provide the basis, and only in this way, and not by direct observation are the required results to be attained. The whole procedure may be summed up in the words 'when the visualization has been realized, set to work. . . .' "[72] Although Coomaraswamy cites many similar passages and explicates them, the wealth and profundity of his exposition and commentary — in metaphysical, mythical, theological, philosophical, aesthetic, and etymological terms — can no more than be suggested here. It will suffice to say that the doctrine emerges clearly and convincingly, especially when the more familiar Platonic, Aristotelian, and Christian analogues are pointed out.

43

Viewing the Renaissance as introducing an age of individualism that produced few great thinkers and artists in the tradition of the Philosophia Perennis, Coomaraswamy seldom refers to the well-known writers, artists, and critics after the Middle Ages. One writer that he often cites with complete approval as a foremost representative of the Tradition is William Blake, whose doctrine of art makes him, as he notes, "Eckhart's nearest and natural descendant."[73] Blake believed that "All Things Exist in the Human Imagination"[74] and that "One Power alone makes a Poet: Imagination, the Divine Vision."[75] Point for point, in fact, the essential congruence of Blake and the other Traditionalists could be demonstrated, as Coomaraswamy knew. As for the theories of various others — e.g., Coleridge, Schelling, Carlyle — which may have some kinship with Traditional doctrine, Coomaraswamy ignores them. Most modern thinkers he ruled out with his magisterial motto, "Do not consider the inferior philosophers." In any event he found sufficient support for perennial doctrine from the more canonical thinkers who were not tainted by "modernism" and heterodoxy.[76]

❈　　❈　　❈

To the degree that there is a true marriage of intellect and means, the artist is said to be inspired. The concept of inspiration, which a modern professor typically believes is "hardly a subject for serious literary criticism," is defined most rigorously by Coomaraswamy. He deprecates the common misuse of the term — e.g., "Such-and-such an artist was inspired by the rain or by his materials" — and insists that, properly speaking, one of the dictionary definitions is to be preferred: "a supernatural influence which qualifies men to receive and communicate divine truth."[77] In the perennial Tradition, he writes, "it is always by the Spirit that a man is thought to be inspired." For him, it would seem, the invocations of the Muses and the references to inspiration in poets like Homer and Hesiod are not — at least, *were* not originally — empty formulas or mere literary conventions but genuine expressions of a belief in supernatural aid "breathed into" men.[78] One of his passages on inspira-

tion is so typical of his late method in its manner of handling citations that it must be set down in its entirety.

Christ, "Through whom all things were made" does not bear witness of (express) himself, but says, "I do nothing of myself, but as my Father taught me, I speak";[79] Dante is one who "When Love (Amor, Eros) inspires me (*mi spira*), attend, and go setting it forth in such wise as He dictates within."[80] For "there is no real speaking that does not lay hold upon the Truth."[81] And who is it ("What self?") that speaks "the Truth that cannot be refuted"? Not this man, So-and-so, Dante or Socrates or "I," but the Synteresis, the immanent Spirit, Socrates' and Plato's Daimon, he "who lives in every one of us"[82] and "cares for nothing but the Truth";[83] it is "the God himself that speaks" when we are not thinking our own thoughts but are His exponents, or priests.[84]

When the act of contemplation has been such that the absorption in the form to be imitated has been complete — there being little or no egoity or self-consciousness present to vitiate the act — the artist can be said to have fulfilled the primary condition for inspiration.[85]

Coomaraswamy continues,

And so as Plato, the father of European wisdom asks, "Do we not know as regards the practice of the arts . . . the man who has this God for his teacher will be renowned and as it were a beacon light, but one whom Love has not possest will be obscure?"[86] This is a particular reference to the divine originators of archery, medicine, and oracles, music, metalwork, weaving, and piloting, each of whom was "Love's disciple." He means, of course, the "cosmic Love" that harmonizes opposite forces, the Love that acts for the sake of what it has and to beget itself, not the profane love that lacks and desires. So the maker of anything, if he is to be called a creator, is at best the servant of an immanent genius; he must not be called "a genius" but "*in*genious"; he is not working of or for himself, but by and for another energy, that of the Immanent Eros, Sanctus Spiritus, the source of all "gifts." "All that is true, by whomsoever it has been said, has its origin in the Spirit."[87]

One of the most familiar passages on inspiration — indeed the *locus classicus* in European criticism — comes from Plato's *Ion*. This passage Coomaraswamy translates in such a way as to make it clear that the poetic inspiration described is a type of all artistic inspiration.

"It is a divine power that moves" ($\theta\epsilon ί a$ $\delta \grave{\epsilon}$ $\delta ύ ν a\mu i s$ $\acute{\eta}$ $\sigma\epsilon$ $\kappa i\nu\epsilon \hat{i}$) even the rhapsodist, or literary critic, in so far as he speaks well, though he is only the exponent of an exponent. The original maker and exponent, if he is to be an imitator of realities and not of mere appearances, "is God — indwelt and possess ($\check{\epsilon}\nu\theta\epsilon os$, $\kappa a\tau\epsilon\chi ό\mu\epsilon\nu os$) . . . an airy, winged and sacred substance ($\iota\epsilon\rho\grave{o}\nu$, Skr. *brahma-*); unable ever to indite until he has been born again of the God within him ($\pi\rho\grave{i}\nu$ $\check{a}\nu$ $\check{\epsilon}\nu\theta\epsilon ό s$ $\tau\epsilon$ $\gamma\acute{\epsilon}\nu\eta\tau a\iota$) and is out of his own wits ($\check{\epsilon}\kappa\phi\rho\omega\nu$) and his own mind ($\nu o\hat{v}s$) is no longer in him; for every man, so long as he retains *that* property is powerless to make ($\pi o\iota\epsilon \hat{i}\nu$) or to incant ($\chi\rho\eta\sigma\mu\omega\delta\epsilon \hat{i}\nu$, Skr. *mantra-kṛ*) . . . The men whom he dements God uses as his ministers ($\dot{v}\pi\eta\rho\acute{\epsilon}\tau a\iota$). . . . It is the God himself ($\dot{o}$ $\theta\epsilon\grave{o}s$ $a\dot{v}\tau ό s$) that speaks, and through them enlightens ($\phi\theta\acute{\epsilon}\gamma\gamma\epsilon\tau a\iota$) us. . . . The makers are but his exponents ($\epsilon\rho\mu\eta\nu\eta s$), according to the way in which they are possest."[88]

With this passage Coomaraswamy quotes several additional statements from Plato that make it clear that this is no early doctrine later to be abandoned by the philosopher. "'The madness that comes of God is superior to the sanity which is of human origin.'"[89] When one is rapt out of himself into the higher reaches of the intellect, he may appear mad to ordinary men; however, as Giordano Bruno remarks, this is not because he does not know but because he over-knows — that is, "divination is of a Truth that cannot (with human faculties) be seen directly. . . ."[90]

According to the Tradition it is *we* — as congeries of individual personalities or disparate powers — that do things imperfectly. St. Thomas Aquinas says, "In so far as men are sinners, they are not, and they fail of being. . . ."[91] To the extent that our personality, which is not a real but a "hypothetical unity that one postulates to account for the doings of people,"[92] is allowed to obtrude because it does not acknowledge its true master, we fail to be in act and the work that we would perform fails to be done properly and is rather undone. "Artificial things," writes Aquinas, "are said to be false absolutely and in themselves, in so far as they fall short of the form of the art; whence a craftsman is said to produce a false work if it falls short of the proper operation of his art."[93] The proper operation of one's art can be achieved only when the powers and the mind are subject and not assertive.[94] The artist can be perfectly

46

controlled only to the extent that "his own mind is no longer in him." It is then that one can say with Plato, "It is God himself that speaks." From Meister Eckhart we can quote a few of many similar dicta concerning work: "Above all, lay no claim to anything. Let go thyself and let God act for thee. . . . If thou wouldst live and have thy work live also thou must be dead to all things and reduced to naught. . . . Works wrought out of the kingdom of God are dead works but works wrought in the kingdom of God are living works."[95]

When an artist well skilled and in command of his art gives himself up, at least for the duration of the creative act, to an intense interior vision of the very form he will create, the immanent Spirit (Intellect, Daimon, Eros) may use his soul and body efficiently as an instrument.[96] As Coomaraswamy has noted several times, it is not as if such an artist were completely passive, a mere tool employed by an exterior power, but he is rather directed by his inner or true Self; he is Self-directed and he expresses his true Self.[97] Now, if the "innermost Self of man" (as Eckhart has it) is to come out in work, two conditions are necessary. First, as we have seen, the mirror of the intellect must be clear so that the artist may apprehend the form of that which he plans to embody in a material. If the conscious or unconscious unresolved elements in the nature of the artist dissipate his powers of attention to the one thing needful at the time, the interior vision will be distorted. The second condition necessary for successful creation is the artist's skill perfected through long practice.

❉    ❉    ❉

It is obvious that more than purity of contemplative vision is required by the artist. A sage, we can suppose, may have a vision of the supreme Truth and Beauty and a philosopher-king from Plato's *Republic* may be able to look on the Good with the "eye of the soul," but it is quite possible that they could not create a poem, statue, or temple. A man's psychophysical nature must be amenable to the shaping of the Spirit if it is to become an efficient instrument for creation. One must then at best have a natural vocation. Besides

47

possessing the proper natural endowments, he must also have trained and practiced until the execution of his works approaches the limits of his perfection.[98] The interior image must come into outward manifestation with as few distortions as possible caused by lack of skill and insufficient discipline.[99] Drawing from Sanskrit works on poetry, Coomaraswamy writes, "The one thing most necessary to the human workman is *abhyāsa*, 'practice,' otherwise thought of as *anuśīla*, 'devoted application' or 'obedience,' the fruit of which is *śliṣṭatva*, 'habitus,' or second nature, skill, lit. 'clinginess,' 'adherence.' . . ."[100] The more the artist practices intelligently and is obedient to the canonical rules of his work and the more he develops facility in executing his design as he conceives it, the more he approaches the archetypal divine manner of working which is spontaneous and instantaneous, there being no gap between thought, will, and act in God, who is perfect and complete act.

The success of the work of art will depend, then, upon both the perfection of contemplation and the mastery of the proper operative skills. As Coomaraswamy quotes the *Bhagavad Gītā*, "skill in any performance is a yoking, as of steeds together"; it implies a true marriage of the master and the means. In a characteristic passage he discusses this one marriage of the many that a Traditional man makes:

The product of the marriage of the player, Intellect, with the instrument, the Voice, is "Truth" (*satyam*) or Science (*vidyā*); not that approximate hypothetical and statistical truth that we refer to as "science" but "philosophy" in Plato's sense. . . . The raison d'être of the Voice is to incarnate in a communicable form the concept of Truth; the formal beauty of the precise expression is that of the *splendor veritatis*. The player and the instrument are both essential here. We in our somatic individuality are the instrument, of which the "strings" or "senses" are to be regulated, so as to be neither slack nor overstrained; we are the organ, the inorganic God within us is the organist. We are the organism, He its energy.[101]

To approach the divine spontaneity the Traditional artist must practice not only long and arduously but also diligently by using the rules of his art that have been transmitted from the initiated and

dedicated artists of one generation to those of the next. These rules, which in many societies are thought of as having been given by the gods in the beginning, are to be conceived as "the vehicle assumed by spontaneity,"[102] as Coomaraswamy has it in his grand phrase. They are the tried and effective means for success in a given art and, as such, have ultimately a metaphysical basis; they should, therefore, be faithfully observed lest the introduction of one's own personal techniques vitiate one's work and introduce a decline into an established order.[103] "In tending toward an *ultimate coincidence of discipline and will*," such as there is only in God, "the artist does indeed become less and less conscious of rules, and for the virtuoso intuition and performance are already simultaneous; but at every stage the artist will delight in rules. . . ."[104] It is only by following the rules which have been the means both for the artistic success and the self-integration of those better than he that the artist can make the rules second nature and cease being conscious of them as he approaches spontaneous performance.[105] Pending complete discovery of the God-given art within himself, the Traditional artist must use rules discovered by the great masters or revealed to them.[106]

About the conservation of techniques, rules, and themes Coomaraswamy writes,

In the economy of the great living traditions we find . . . that certain restricted kinds or groups of themes are adhered to generation after generation in a given area, and that the technique is still controlled by most elaborate rules and can only be acquired in long years of patient practice. . . . Historical conditions and environment, an inheritance of older symbolisms, specific racial sensibilities, all these provide a better determination of the work to be done than "individualism"; for the artist or artisan, who "has his art which he is expected to practice," this is a means to the conservation of energy; for man generally, it secures a continued comprehensibility of art, its value as communication.[107]

After the artist has finished his work, he must, of course, judge and correct his effort before he can allow it to leave his hands. Even when he has been inspired and rapt out of himself (much as Plato describes in the *Ion*), he must take care to examine the

49

finished product critically. "It is only when he returns to himself from what is really a sacrificial operation that the maker exercises his own powers of judgment; and then primarily to 'try the spirits, whether they be of God' [I John 4:1], and secondarily to try his work, whether it agrees with the vision or audition."[108] Thirdly, he must determine whether he has followed canonical prescriptions as to expression and themes. (This problem of judgment will be dealt with in Chapter VI below.)

❋    ❋    ❋

So far it has been mainly a general theory of the creative process that has been set forth, specific reference to literary creation being included with others without differentiation. Most of the general theory, no matter in terms of what art it is discussed, is applicable in principle to the method of the poet and writer, for it has been said repeatedly, "All our sources are conscious of the fundamental identity of all the arts,"[109] and again in the words of Plato, "The productions of all arts are kinds of poetry, and their craftsmen are all poets."[110] Superficially, however, there seems to be a significant difference between the work of a sculptor, for example, as a type of the artist who manipulates physical materials into a shape that is a copy of an interior image and the work of the literary poet, who expresses his idea in words which seem somehow to have more meaning in themselves as materials than the clay or stone of the sculptor. And granted that the artist imitates a contemplated form, it may be questioned whether a poet imitates or copies this form as does a sculptor. In short, how can one copy or imitate in words?

Coomaraswamy writes, "We cannot entertain an idea except in a likeness; and therefore we cannot think without words or other images."[111] In this he follows Aristotle, whom he quotes as follows: "Even when one thinks speculatively, one must have some mental picture with which to think."[112] From Plotinus can be adduced a similar statement, "Every mental act is accompanied by an image . . . fixed and like a picture of the thought . . . the Reason-Principle [logos] — the revealer, the bridge between the concept and the image-taking faculty — exhibits the concept as in a mir-

ror."[113] It is these ideas or images that the poet as well as the sculptor and architect "sees," as it were, in interior vision, holds fast before his mind's eye, and copies in his material — sound, written or printed letters, stone, or wood. Eckhart describes the process: "First when a word is conceived in my mind it is a subtle intangible thing; it is a true word when it takes shape in my thought. Later, as spoken aloud by my mouth, it is but an outward expression of the interior word."[114] As one focuses his attention he is vaguely aware that he possesses an idea within him. When the focus becomes sharpened, the idea is discovered or recollected, as it were; one then is conscious of knowing it.

In the above-mentioned passage on the master who was answering his pupil's questions about the angelic order, Eckhart defines the method by which this knowledge could be gained: self-identification with the angels in an act of contemplation. Now it would seem that this interior image of the angels could be copied in any appropriate material — in stone or wood by a sculptor, in pigment by a painter, or in words by a poet. Dante, it will be remembered, did describe the angelic orders in words in his *Commedia*. And Dante it was who observed, "No painter can portray any figure, if he have not first of all made himself such as the figure ought to be."[115] When he did copy his vision in words, he spoke of the "figures as I have them in conception."[116] It is to Eckhart, great contemporary of Dante, that we can go again to get some more complete understanding of the nature of this interior image copied by the artist. He writes, "If my soul knows an angel she knows him by some means and in an image, an image imageless, not in an image such as they are here [e.g., in a painting on the wall]."[117] Again he writes, "I do not see the hand, the stone, itself; I see the image of the stone, but I do not see this image in a second image or by any means; I see it without means and without image. This image is itself the means; image without image like motion without motion although causing motion and size which has no size though the principle of size."[118] Here is described, it would seem, knowledge that is being; when one knows anything really, he is what he knows, as the ancient epistemological principle maintains.

Many examples could no doubt be found to demonstrate the theory that the interior image, such as it is, could be copied in any appropriate material. In the Old Testament one can discover the sort of canonical statement that Coomaraswamy would cite: "The words of Amos . . . which he *saw* concerning Israel," "The vision of Obadiah," "The word of the Lord that came to Micah . . . which he *saw* concerning Samaria and Jerusalem." In the vision of the Apocalypse St. John, who "was in the Spirit on the Lord's day," heard the great voice charge him, "What thou seest, write in a book." Again he states, "I turned to *see* the voice that spake with me." An interesting example can be found in the myth of the hero Rāma which was related by the great sage Nārada to the hermit Vālmīki. Subsequently the god Brahmā, Creator of the World, appeared before Vālmīki and commanded him to compose the story of Rāma in a new-found meter.

Then Vālmīki, dwelling in the hermitage amongst his disciples, set himself to make the great Rāmāyan, that bestows on all who hear it righteousness and wealth and fulfilment of desire, as well as the severing of ties. He sought deeper insight into the story he had heard from Nārada, and thereto took his seat according to *yoga* ritual and addressed himself to ponder on that subject and no other. Then by his yoga-powers he beheld Rāma and Sītā, Lakshman, and Dasharatha with his wives in his kingdom, laughing and talking, bearing and forbearing, doing and undoing, as in real life, as clearly as one might see a fruit held in the palm of the hand. He perceived not only what had been, but what was to come. Then only, after concentred meditation, when the whole story lay like a picture in his mind, he began to shape into *shlokas* [epic stanzas].[119]

"As a man among men," F. M. Cornford writes in his discussion of inspiration among the Greeks, "the poet depends upon hearsay [as when Vālmīki heard the story of Rāma from Nārada]; but as divinely inspired [e.g., Vālmīki in yogic vision], he has knowledge of an eyewitness, 'present' at the feats he illustrates."[120]

In English literature one can go back at least as far as "The Dream of the Rood" for a reference to an inner vision but one could probably choose no better example than the great lines at the beginning of *Paradise Lost* to illustrate some of the theses ad-

vanced in Coomaraswamy's theory of poetic creation. Here we have the invocation of the Holy Spirit, the belief in divine inspiration, and the awareness of the need for purification before a vision is realized. The lines are so well known that only a few need to be quoted.

> And chiefly thou O Spirit, that dost prefer
> Before all Temples th' upright heart and pure,
> Instruct me, for thou know'st:
> . . . . . . . . . . . . . . . . . . . . . . .
> What in me is dark
> Illumine, what is low raise and support;
> . . . . . . . . . . . . . . . .
> So much the rather thou Celestial light
> Shine inward, and the mind through all her powers
> Irradiate, there plant eyes, all mist from thence
> Purge & disperse, that I may *see* & tell
> Of things invisible to mortal sight.[121]

Milton's invocations in Books VII and IX are also noteworthy in this context. There is no doubt that these are, in the words of Coomaraswamy adapted from Quintilian, "figures of thought" as well as "figures of speech," to be taken seriously and not to be explained away as "mere literary convention."

From a discussion of Buddhist iconography we can cite one more statement of the many that Coomaraswamy has made on this "unmodern" subject:

. . . the form is not of human invention, but revealed and "seen" in the same sense that the Vedic incantations are thought of as having been revealed and "heard." There can be no distinction in principle of vision from audition. And as nothing can be said to have been intelligibly uttered unless in certain terms, so nothing can be said to have been revealed unless in some form. All that can be thought of as prior to formulation is without form and not in any likeness; the meaning and its vehicle can only be thought of as having been concreated.[122]

Strange though such an idea may seem, we cannot burke it, especially when we remember that some of the sublimest creations of man are admitted by their authors to owe their origin to divine inspiration in the manner described.

The theory of artistic creation that emerges from Coomaraswamy's work is consistent with the metaphysics of the perennial Tradition. It may resemble, in many ways, various modern psychological theories of creation,[123] but it is, Coomaraswamy would point out, of a higher order than they. So far as the "psychological theories" are correct they reflect on their level the truths of a superior order. On the other hand, the theory that Coomaraswamy expounds has a greater degree of explanatory power, free from profane limitations; furthermore, it is impersonal (also, transpersonal) and absolutely consistent with canonical doctrines concerning the nature of God, man, and the universe.

# The Work of Art

*For the invisible things of him from the creation of the world are clearly seen, being understood by the things that are made, even his eternal power and Godhead.* ST. PAUL.

W HEN THE TRADITIONAL ARTIST finishes the operative phase of the creative process, he will judge and correct his work before delivering it to the patron or otherwise releasing it for use. If he has acted as a responsible member of society, he will have executed the work for eventual good use. And if he has not fallen short of the proper operation of his art, this good use will be facilitated by his skill. Good use, Coomaraswamy repeatedly observes, is traditionally considered to be both intellectual and physical. Concerning use, Coomaraswamy, as we have seen, often refers to Plato, who "has always in view an attainment of the best for the body and the soul, 'since for any single kind to be left by itself pure and isolated is not good, nor altogether possible.'"[1]

Although the immediate need that suggests the work of art may be urgent and primarily physical, its satisfaction will afford an occasion to reaffirm the similarity, if not the ultimate identity, of all orders of existence. The urgency of the physical need may cause men to forget that they do not live by bread alone and to consider physical existence as separate from the spiritual. Hence, Traditional societies produce artifacts whose very aspect, ornament, and form enable their use to be suitably good in itself as well as to be an exercise in contemplation. In short, every effort is bent toward making all aspects of life sacred, for properly speaking the profane has no part in the Traditional mode of existence. Clement of Alex-

andria, for instance, instructs Christians to decorate their domestic utensils with the accepted symbols of Christ; these presumably will serve as constant reminders of the identity of the Inner Man who is fed and who also truly nourishes man.[2] Concerning the dual use of works of art Coomaraswamy has written at length and in great detail. He has explicated, for instance, the use and symbolic significance of the bow and arrow, thread and needle, the house, and the temple, to mention only several.

The question to be dealt with here concerns the essential characteristics of the Traditional work of art; particular reference will appropriately be made to works of literature. The properly made artifact will be efficient both physically and spiritually or intellectually. Physical uses are manifold and need not be discussed here. In any case legitimate physical use is determined immediately by the nature of the indigence the artifacts seek to remedy and ultimately by the higher ends of man. As St. Thomas Aquinas writes, "Every artist intends to give his work the best disposition; not absolutely the best, but the best as regards the proposed end."[3] And, "The practical arts are directed by the speculative arts, and again every human operation, to intellectual speculation, as its end . . . The knowledge of God is the last end of all human knowledge and activity."[4]

In an article written in collaboration with Stella Block, Coomaraswamy states, "The ultimate subject of all pure or revealing art is God." God is the subject whom all men naturally desire to know; hence, He is the proper subject, in one form or another, of the Traditional work of art whose intellectual function is to be a reminder or a support of contemplation. Coomaraswamy notes, "There are three kinds of art: the first, pure art, which is the symbol of spiritual vision; the second, dynamic art, which springs out of man's passion and emotional experience on earth; the third, apathetic (uninspired) or morbid art, which in cold blood deliberates on forms and shapes and generates conventions or would-be symbols behind which there is no meaning, or, having nothing to say, makes use of already existing symbols only for divertissement."[5] It is largely with "pure art," which seeks to perfect man

in contemplative vision, that Coomaraswamy deals. This art pro
duces works that are a means to remedy ignorance, which is man's
primary and persistent indigence. As Walter Andrae writes in
his *Die ionische Säule, Bauform oder Symbol?* (translated in part
and often quoted by Coomaraswamy),

In order to bring the realm of the spiritual and the divine within
the range of perception, humanity is driven to adopt a point of
view in which it loses the immediate vision of the spiritual. Then
it tries to embody in a tangible or otherwise perceptible form, to
materialize let us say, what is intangible, and imperceptible. It
makes symbols, written characters, and cult images of earthly
substance, and sees in them and through them the spiritual sub-
stance that has no likeness and could not otherwise be seen.[6]

For Coomaraswamy ". . . a real art is one of symbolic and signifi-
cant representation, a representation of things that cannot be seen
except by the intellect." [7] All true works of art point to the Creator,
revealing Him in some manner and rendering the soul amenable
to His influence.[8]

    �   �   �

Coomaraswamy believes that the whole man — rather, the man
trying to become whole — is naturally a metaphysician. "His reason-
ing is by analogy, or in other words by means of an 'adequate
symbolism.' As a person rather than an animal he knows immortal
through mortal things. That the 'invisible things of God' (that is to
say, the ideas or eternal reasons of things, by which we know what
they ought to be like) are to be seen in 'the things that are made'
[Rom. 1:20] applied for him not only to the things that God has
made but to those that he made himself." [9] If works of art are tc
perfect men, they must be reminders of the truth of things.[10] At
their best they will be anagogic (from ἀναγωγή, a leading up) and
to be anagogic, they will be symbolic (from σύν + βάλλειν, to
throw together, which suggests the energy of the symbol to carry
the mind to its ultimate referent).

    Symbolism that is an adequate and effective reminder Coomara-
swamy defines as the "representation of reality on a certain level
of reference by a corresponding reality on another." [11] Again he

writes, "Symbolism is a language and a precise form of thought; a hieratic and a metaphysical language and not a language determined by somatic or psychological categories. Its foundation is in the analogical correspondence of all orders of reality and states of being or levels of reference; it is because 'This world is in the image of that, and vice versa' (*Aitareya Brāhmaṇa*, VIII,2, . . .) that it can be said *Coeli enarrant gloriam Dei.*"[12]

In a recondite study, "Parokṣa,"[13] that employs the Sanskrit terms of Hindu metaphysics, Coomaraswamy discusses the nature of symbols, distinguishing thus between symbol and sign:

A symbolic expression is one that is held to be the best possible formula by which allusion may be made to a relatively unknown "thing," which referent, however, is nevertheless recognized or postulated as "existing." The use of any symbol, such as the figure "*vajra*" [literally, "adamantine" and "thunderbolt," a symbol of the Buddha found in many shapes] or the word "Brahman," implies a conviction, and generally a conventional agreement resting on authority, that the relatively unknown, or it may be unknowable, referent cannot be any more clearly represented. A sign, on the other hand, is an analogous or abbreviated expression for a definitively known thing; every man knows or can be informed, by indication of an object, as to what the sign "means." Thus wings are symbols when they "mean" angelic independence of local motion, but "signs" when they designate an aviator. . . .[14]

In this essay Coomaraswamy makes an illuminating distinction between the *parokṣa* and *pratyakṣa* use of terms. *Parokṣa* terms, he writes, are "proper to Angels . . . who are . . . 'fond of' the symbolic"; *pratyakṣa* language, on the other hand, is "proper to man . . . as individual . . . who is 'fond of' the obvious. . . ."[15] For instance, the Sanskrit word *puṣkara* designates the lotus flower on the *pratyakṣa* level; it refers to something that can be sensibly experienced. On the *parokṣa* level "lotus means the Waters" [*Satapatha Brāhmaṇa*, VII, 4, 1, 8], that is, the sum of the possibilities of manifestation; it is "the symbol and image of all spatial extension."[16] The referent here is not to be sensibly experienced. The lotus is a symbol of a metaphysical reality known naturally by angels and supernaturally by a few men beyond the ordinary human condition. The rose is used in Christian mythology for the

same purpose as the lotus in the Orient.[17] "What presents itself
directly to men [e.g., the sensible aspect of the flower] presents
itself indirectly (or metaphysically) to the Angels, and what
presents itself indirectly to men presents itself directly to the
Angels."[18]

In yet another essay Coomaraswamy quotes from St. Thomas
Aquinas the Scholastic distinction of sign and symbol: "Whereas
in every other science things are signified by words, this science
[theology] has the property that the things signified by the words
have themselves also a signification; . . . the parabolical sense is
contained in the literal, for by words things are signified properly
and figuratively."[19] These distinctions Coomaraswamy applies to
art. Since the truly significant works of art are essentially meta-
physical in import, it is necessary to use those devices — i.e., sym-
bols — that have efficacy in revealing or suggesting the reality
behind or beyond sense experience. The doctrine suggested by St.
Bonaventura in the title of his opus, *The Reduction of Art to
Theology*, is acceptable to Coomaraswamy, who might, however,
speak more precisely and refer to the metaphysical rather than to
the theological significance of Traditional art, metaphysics being
of a higher order of intellection than theology.[20]

Traditional art, we have seen, is conceived as being imitative of
the *forms* (i.e., reality on a certain level of manifestation) and not
merely the aspects of things.[21] "And true 'imitation,'" Coomara-
swamy writes, "is not a matter of illusory resemblances (ὁμοιότης)
but of proportion, true analogy or adequacy (αὐτὸ τὸ ἴσον, i.e.,
κατ' ἀναλογίαν), by which we are reminded of the intended referent;
in other words, of an 'adequate symbolism.'"[22] Symbolism is ade-
quate if it is an efficient means of producing in a qualified and
receptive person an "adaequatio rei et intellectus," or a condition
of true knowledge. "The work of art and its archetype are different
things; but 'likeness in different things is with respect to some
quality common to both.'"[23]

In his closely reasoned essay, "Imitation, Expression, and Par-
ticipation,"[24] Coomaraswamy draws upon St. Bonaventura, who
discusses three kinds of likeness (*similitudo*). The first is absolute

59

likeness, which amounts to sameness or identity; this likeness is perceptible only to God. The second is "imitative or analogical likeness, *mutatis mutandis*, and judged by comparison, e.g., the likeness of a man in stone," and the third is "expressive likeness, in which the imitation is neither identical with, nor comparable to the original but is an adequate symbol and reminder of that which it represents, and to be judged only by its truth, or accuracy (ὀρθότης, *integritas*); the best example is that of the words that are images of things." [25] Coomaraswamy notes that "imitative and expressive are not mutually exclusive categories; both are imitative in that both are [based upon] images, and both are expressive in that they make known their model. . . . The inseparability of imitation and expression appears again in [St. Bonaventura's] observation that while speech is expressive, or communicative, 'it never expresses except by means of a likeness' . . . , i.e. figuratively. In all serious communication indeed, the figures of speech are figures of thought." [26] These likenesses and pictures used in discursive thinking are not themselves the objects of contemplation but rather the *supports* of contemplation.[27]

Again and again Coomaraswamy emphasizes the difference between *le symbolisme qui sait* and *le symbolisme qui cherche*. With specific reference to literature he says that the former is "the universal language of tradition" and the latter is merely the usage of "the individual and self-expressive poets who are sometimes called 'Symbolists,'" [28] these being taken here as types of *littérateurs* who use figures of speech that are not precise and universal reminders of the truth. Personal or individual symbols with restricted and ambiguous associations are *self*-expressive and not expressive of knowledge of a higher order. They are often fanciful, arbitrary, and insignificant, the products frequently of the free association of thought; as such they tend to misrepresent reality and to suggest mainly the condition of the author. Adequate symbols, on the other hand, are true, analogical, accurate, canonical, hieratic, anagogic, and archetypal.

Adequate symbols, according to Coomaraswamy, can be said to participate in that which they resemble or symbolize. The physical

line of plane geometry is a conventional (but not arbitrary) representation or imitation of the conceptual line which is the shortest distance between two points; it is a line with a meaning and, as such, it can be said to participate in the conceptual line.[29] The canonical symbol can also be said to "participate in," imitate or express analogically its referent. "Symbols are projections of the referents, which are in them in the same sense that our three-dimensional face is reflected in the plane mirror. . . . Symbols are projections or shadows of their forms, in the same way that the body is an image of the soul, which is called its form, and as words are images ($\epsilon$ἰκόνας, *Crat.* 439A, εἴδωλα, *Soph.* 234C) of things."[30]

Dante has written that "no object of sense in the whole world is more worthy to be made a type of God than the sun."[31] Better than anything we perceive and know in our universe the sun reveals and expresses the power and centrality of the Light of Lights.[32] Without much difficulty it can be seen that the sun is a better symbol of God, say, than Michelangelo's great figure of Jehovah creating Adam. The latter, though not entirely inadequate, suggesting as it does the majesty of the deity, may tend to imply that God is made in the aspect of man, with some of man's ordinary limitations, which is a patent falsehood. The physical sun represents, participates in, and suggests the Intelligible Sun, " 'The Sun of the Angels' as distinguished from the sun of sense," as Dante expresses it, or the "Sun of the sun," as Philo Judaeus has it. Coomaraswamy remarks, "In one sense, though not essentially, the aniconic image may be regarded as *more* a likeness of Him, that is, in so far as it reminds us of the relative unimportance of the human mode, as merely a particular case amongst the possibilities of existence."[33]

In a passage that corroborates Coomaraswamy's theories Frithjof Schuon throws light upon the problems of adequacy and participation in symbolism. First, he defines adequacy thus:

There are two aspects in every symbol: the one adequately reflects the divine function and so constitutes the sufficient reason for the symbolism; the other is merely the reflection as such and so is contingent. The former of these aspects is the content; the latter is

61

the mode of its manifestation. On the one hand the sun shows a content, which is its luminosity, its emanation of heat, its central position and its immutability in relation to its planets; on the other hand it has a mode of manifestation, which is its matter, its density and its spatial limitation. Now it is clearly the qualities of the sun and not its limitations which show forth something of God.[34]

Having set forth this definition, Schuon goes on to explain one of the most difficult concepts in the Traditional doctrine concerning symbolism — how the symbol can actually *be* that which it represents.

And the manifestation is adequate, for in reality the symbol is nothing other than the Reality it symbolizes, in so far as that Reality is limited by the particular existential level in which it "incarnates." And thus it must of necessity be, for, in an absolute sense, nothing is outside God; were it not otherwise there would be things that were absolutely limited, absolutely imperfect, absolutely "other than God" — a supposition that is metaphysically absurd. To say that the sun is God is false in so far as it implies that "God is the sun"; but it is equally false to pretend that the sun is only an incandescent mass and absolutely nothing else. That would cut it off from its divine Cause; and at the same time it would be to deny that the effect is always something of the Cause. . . . Apart from this there exist mere metaphors: These are pseudo-symbols, i.e. pictures which are in short ill-chosen. A picture which does not touch the essence of what it seeks to express is not a symbol but an allegory.[35]

In his essay "Primitive Mentality" [36] Coomaraswamy writes in much the same manner: "A thing is not only what it is visibly but also what it represents. Natural or artificial objects are not for the primitive, as they can be for us, arbitrary 'symbols' of some other and higher reality. The eagle or the lion is not so much a symbol or image *of* the Sun as it *is* the Sun in a likeness (the form being more important than the nature in which it is manifested); and in the same way every house *is* the world in a likeness, and every altar situated at the centre of the earth. . . ."[37] To explicate this he quotes William Blake, "The lust of the goat is the bounty of God. . . . When thou seest an Eagle, thou seest a portion of

62

Genius [i.e. God]." [38] The goat in his lust manifests the energy of God which moves the worlds; he is part of the play of God in the world. And as Blake observes, "Energy is Eternal Delight": [39] that is, when our powers are freely exercised with spontaneity according to our primordial nature and without thought or self-consciousness, they are a joy to creatures and to God. The eagle, perennial symbol of the Spirit, displays the essential qualities of the divine archetype — noble freedom of flight, all-seeing vision in the face of the Sun, the ability to stoop with great speed and force. Commenting on animal symbolism, Schuon writes, "The lion is solar and the aspect of passion is here neutralized by a sort of royal serenity. Like the eagle, which, in its own order, manifests the principle of lightning, or revelation, the lion in its fashion expresses the force of the spirit." He again corroborates Coomaraswamy's doctrine of traditional symbolism: "All true symbolism dwells in the very nature of things. The earth from which we live is truly a reflection in the material order of the divine generosity." [40]

Even the skeptic can recognize that the eagle and the lion can be symbols — "conventional," he would call them — of the deity as he is conceived by various men. However, nonbelievers, so to speak, neither accept the principle of the analogical correspondence of all orders of existence nor the doctrine that the world is a theophany: hence, they cannot really understand or use precisely in all their richness and power many of the archetypal symbols — i.e., *le symbolisme qui sait*. [41] For Coomaraswamy, who like Śaṅkarâcārya endorses the statement that "all who sing here to the harp, sing Him," [42] everything is an expression of divinity; it is adequate as an expression in the degree in which it is formal, true, and beautiful — that is, participates in the form of all forms, and in the Truth and Beauty that are divine attributes.

Now, from the point of view of the Tradition, it may be granted that "everything possible to be believ'd is an image of the truth," as William Blake puts it, [43] if this means (1) that any thing that has form at all (as it must to be identified as a thing) must derive this form from the Word, Exemplar of creation, or (2) that any really intelligible statement suggests the truth in some fashion. A person

avid for the Truth and graced in his receptivity to it may find in any object or comprehensible proposition a reminder of the truth which in some manner informs it and him. Hence, it is given to some "to see a world in a Grain of Sand," as Blake also said. Most persons, however, need more formal and cogent reminders. It is with these reminders — archetypal symbols in the metaphysical sense — that Traditional thinkers are largely concerned. They know full well that a Gothic cathedral — which is a universe in miniature, energy made manifest through intelligence by love, compacting the essential elements of the creation — is a more efficacious symbol of the world than a grain of sand which most persons cannot perceive as it is — in God and of God, who ultimately is One and All. And Traditionalists are precise and sure in knowing, for instance, that to frame a putatively "cognitive proposition" with Freud that the libido is the whole available energy of Eros is to state much less of the truth about the nature of life than to say with Sir Thomas Browne, "Life is a pure flame and we live by an invisible Sun within us." The latter statement reverberates with profound associations that are indubitable while the former is quite limited (as well as misleading) in its power to suggest the nature of the principle by which man lives.

Traditional symbols, it is maintained, because they are based upon a knowledge of the analogical correspondences of all orders of being and existence, possess great power to dispel ignorance and to remind men of the truth; they suggest many meanings true on all levels of thought. Browne's great sentence about the Sun within us contains more of significance, to him who can hear, than a thousand novels or works of psychology, which in their way attempt to describe the nature of man.

To interpret traditional symbols, more than mere learning and a lively imagination is required. Coomaraswamy, always aware that knowledge is according to the mode of the knower, deprecates the subjective interpretation of symbolism by the unqualified. "For the meaning of symbols," he writes, "we must rely on the explicit statements of authoritative texts, on comparative usage, and on that of those who still employ the traditional symbols as

the customary form of their thought and daily conversation."[44] And indispensable for the most authoritative interpretation is the capacity for thinking in terms of the Tradition.

Concerning the interpretation of symbols, which is too often attempted by the unqualified these days, Coomaraswamy writes as follows:

We agree, indeed, that nothing can be more dangerous than a subjective interpretation of the traditional symbols, whether verbal or visual. . . . The study of the traditional language of symbols is not an easy discipline, primarily because we are no longer familiar with, or even interested in the metaphysical content they are used to express; again, because the symbolic phrases, like individual words, can have more than one meaning, according to the context in which they are employed, though this does not imply that they can be given any meaning at random or arbitrarily. . . . Whosoever wishes to understand the real meaning of these figures of thought that are not merely figures of speech must have studied the very extensive literatures of many countries in which the meanings of symbols are explained, and must himself have learned to think in these terms. . . . It is in this universal, and universally intelligible, language that the highest truths have been expressed.[45]

In his many works devoted to the interpretation of traditional symbols Coomaraswamy always employs the canon and method here mentioned. Although it does not reveal his method in its greatest rigor and learning,[46] a passage from his essay "Literary Symbolism"[47] is worth quoting at length for the insights it affords into the symbolism of the line, thread, string, and chain.

Thus when Blake writes, "I give you the end of a golden string, Only wind it into a ball; It will lead you in Heaven's gate Built in Jerusalem's wall," he is using not a private terminology but one that can be traced back in Europe through Dante (*guesti la terra in se stringe, Paradiso,* I. 116), the Gospels ("No man can come to me, except the Father . . . draw him," John VII. 44, cf. XIII. 32), Philo, and Plato (with his "one golden cord" that we human puppets should hold on to and be guided by, *Laws,* 44), to Homer where it is Zeus that can draw all things to himself by means of a golden cord (*Iliad* VIII. 18f., cf. Plato *Theatetus,* 153). And it is not merely in Europe that the symbol of the "thread" has been current for more than two millennia; it is to be found in Islamic, Hindu, and Chinese contexts. Thus we read in Shams-i-Tabriz, "He gave

65

me the end of a thread. . . . 'Pull,' he said, 'that I may pull: and break it not in the pulling,'" and in Hāfiz, "Keep thy end of the thread, that he may keep his end;" in the Śatapatha Brāhmaṇa that the Sun is the fastening to which all things are attached by the thread of the spirit, while in the Maitri Upaniṣad the exaltation of the contemplative is compared to the ascent of a spider on its thread; Chuang Tzu tells us that our life is suspended from God as if by a thread, cut off when we die. All this is bound up with the symbolism of weaving and embroidery, the "rope trick," rope-walking, fishing with a line and lassoing; and that of the rosary and necklace, for as the Bhagavad Gītā reminds us, "all things are strung on Him like rows of gems upon a thread."[48]

Because man can know the "immortal things by the mortal," he is different from the animals. And since the last end of man is to know or to be God or to submit wholly to Him — however this end is formulated in various manifestations of the Tradition — he generally has need of those symbols that "bridge the worlds."[49] "The unmanifested can be known by analogy; His silence by His utterance. . . . We have no language whatever except the symbolic in which to speak of ultimate reality: the only alternative is silence; in the meantime, 'The ray of divine revelation is not extinguished by the sensible imagery wherewith it is veiled.'"[50] When we no longer need those symbolic and anagogic supports, we can even say ultimately with St. Augustine, "All scripture is vain."

❊     ❊     ❊

Coomaraswamy from the very beginning of his career as an expositor of the Philosophia Perennis was concerned not only with the symbolism of those traditional figures of speech that are genuine figures of thought but also with that extended symbol, the myth. For Coomaraswamy, as always for the Tradition, "myth represents the deepest knowledge man has."[51] "It is the proper language of metaphysics";[52] especially when enacted in ritual it is one of the best means of imparting principial knowledge and effecting the integration of man.

The primordial myths Coomaraswamy does not consider to be mere human inventions. They have been or are being revealed to

men who are qualified to receive them, not solely for their own welfare but also for the benefit of their fellows who in their ignorance no longer perceive things as they really are.[53] As Walter Andrae writes in a passage translated and often referred to by Coomaraswamy:

It is by no means the case that symbols and likenesses [and myths, one could add] arise in the course of a higher development of spirituality in men; on the contrary they draw nigh as means of rescue when there is a decline in our divinity and spirituality. So it was that Jesus Christ gave out in parables the treasures of the divine kingdom to a declining, not to an advancing humanity, for his own and for all future ages. In the same way, in pre-Christian times, the visible symbols, the images of the great mysteries and experiences, provided a remedy for the indigence of the soul in the time of decline.[54]

Myths as paradigms of human life, according to Traditional doctrines, were given to men who had become self-conscious and divided against themselves, no longer able to live with supreme awareness and spontaneity in the primordial state.

At what time the myths of the various peoples were supposed to have first been revealed to them or even at what time they were first written down after long oral transmission is of little or no interest to Coomaraswamy. His concern is always with the enduring significance of the myth. "A myth," he states, "is true now, or was never true at all";[55] "myth spins out into a tale that is simultaneous and eternal."[56] Myths then are not fictive or fanciful accounts of historical events; they are rather the universal patterns exemplified in historical events. As Coomaraswamy writes, "To speak of an event as *essentially* mythical is by no means to deny the possibility, but rather to assert the necessity of an *accidental*, i.e., historical eventuation; it is in this way that the eternal and temporal nativities [e.g., of Christ and the Buddha] are related. To say 'that it might be fulfilled which was said by the prophets' is not to render a narrative suspect, but only to refer the fact to its principle. . . . The more eminent truth of the myth does not stand or fall by the truth or error of the historical narrative in which the principle is exemplified."[57] He notes that "to speak of

67

'lives' of the Buddha or Christ as 'mythical' is but to enhance their timeless significance."[58]

According to Traditional writers, such as Coomaraswamy, Campbell, and Eliade, the fact that the myths of mankind are so much alike serves to indicate their validity in delineating the pattern of human and cosmic events. The histories of peoples and individual men follow the forms of the myth; the history of the universe itself is reflected in the great cosmic myths. Myths, it is said, embody a higher order of knowledge than can be gained from the examination of discrete events or from the formulation of general laws based upon induction. At best this latter knowledge is general, while myths set forth universal knowledge. For instance, the myth of the marriage of the conjoint principles, heaven and earth, embodies a principle that can be applied on many levels of existence, as was suggested above.

These observations may need the support of some of Coomaraswamy's studies of myths. It is not possible to do more than to suggest the kind of evidence and thought Coomaraswamy brings to the elucidation of the perennial myths; we can, however, briefly describe the content and method of a typical study, "Sir Gawain and the Green Knight: Indra and Namuci."[59] In this essay Coomaraswamy explicates the metaphysical basis of the Middle English poem about the hero who responds to a challenge by cutting off the head of a strange knight and offering his own head as forfeit the next year. As he notes, "The myth in its European setting is of Celtic essence. There are many parallels."[60] It is these illuminating parallels that Coomaraswamy adds to those already pointed out in *Gawain and the Green Knight* (1916) by the late Professor G. L. Kittredge, who was, Coomaraswamy observes, "more interested in the literary history of the motives than in their mythological significance."[61] It is mainly on the ancient literature of India that he draws, though characteristically he refers to the writings of Plato, Philo, Eckhart, Rūmī, and others of the Tradition, as well as to many secondary works.

The analogues and parallels Coomaraswamy finds in the Vedas, Brahmanas, and other works are ultimately creation myths which

relate the diremption of Heaven and Earth from the primal unity. As he states, "The temporally everlasting opposition of the Gods and the Titans . . . is the basic theme of the Vedic tradition; but it must not be overlooked that the opponents are really brothers, or that Namuci [a 'Holdfast' Titan] was Indra's bosom friend and boon companion before the battle, or that in the Early English story, conversely, Gawain becomes the Green Knight's friend and honored guest when all is over." [62] On another level the story is a version of the ancient principle that the only way man can escape his mortal condition is to cease to be the man he believes he is and to become the man he really is. It is a mythical treatment of the well-known theme suggested by the words, "Whosoever would save his *psyche* shall lose it" (Matt. 16:25) and "If any man come to me, and hate not . . . his own *psyche* also, . . . he cannot be my disciple" (Luke 14:26). No creature can rise to a higher level of being, as St. Thomas Aquinas has remarked, without dying — that is, to what he was. Decapitation is the perennial symbol for the slaying of the old self.

With his characteristic techniques, ranging from linguistic analyses in several languages and the extensive citing of analogues in many literatures to metaphysical speculations of a high order, Coomaraswamy demonstrates that this Arthurian romance, which he calls "a masterpiece of English literature," is far more than a superb literary work. As he says, he has endeavored to show, "not how *a* meaning can be read *into*, but how *the* meaning can be read *of* the myths of the heroes who 'play fast and loose with their heads.'" [63] Although he admits that there is always a question about the depth of understanding of the material treated by the writers of romances, he does believe that his observations "support the conclusions reached by that great scholar, J. L. Weston, that 'the Grail [and related] romances repose eventually, not upon the poet's imagination, but upon the ruins of an august and ancient ritual, a ritual which once claimed to be the accredited guardian of the deepest secrets of life.'" [64] If the worlds spring from the sacrifice of God who abandons his primal state of self-sufficiency and solitude, the welfare of these worlds and their creatures de-

pends upon a reciprocal sacrifice by man, who (in one manner of speaking) must restore the original unity or make way for the fructifying light of the Spirit to quicken the dead world. A work like *Sir Gawain and the Green Knight* not only sets forth this truth, but becomes thereby a means of our realizing it in our lives.

Apparently taking the suggestion from the title of Miss Weston's book, Coomaraswamy states what might be called the dialectic of the decline of myth; he believes there can be traced "a descent from myth and ritual to epic, epic to romance, and from romance to the realistic novel."[65] We may not know the precise nature of the ritual and mythological bases for the Gawain story but, considering the wide currency of the myths of the sacrifice and regeneration of Gods and men, we can well suppose that the contention of Weston and Coomaraswamy is true. Although the subject of the function of literature will be discussed in the following chapter, it can be noted here that Coomaraswamy's "law" of descent is, from the point of view of the Tradition, essentially correct in suggesting a progressive weakening in the efficacy of poetry, song, and literature in general to effect the "self-integration" of man. Originally the myths, whether in scriptures or in folk or fairy tales, are treated with an understanding and sureness that gives them power to inform and enlighten. "Later on, all these motifs fall into the hands of the writers of 'romances,' littérateurs and in the end historians and are no longer understood. That these formulae have been employed in the same way all over the world in the telling of what are really only variants and fragments of the one Urmythos of humanity implies the presence in certain kinds of literature of imaginative (iconographic) value far exceeding those of the belle-lettrist's fantasies, or the kinds of literature that are based on 'observation'; if only because the myth is always true (or else is no true myth) while the 'facts' are only true eventfully."[66]

A specific application of Coomaraswamy's theory could be constructed somewhat in the following manner. That myth and ritual (which are two ways of describing the same thing, for ritual is the dramatic enactment of myth) are better means of imparting princialial knowledge (or putting men back together again in a knowl-

edge that is being) can be seen when one compares, so far as he is able, the efficacy of a sacrificial rite such as the Christian mass or even the Eleusinian mysteries with that of the *Odyssey*, a literary epic that treats of the hero's journey to fulfillment. Since man learns by imitation, as Aristotle has noted, it is apparent that taking part in a rite (that is, actively, though vicariously, living the lives of gods and heroes) is a much more deeply moving and instructive experience than listening to a rhapsode recite the tales of the *Odyssey*, many of which have the same metaphysical bases as the rites. Even an epic like the *Rāmāyana*, which, it is said, "bestows on all who hear it righteousness and wealth and fulfillment of desire, as well as the severing of ties,"[67] cannot be as efficacious as a true rite in transforming a man. In turn, an epic recited under the proper circumstances will probably be more effective than a romance read or heard. And, compared with the best romances like *Sir Gawain and the Green Knight* and *The Golden Ass*, even a novel like *Crime and Punishment*, which treats essentially the same theme — the progress to a higher state through suffering and "death" — lacks power and persuasiveness because it has many vitiating naturalistic and moralistic elements. As Coomaraswamy has observed, ". . . it is just because the hero exhibits universal qualities, without individual peculiarities or limitations [which increase with the decline of the myth, one might add], that he can be a pattern imitable by every man alike in accordance with his own possibilities whatever these may be. In the last analysis the hero is always God, whose only idiosyncrasy is being, and to whom it would be absurd to attribute individual characteristics."[68] The universal implications of the theme of sacrifice and rebirth are most obvious and effectively suggested in ritual and myth, then in epic, romance, and realistic novel in descending order.[69]

Efficacy, of course, varies with the condition of the participants, audience, or readers; a novel may well be more meaningful to a man than an ancient rite, but that is the result of his relative imperviousness or lack of preparation for the rite. And in the economy of individual lives in the modern world, it may be possible for certain persons, at particular stages in their lives, that it would be more

enlightening to read great novels, however degenerate this literary type is, than to attend canonical rites, resisting, unreceptive, and abstracted. (Contemning the novel, Coomaraswamy would doubtless deny this. Yet we know that in our own age a novel like Dostoevsky's *The Brothers Karamazov* can thrust men on to the Scriptures and rites that they were too confused to understand before. Even the road to Damascus is a circuitous but necessary way to "Jerusalem the golden.")

Since folk and fairy tales are studied these days by at least two groups — scholars and children — it may be well briefly to set forth Coomaraswamy's doctrine concerning these genres. After discussing the anagogic symbolism of several myths, Coomaraswamy observes, "In the same way every genuine folk and fairy tale can be 'understood,' for the references are always metaphysical; the type of 'The Two Magicians,' for example, is a creation myth . . . , John Barleycorn is the 'Dying God,' Snow-White's apple is 'The fruit of the tree,' it is only with 'seven-league boots' that one can traverse the 'seven worlds' (like Agni and the Buddha), it is Psyche that the Hero rescues from the Dragon, and so forth."[70] As he says, "The content of folklore is metaphysical."[71] He notes that "the actual unity of folklore represents on the popular level what the orthodoxy of an elite represents in a relatively learned environment. . . . To a very large extent both the popular and learned metaphysics employ one and the same symbols, which are taken more literally in one case and in the other understood parabolically. . . ."[72] "The life of the popular wisdom," he observes finally in this penetrating essay, "Primitive Mentality," "extends backward to a point at which it becomes indistinguishable from the primordial tradition itself, the traces of which we are more familiar with in the sacerdotal and royal arts. . . ."[73] Coomaraswamy's many studies of folklore support this position irrefutably — at least to one who accepts the doctrines of the Tradition.

If it is true, as Meister Eckhart has said, that "words derive their power from the original Word," it can be assumed that the more universal the myth and symbol the more powerful they will be as means to knowledge. The great effectiveness of myths is

their universality; they are valid on many levels of reference, the highest being the best expressions of the primal word that men can utter. If a metaphysical or mythical statement is true on a high ( e.g. cosmic) level of reference, it is also true on the lowest; this follows, of course, from the principle of analogical correspondence. The primordial myth about the sacrifice of God — his division of himself to produce the worlds — is significant of the deepest mysteries. Furthermore, it is true on lower levels; political, social, and individual functions are successful to the degree that they are discharged by those who willingly sacrifice themselves to their Self. (It can be noted that we have here a reverse analogy: God's sacrifice is division of himself, man's is unification of himself. The ancient saying has it in another context: God became man so that man could become God.) As St. Thomas Aquinas wrote about scripture, which, for Coomaraswamy, serves as the highest type of literature, "The parabolic sense is contained in the literal."[74] It is not that the myth is equivocal; it is true in all intended senses, as St. Augustine observes.[75] And the symbolic formulation of the truths it embodies permits it to be understood according to the condition and abilities of all those who hear it. The greater one's receptiveness, which is a matter of both wit and will, the more the myth will say to him. And the power of the primordial myths is such that they provide one with a course in initiation, drawing him on to higher levels of knowledge; a man understands so much as he is able, but if his attitude of approach is proper, and graced by Love, he will be led to understand more.

The virtues of the mythical mode have been well expounded by St. Thomas Aquinas:

As Dionysius says, it is more fitting that divine truths should be expounded under the figure of less noble than of nobler bodies; and this for three reasons. First, because thereby men's minds are better freed from error. For then it is clear that these things are not literal descriptions of divine truths, which might have been open to doubt had they been expressed under the figure of nobler bodies, especially in the case of those who could think nothing nobler than bodies. Second, because this is more befitting the knowledge of God that we have in this life. For what He is not is

73

clearer to us than what He is. Therefore similitudes drawn from things farthest away from God form within us a truer estimate that God is above whatsoever we may say or think of Him. Third, because thereby divine truths are better hidden from the unworthy.[76]

Coomaraswamy has said, "'Half reveal and half conceal' fitly describes the parabolic styles of the scriptures and of all conceptual images of being in itself, which cannot disclose itself to our physical senses."[77] The so-called cognitive mode of expression with its explicit denotation is coordinated always with a system of definitions, axioms, and primitive propositions; but, as Leibniz says, "every system is true in what it affirms and false in what it denies."[78] The mythical mode is not systematic, hence not so limited by the inadequacies of language. And since "a conception always contains something that surpasses its expression,"[79] that mode of expression that is both less limited and also based upon the order of things is likely to be able *better* to express those truths that strain the capacities of language and those that ultimately transcend it. Although myths surely are liable to misinterpretation, they are often so elusive to those who do not really grasp their meaning that they are less likely to give the illusion of knowledge than the formulations of the cognitive mode which can be mastered by memory without real understanding. Be that as it may, Coomaraswamy agrees with Nicolas Berdyaev, whom he cites thus: "Behind the myth are concealed the greatest realities, the original phenomena of spiritual life."[80]

❉    ❉    ❉

Any work of art should be endowed with those ornaments "essential to utility and beauty."[81] In his essay "Ornament,"[82] Coomaraswamy has studied the Traditional use of decoration and ornament and briefly discussed their degeneration in declining ages. He notes that modern man, who is little interested in the metaphysical knowledge which traditional art aims to impart, can scarcely believe that "'ornament' and 'decoration' are, properly speaking, integral factors of the beauty of the work of art, certainly not insignificant parts of it, but rather necessary to its efficacy."[83]

The notion that decoration and ornament are something adventitious and merely pleasing aesthetically without serving "to endow the object or person with its or his 'necessary accidents,' with a view to its 'proper' operation," [84] he exposes as a natural concomitant of a modern and "provincial view of art, born of a comparison between the (objective) beauty of order and the (subjectively) pleasant and fathered by a preoccupation with pleasure."[85]

With especial reference to Sanskrit, Greek, Latin, Chinese, and English usages, he employs his characteristic techniques — mainly linguistic analyses coupled with metaphysical speculations — to prove that "appropriate ornament is . . . essential to utility and beauty"[86] and is necessary to the work of art so that its thesis may be communicated effectively. But that which is of main interest for a theory of literature are the principle of economy that emerges from Coomaraswamy's study and the insights into the interpretation of traditional works of literature.[87]

In his discussion of the Sanskrit word *alaṁkāra* ("ornament," usually referring to rhetorical ornaments or to jewelry or trappings), Coomaraswamy states that the rhetorical devices in traditional literature, appearing anciently even in Vedic texts, are not mere embellishments but integral stylistic phenomena demanded by the theme. As he says, " 'Scriptural *style* is parabolic' [Clement of Alexandria] by an inherent necessity, the burden of scripture being one that can be expressed by analogies. . . ."[88] When these integral devices are employed without an understanding of their primary significance, they may retain some of their original power and suggestiveness but they ultimately degenerate into *Spielerei*, as he says, in the hands of mere littérateurs. When the figures of speech are no longer figures of thought reflecting or expressing reality on a certain level — that is, when form and significance are not "indissolubly wedded" — their use becomes superstitious and idolatrous in Coomaraswamy's view. (Superstition is to be defined here as use of true symbols incorrectly and with little or no awareness of their depths of meaning; idolatry is to be defined as adulation of the symbol rather than the reality it represents.)

75

In this essay Coomaraswamy makes no detailed reference to any specific work of art. He does, however, enunciate a principle of ornament which by itself would probably not be exceptionable to many modern artists. Many artists consciously adorn and decorate only enough to gain the desired effect. If their purpose is to express their personalities or primarily to afford pleasure alone, Coomaraswamy would criticize their efforts not for superfluity of ornament but for being superfluous as a whole. In the expression of a Traditional theme any excess of ornament and decoration is an artistic sin — sin being defined, according to St. Thomas Aquinas and others, as departure from the order to the end. The very expression of another kind of theme Coomaraswamy regards as a moral sin, affording as it does an occasion for diversion or dissipation.

According to the principle of artistic economy Coomaraswamy sets forth, a work should have those ornaments or properties necessary for its proper functioning. This does not imply a condemnation of richness of ornament but rather a condemnation of excess.[89] "Fine" writing, purple passages, free association of ideas and words, love of rhetoric in itself, limited personal references, flights of "fancy" — even aside from their use in setting forth unworthy themes — are to be avoided by the writer who understands the proper operation of his art. This implies that the austerity should be primarily in the artist and not necessarily in the work, which may or may not need richness of ornament. Beyond explicating this doctrine of ornament which has perennial importance for the artist, Coomaraswamy makes it clear that we should do well to try to understand the true significance of ornament in Traditional works, where it is always related to the theme; from his point of view it is inadmissible to see the figures of speech in scriptures, myths, and folk tales as mere literary convention or devices for meaningless but pleasant embellishment.

❉    ❉    ❉

In several passages Coomaraswamy has touched upon a problem of literary theory often discussed — the nature of poetry and

prose. Although he has not treated this problem systematically, his obiter dicta and more or less incidental references are worth more than whole treatises by the less gifted. For those interested in the Tradition, his speculations, which are based on universal metaphysical principles, add a significant dimension to a familiar topic. Others may find interesting insights in Coomaraswamy's observations — empirical in basis, one could say — on the superior power of poetry over prose in effecting the self-integration of the reader or listener.

The metaphysical principle that is used to explain the nature of both poetry and prose — indeed, the nature of any art — is that of the mythical marriage or the union of conjoint principles. And it is in terms of this principle that one of the ultimate differences between poetry and prose is to be defined. The universe itself, properly viewed by the Intellect, or the "eye of the heart," as it is often called, is the result of the marriage of Harmony (*sāman*) and the Words (*ṛc*)[90] or, in another idiom, the union of essence and substance. The active, intellectual principle is masculine and the formless, passive principle is feminine. So in language, the words by themselves, feminine in nature, are the material of speech (sounds) and the meaning or intelligible aspect is the masculine principle that informs them. When there is a true union of those principles, the result is "an effective harmony and the reproduction of the higher of the two principles involved."[91] To the extent that the formal or superior principle has hegemony, the Truth is expressed; to the extent that the passive, material principle is not mastered or informed by the superior, Truth will be obscured in the offspring — though it may afford the occasion for pleasure to some.[92]

There are no absolute distinctions between poetry and prose, for they are both, so far as they are intelligible, linguistic vehicles of the Truth. The specific aspect of words as written or spoken — in verse or prose — is an accidental feature; the essential distinction concerns words in whatever pattern or arrangement as manifestations of Truth. The letter or sound is the outward aspect which is of little importance compared to the spirit or meaning embodied

in the words. Again and again in his work Coomaraswamy emphasizes this point by use of myth and metaphysical principles.

A basic distinction between poetry and prose is that prose is relatively unformed, informal, and "naturalistic." Poetry, on the other hand, like music, is a clearer and more truthful "earthly representation of the music [or poetry, we may add] that there is in the rhythm of the ideal world"; [93] it is more formal, informing, "measured" (metrical), and harmonious than prose. It is said that "harmonies unheard in sound create the harmonies we hear and wake the soul to the consciousness of beauty, showing the one essence in another kind: for the measures of our sensible music are not arbitrary but are determined by the Principle whose labour is to dominate Matter and bring pattern into being." [94] Poetry, at best, has a greater faculty for "dominating matter" and for reproducing in the medium of words the unheard harmonies.

It must be noted that the poetry that Coomaraswamy considers generally to be the best vehicle of knowledge is ritual poetry or chant. This poetry, which is usually part of a mimetic rite that enacts a primordial myth, is recited or chanted to the sound of musical instruments, and indeed it often itself approaches the condition of music. In fact, Coomaraswamy renders the Sanskrit word *sāman* (chant) by "Harmony" (Attunement or Music) because "all chanting and singing is music." [95] He writes:

The contrast of *sāman* and *rc* [words] is that of a harmony that transcends Speech, and a verbal articulation on which the music is supported as if in a vehicle. . . . The music is sung on words . . . and borne or supported . . . on them as on earth . . . thus the Harmony wedded to the words is incarnated as if by a mother. The *Rc* is *Vāc* [the voice, i.e., that by which the Harmony is made manifest]. . . . [96]

Coomaraswamy's major treatment of this subject is a nine-page footnote in his *Spiritual Authority and Temporal Power in the Indian Theory of Government*. [97] From this abstruse and closely reasoned essay in small type it emerges that the *sāman* or Harmony (which one can equate with Essence, Act, Form, or the Intelligible as opposed to Substance, Potency, Matter, and the Sensible) is metaphysically sufficient unto itself. In sexual terms, the supreme

principle is androgynous originally and divides to become a pair that is reunited in marriage to produce offspring. This suggests that there is *in divinis* (and in the Kingdom within) an understanding beyond words, a knowledge that is ineffable.[98] However, if this knowledge is to be communicated from man to man it must be expressed in various materials — sounds and written words being among them. Poetry, Coomaraswamy avers, is the best verbal means of expressing this knowledge; it has greater efficacy in ordering the divergent elements of our nature and evoking the knowledge that lies potentially within us. He quotes with approval "the notable dictum of Gerhard Hauptmann, 'Dichten heisst, hinter Worten das Urwort erklingen lassen.' That is, freely, 'Poetry . . . should be defined as such a use of words that there resounds in them the primordial Word.'"[99]

Poetry which is formal and measured — that is, set forth in rhythms analogous to those inherent in the intelligible cosmos[100] — is better, granted a common and worthy theme, than prose or relatively formless poetry in effecting the end of all speech. Explaining the need for studying words in their most life-giving form — that in which they are sung — Coomaraswamy says, "It is because the reconstitution . . . of the disintegrated and manifold self effected in the [rite of] Sacrifice (for which the Chant is absolutely indispensable . . .) is essentially metrical: 'The sacrificer perfects himself as composed of the metres' . . . , and is thus a 'perfected Self' . . . : Prajapati [Creator, supreme deity], broken up by the emanation of his children [the worlds and their creatures] . . . 'unified himself by means of the metres' . . . , i.e., synthesises the manifold self with the simple Self (the rebel with the rightful sovereign)."[101] This is to say that it is in man, who seems often to be composed of many personalities or powers with which he successively identifies himself and who perceives the universe under the guise of multiplicity, that God (so to speak) unites Himself in unitive vision; in this instance, the Chant harmonizes the "personalities" in various individuals under the rule of the Self of all selves. Given efficacy by the Divine Spirit, the Chant (Scriptures, true poetry) renders the powers of the soul quiescent

so that one approaches the state of St. Paul who could say, "I live, yet not I, but Christ in me." Poetry arrests the flow of the mind, frees the fixation of the passions, harmonizes the component parts that separately divide one, and carries the Truth into the quiet center where it can live.

Plato, as an exponent of the Tradition, was aware of the efficacy of the chant in education, which in his ideal communities was yet another device for ordering men to their perfection. In the *Laws* he writes, "In order to produce this effect [of the youths' following the laws] chants appear to have been invented, which really enchant, and are designed to implant that harmony of which we speak."[102] The effectiveness of ritual chant is due to its suitability and affinity to our nature. As Plato has written in the unforgettable passage often quoted by Coomaraswamy, "We are endowed by the Gods with vision and hearing, and harmony was given by the Muses to him that can use them intellectually . . . to assist the soul's revolution . . . to restore it to order and concord with itself (i.e. the 'Self')."[103] "The composition of sounds," Coomaraswamy observes here, "is the basis of an affect ($\pi\acute{\alpha}\theta\eta$) that affords indeed 'pleasure ($\dot{\eta}\delta ov\acute{\eta}$) only to the unintelligent, but to the intelligent . . . that heartsease also which is induced by the mimesis of the divine harmony made manifest in mortal motions.'"[104] So far as words are useful as a means for achieving the universal purpose of art as set forth in the *Timaeus*, it is chant or ritual poetry that has the power to harmonize the warring elements within us so that we can approach or reach the summum bonum, gnosis. Mere exercise of the *mental* (as different from *intellectual*) powers can be a passion. That which one "knows" when the component parts of his nature are not harmonized and ordered each in its proper function is at best "true opinion" (in Plato's terms); but it is not that ultimate knowing that is being, for one can forget or be dissuaded from the truth he holds as mere right belief or opinion. When one truly knows, as we have seen, he is, according to the Tradition, that which he knows; but when he merely thinks in a state of unresolved conflicts (to use another idiom) he does not have that gnosis which alone brings freedom and fulfillment.

For Plato, as we have seen, music (which includes poetry) has been given to man to harmonize the soul and bring it into agreement with its true Self. He says that inasmuch as a man

is forever tending his divine part and duly magnifying that daemon who dwells along with him he must be supremely blessed. And the way of tendance of every part by every man is one — namely to supply each with its own congenial food and motion; and for the divine part within us the congenial motions are the intellections and revolutions of the Universe [that is, the intelligible universe, the "only-begotten" (μονογενής) heaven (*Timaeus*, 92C), the archetypal universe; in Christian terminology, the exact equivalent is Christ, the intelligible aspect of the Father and exemplar of creation]. These each one of us should follow, rectifying the revolutions within our head, which were distorted at our birth, by learning the harmonies and revolutions of the Universe, and thereby making the part that thinks like unto the object of its thought, in accordance with its original nature, and having achieved this likeness attain finally to that goal of life which is set before men by the gods as the most good both for the present and for the time to come.[105]

Because, as we have seen, Plato "has always in view an attainment of the 'best' both for the body and the soul, 'since for any single kind to be left by itself pure and isolated is not good, nor altogether possible,'"[106] it is easy to understand his great concern for those kinds of music and poetry that would have the right influence upon the affections (which are somatic) as well as upon the mind.[107] His "puritanism" in matters of art is really based on an awareness of the total physical and intellectual effect of the various genres.

There are persons today who have the attitude toward poetry clearly expressed by Housman in statements such as the following: "For me the most poetical of all poets is Blake . . . Blake's meaning is often unimportant or virtually non-existent so we can listen with all our hearing to his celestial music."[108] Types like this Coomaraswamy labels idolaters because they care more for the aesthetic aspects of works of art than they do for the intellectual. There are others who consider poetry the vehicle of emotion and

81

prose the medium of truth. And still others study the great scriptures and myths of the world as "literature" or as documents primarily of importance for their anthropological, psychological, and linguistic significance. Since there are these and probably many more who have a view of poetry much different from the Traditional one accepted by Coomaraswamy, it may be well to set down one more long quotation, though much abridged from the original, that explains a good deal of his doctrine.

Art can have, not only "fixed ends," but also "ascertained means of operation"; that it is not only for those who sing here to sing of Him, but to sing as He sings. On the one hand, a prosaic, historical and anecdotal, sentimental and humanistic interpretation of "scripture as literature," or of any other traditional symbol, whether visual or auditory, is a deadly error. . . . On the other it is clear that our substitution of stress for tone, our "expressive" and informal manner of reading and singing — so different from the measured "singsong" of traditionally spoken verse — are essentially profane developments characteristic of an age that can no longer think of song as an evocative or creative ($\pi o \iota \eta \tau \iota \kappa \acute{o}s$) art in any literal sense of the words, or of Sacrifice as necessary for our daily bread. . . .

Intoned poetry in "incantation" is the language of truth: in-tonation is analogous to in-formation. . . . If the texts are to be made "enchanting" (cf. Plato *Laws* 659E), this is not in the modern sense of the word but in that sense in which the Cantor (. . . the harpist whose songs are a mimesis of the solar music of the spheres . . .) is strictly speaking an Enchanter, voicing words of power, a chanticleer announcing the morning.[109] If the intoned . . . text is actually more "charming" than the prosaic reading (this time "charming" in the modern sense), this charm was not their first intention or last end; the aesthetic value of the incantation, so artfully constructed, is indeed an undeniable value, not however the value of a *raison d'être*, but that of "the pleasure that perfects the operation."[110]

The principles suggested here contain the essence of a more complete theory which could be developed from them and others based upon the practice of Traditional poets — e.g., Vālmīki, Rūmī, Dante, and Blake. Such a theory would be both detailed and comprehensive as well as coherent with the metaphysical doc-

trine of the Tradition. Though possibly of little use to modern poets and critics in its pure form, this theory would represent a polar position and give orthodox formulation to ideas found frequently in the history of European poetry and criticism.

These several dicta on poetry, despite their brevity, can increase one's understanding of many theories of poetry and reveal their larger significance — one often not recognized by the original proponents. A modern critic can still speak of "The incarnation in actuality of the Divine Logos of Poetry." Milton spoke of the music of the spheres and suggested its connection with poetry. Matthew Arnold could say in words scarcely exceptionable to a Traditional writer on poetics, "The best poetry will be found to have a power of forming, sustaining, and delighting, as nothing else can." To mention briefly a few scattered analogues to Coomaraswamy's doctrine is to suggest that the latter might serve to orient and explain various concepts and theories within the larger context of world literature and the Traditional view of life.

❋　　❋　　❋

The one characteristic possessed by all well and truly made works of traditional art is beauty.[111] As we have seen, these works are generally executed to satisfy a double indigence in man. Quoting St. Augustine, Coomaraswamy writes, "An iron style is made by the smith on the one hand that we may write with it, and on the other that we may take pleasure in it; and in its kind it is at the same time beautiful and adapted to our use, where 'we' refers to man a patron, as in St. Thomas, *Phys.* II.4.8, where it is said that 'man' is the general end of all things made by art, which are brought into being for his sake."[112] Coomaraswamy always insists that the Traditional artist — hence, any true artist — does not create works primarily for their beauty. "The artist may know that the thing well and truly made . . . will and must be beautiful, but he cannot be said to be working with this beauty in immediate view, because he is always working to a determinate end, while beauty, as being proper to and inevitable in whatever is well and truly

83

made, represents an indeterminate end."[113] Because all beauty is formal and specific — that is, relating to species — "things are beautiful *in their kind* and not indefinitely."[114] Citing both St. Thomas Aquinas and St. Bonaventura, he demonstrates that every rational agent is thought of as working toward determinate ends; he knows in his intellect the form he wishes to embody in his material. "What is true of *factibilia*," Coomaraswamy observes, "is true in the same way of *agibilia*; a man does not perform a *particular* good deed for the sake of its beauty, for *any* good deed will be beautiful in effect, but he does precisely *that* good deed which the occasion requires, in relation to which occasion some other good deed would be inappropriate (*ineptum*) and therefore awkward and ugly. In the same way the work of art is always occasional, and if not opportune, is superfluous."[115]

In the doctrine Coomaraswamy expounds, beauty is the attractive power of perfection[116] and is not only a means to pleasure which itself "perfects the operation"[117] whatever it may be, but is also a means to knowledge, for "beauty relates to a cognitive power."[118] The beauty of a work of art wrests man's consciousness away from illusion and multiplicity and recalls to his mind the intelligible species or form of that which is imitated or expressed. If the idea has been imperfectly embodied in the work it cannot be beautiful. And to the degree that it truly expresses its idea — ultimately, the idea as it exists *in divinis* — a work is beautiful; it delights and informs.

In his long career Coomaraswamy wrote several essays on beauty, the first appearing in 1915. In his earlier works — e.g., "That Beauty Is a State" and "Hindu View of Art: Theoretical"[119] — he refers largely to Oriental sources and does not write with the concentration and rigor displayed in his late (1946) essay, "The Mediaeval Theory of Beauty,"[120] which is the revised version of two earlier pieces entitled "Mediaeval Aesthetic" (1935 and 1938).[121] It is from this later work that we will draw for our purposes, not only because it represents his mature views but because therein he translates and explicates Western sources that have directly influenced European theories of art and literature. The

theory of beauty that Coomaraswamy finds in the Fathers of the Church and in the Schoolmen is a particular formulation of the universal Traditional doctrines to which he subscribes.

As Coomaraswamy points out, "The Scholastic doctrine of Beauty is fundamentally based on the brief treatment by Dionysius the Areopagite in the chapter of the *De divinis nominibus* entitled *De pulchro et bono*."[122] This in turn is based upon Plato's doctrine which is translated here by Coomaraswamy from the *Symposium* 211:

To him who has been instructed thus far in the lore of love (τὰ ἐρωτικά), considering beautiful things one after another in their proper order, there will suddenly be revealed the marvel of the nature of Beauty, and it was for this, O Socrates, that all the former labours were undertaken. This Beauty, in the first place is everlasting, not growing and decaying, or waxing and waning; secondly, it is not fair from one point of view and foul from another, or in one relation and in one place fair and at another time or in another relation foul, so as to be fair to some and foul to others . . . but Beauty absolute, ever existent in uniformity with itself, and such that while all the multitude of beautiful things participate in it, it is never increased or diminished, but remains impassible, although they come to be and pass away . . . Beauty itself, entire, pure, unmixed . . . divine and coessential with itself.[123]

Coomaraswamy also translates Dionysius the Areopagite's *De pulchro et bono* and the commentaries on it by Ulrich Engelberti and St. Thomas Aquinas. To these he appends his own commentary. The whole essay should probably be consulted by those who care to examine a masterly analysis of an abstruse doctrine. However, for our purposes it can be largely summarized or quoted selectively with omission of some of the metaphysical and theological ramifications.

For Dionysius, as for Plato, Beauty is one of the names of God. "Beauty absolutely," he writes, ". . . is the cause of all things being in harmony (*consonantia*) and of illumination (*claritas*); because, moreover, in the likeness of light it sends forth to everything the beautifying distributions of its own fontal raying; and for that it summons all things to itself."[124] The unchanging super-

beautiful is the "fount of all beauty"; by it all beauty in individual things exists. As St. Thomas Aquinas comments, "The creature's beauty is naught else but a likeness (*similitudo*) of divine beauty participated in by things."[125] As the being of creatures derives from God so does their beauty, which is reflection or likeness of the universal Beauty; their beauty, which is formal, imitates or expresses the divine Beauty just as the aspect of an artifact imitates or expresses the form in the artist's mind. God as the Beautiful, in this doctrine, is the efficient, exemplary, and final cause of all created beauty; as Beauty He moves all things, makes all things for the sake of the beautiful (their perfection) and determines their forms. Nothing exists that does not participate in the Beautiful. As final cause "the divine Beauty in itself, or in any likeness of it is an end attracting every will."[126]

"The form of anything whatever is its 'goodness' [that which any creature desires or relishes],[127] perfection being desired by whatever is perfectible, so also the beauty of everything is the same as its formal excellence."[128] To the degree that a thing imitates or expresses the idea that informs it, it is beautiful. "So then the beautiful by another name is the 'specific,' from species or form."[129] Ugliness is privation of form; hence "an image is said to be beautiful if it perfectly represents even an ugly thing."[130]

"Beauty," writes Coomaraswamy, "is not in any special or exclusive sense a property of works of art, but much rather a quality or value that may be manifested by all things that are, in proportion to the degree of their actual being or perfection."[131] From St. Thomas Aquinas he quotes the following passage: "Three things are necessary to beauty. First indeed, accuracy [*integritas*] or perfection; for the more things are impaired [*diminuta*], thereby the uglier they are. And due proportion [*debita proportio*] or harmony [*consonantia*]. And also clarity [*claritas*]; whence things that have a bright colour are called beautiful."[132] Part of Coomaraswamy's commentary on this cryptic passage is worth quoting at length.

*Integritas* in the moral sense is not what is meant, but rather in that of "entire correspondence with an original condition" (Web-

ster). . . . *Perfectio* must be taken in the triple sense of *Sum. Theol.*, I.6.3, "first according to the condition of a thing's own being all it can or ought to be; second in respect to any accidents being added as necessary to its perfect operation; thirdly, perfection consists in the attaining to something else as the end." . . . Since "the first perfection of a thing consists in its very form, from which it derives its species" . . . and that "likeness is with respect to the form" . . . we see that *integritas* is really "correctness" of the iconography and corresponds to Plato's ὀρθότης; all things being beautiful to the extent that they imitate or participate in the beauty of God, the formal cause of their being at all. . . . *Diminuta* does not mean "broken up," but rather "impaired," abated or diminished by defect of anything that should be present. . . . "Due proportion" and "consonance" (*consonantia* = ἁρμονία) are (i) of the actual to the substantial form and (ii) of the parts of a thing amongst themselves. . . . *Claritas* is the radiance, illumination, lucidity, splendour, or glory proper to the object itself, and not the effect of any external illumination.[133]

"The net result of the traditional doctrine of beauty," Coomaraswamy writes, "as expounded by St. Thomas Aquinas and others, is to identify beauty with formality or order, and ugliness with informality or want of order."[134] To the extent that the aspect or material form of a work of art truly expresses, imitates, or participates in the intelligible form (which itself is often not apprehended clearly by the artist) it is beautiful. "The material beauty, perfection, or goodness of anything is . . . defined by the ratio of essential (substantial) form to accidental (actual) form, which becomes in the case of manufacture the ratio of the art in the artist to the artifact; in other words, any thing participates in beauty, or is beautiful, to the extent that the intention of the maker has been realized in it."[135] Plotinus writes thus concerning beauty, ". . . Perhaps the soul itself acts immediately, affirming the beautiful where it finds something accordant with the Ideal-Form within itself, using this Idea as a canon of accuracy in its decision." Again, "On what principle does the architect, when he finds the house standing before him correspondent with his inner ideal of a house, pronounce it beautiful? Is it not that the house before him, the

stones apart, is the inner idea stamped upon the mass of exterior matter, the indivisible exhibited in diversity?"[136]

This theory of beauty, it is clear, is coordinated with the theory of artistic creation advanced above. The theories dealing with aesthetic experience and the judgment of works of art — to be discussed below — are in like manner derived from the basic principle of this whole doctrine of art: the imitation of intelligible forms in the work of art, whatever its nature.

⁂    ⁂    ⁂

Each work of art by whomever executed will have yet another characteristic — style. As Coomaraswamy writes, "accidental idiosyncrasy due to the efficient cause is represented by 'style,' that which betrays the hand of the given artist, race, or period: it is because as Leonardo says, *il pittore pinge se stesso* that it is required that the artist be a sane and normal man, for if not, the work will embody something of the artist's own defect. . . ."[137] "The style," he agrees, "is the man."[138] So far as the individual style obtrudes and vitiates the force of the theme of the work it is a defect; so far as it adapts the theme to the condition of the men for whom the work was created it is, as it were, a necessary defect. "Styles are the accident and by no means the essence; the free man is not trying to express himself, but that which was to be expressed."[139]

"The traditional artist," Coomaraswamy observes, "is always expressing, not indeed his superficial 'personality,' but himself, having made himself that which he is to express, and literally *devoting* himself to the good of the work to be done. What he has to say remains the same. But he speaks in the stylistic language of his own time; and were it otherwise would remain ineloquent, for, to repeat the words of the *Laṅkāvatāra Sūtra* . . . , 'Whatever is not adapted to the such and such persons as are to be taught, cannot be called a 'teaching.'"[140] Traditional themes must be accommodated to the capacities of those to whom they are presented; certain "styles" then will succeed one another, even in a relatively

stable social order. Such styles, though possibly declining in energy and efficacy from earlier ones, will be necessary vehicles for the themes. However, any worthy Traditional artist will not employ or develop a particular style to express himself as an individual personality.

Coomaraswamy in his voluminous writings on art frequently concerns himself with style, for he knows that the idiosyncrasies of expression need to be explained so that men of another age or orientation can understand the essential elements of the works. The styles of artists today — highly individualized and often deliberately "original" and self-expressive — he generally contemns. If the individual "sensibility," symbolism, and techniques are worth investigating and interpreting, it is only to be able to understand what has been said. And since what is worth saying is said poorly so far as the limitations of the artist's life and times affect the work, Coomaraswamy cannot think that many persons in an age like ours, which in the main inverts the Traditional ideals of life and art, can have much to say that is worthy of attention.

❈   ❈   ❈

It is clear that Coomaraswamy considers that works of art should be effective means to knowledge — so far as possible as it is *in divinis*. The ultimate knowledge or Truth with which he is concerned as the Traditional end of man's life cannot really be stated. An incident from Wu Ch'eng-en's novel *Monkey* describes Monkey's trip from China to India to get sacred scriptures and his anger at finding that he had been given only blank copies. The Buddha answers him ". . . It is such blank scrolls as these that are the true scriptures. But I quite see that the people of China are too foolish and ignorant to believe this, so there is nothing for it but to give them copies with some writing on."[141] While some men may not need to use words at all as reminders of the one Word, most can profit by the verbal support to contemplation. For some this literary reminder of the truth can be quite simple. For instance, Sri Ramakrishna, Hindu sage of the last century, tells of the monk who had a book on every page of which was in-

scribed the sacred Sanskrit syllable OM; this for him was apparently a sufficient literary reminder of the truth.

From Coomaraswamy's point of view, as we have seen, the ideal work of literature should have certain characteristics. First, it should express archetypal myths and metaphysical principles that reflect and suggest cogently the true order of reality. Second, it should be set forth in the form of poetry in which the very pulse of the universe resounds; for such poetry — chanted, preferably — is a powerful means for quieting and ordering the diverse elements in our nature so that we can perceive, without distraction, in the stillness, that immanent knowledge we all possess virtually. Third, it should be ornamented or furnished with those literary devices that enhance its efficacy as a means to knowledge. Fourth, it should be beautiful, as it will be if it has been well and truly made. Beauty as the attractive power of perfection relates to the cognitive power. A work approaches perfection to the degree that it expresses or imitates adequately the conception of it in the artist's intellect. Last, a Traditional work of literature will have a style. This style, which is a personal thing only accidentally, is conceived as a means to accommodating knowledge to the condition of those for whom the work was made, but without distortion or radical misrepresentation of that knowledge.

V

# The Function of Works of Art

*Even the best of writings are but a reminiscence of what we know.*

PLATO

THE FUNCTION OF WORKS OF ART,[1] it has been noted several times, is Traditionally "always and only to supply a real or imagined need or deficiency on the part of the human patron, for whom as the collective 'consumer' the artist works. . . . The necessities to be served by art may appear to be material *or* spiritual, but as Plato insists, it is one and the same art, or a combination of both arts, practical and philosophical, that must serve both body and soul if it is to be admitted in the ideal city."[2] A man with the Traditional view of reality, who hallows all his acts so far as he can and does not therefore distinguish the sacred and the profane, has no strictly "physical" needs that are void of intellectual or spiritual content. And so far as needs seem to be merely physical they should be satisfied in such a manner as not to be an occasion for sin or divagation from one's path to his final end.

As Coomaraswamy points out, "The end of the work of art is the same as its beginning, for its function as a support of contemplation . . . is to enable the *rasika*[3] [one competent to the tasting of the *rasa* or true intellectual flavor of the work] to identify himself in the same way with the archetype of which the [work of art] is an image."[4] "The purpose of art," Coomaraswamy insists, "is always one of effective communication."[5] Its intellectual purpose is the communication of a thesis, essential knowledge, ideas as they are in their eternal forms. As Aristotle notes, all men desire to know;

91

this desire for knowledge is partially satisfied in a Traditional society by works of art.

Plato's *Timaeus*, as we have seen, is the source of the passage that Coomaraswamy frequently cites when dealing with the nature of man and the function of art in rectifying that nature.

We are endowed by the Gods with vision and hearing, and harmony was given by the Muses to him that can use them intellectually (κατὰ νοῦν), not as an aid to irrational pleasure (ἡδονὴ ἄλογος), as is nowadays supposed, but to assist the soul's interior revolution, to restore it to order and concord with itself. And because of the want of measure and lack of graces in most of us, rhythm was given us by the same Gods for these ends.[6]

He notes, "That while the passion (πάθη) evoked by a composition 'furnishes a pleasure-of-the-senses (ἡδονή) to the unintelligent, it (the composition) bestows on the intelligent that heartsease [εὐφροσύνη] that is induced by the imitation of the divine harmony produced in mortal motions' (*Timaeus* 80B). This last delight or gladness that is experienced when we partake of the feast of reason, which is also a communion, is not a passion but an ecstasy, a going out of ourselves and being in the spirit: a condition insusceptible of analysis in terms of the pleasure and pain that can be felt by sensitive bodies or souls."[7] He adds, ". . . Plato's 'heartsease' is the same as that 'intellectual beatitude' which Indian rhetoric sees in the 'tasting of the flavour' of a work of art, an immediate experience, and congeneric with the tasting of God."[8]

Works of art are among the primary means by which man tends and feeds his body and the spirit within it. As Plato has written, "The way of tendance of every part by every man is one — namely, to supply each with its own congenial food and motion; and for the divine part within us the congenial motions are the intellections and revolutions of the Universe"[9] which are reproduced or expressed by works of art. Coomaraswamy sets forth much the same idea in this characteristic statement:

It is true that what we have come to understand by "man," viz., "the reasoning and mortal animal," can live by "bread alone," and that bread alone, make no mistake about it, is therefore a good;

to function is the very least that can be expected of any work of art. "Bread alone" is the same thing as "merely functional art." But when it is said that man does not live by bread alone but "by every word that proceedeth out of the mouth of God,"[10] it is the whole man that is meant. The "words of God" are precisely those ideas and principles that can be expressed whether verbally or visually by art; the words or visual forms in which they are expressed are not merely sensible but also significant.[11]

Dante, whom Coomaraswamy respects as one of the great figures of the Tradition, declares the purpose of all great art when he writes thus about his *Commedia*: "The whole work was undertaken, not for a speculative but for a practical end. . . . The purpose of the whole . . . is to remove those who are living in this life from the state of wretchedness, and to lead them to the state of blessedness."[12] This state of blessedness is that state of union or the beatific vision described in the last canto of the "Paradiso"; after Dante sees all the scattered leaves of the universe ingathered into one volume by Love, he is absorbed into the Deity.

❊    ❊    ❊

Coomaraswamy's analyses of the so-called aesthetic experience are generally in terms of the katharsis effected by the work of art and the "tasting of the flavour" induced by the concentration of one's powers upon the theme of the work. An effective work of art tends, seemingly, to separate soul from body (Plato and Plotinus) — that is, to free the soul from its concern with psychic and somatic matters — so that the ideal form of the work can be experienced or known ("tasting of the flavour") in the same manner as the artist originally experienced it or intended to know it. Katharsis of all or most of that which will vitiate the intellectual effectiveness of the work is necessary before its potential beatitude can be experienced.

To join Coomaraswamy's theory of *rasa* with that of katharsis, which he documents largely from Indian and Greek sources respectively,[13] is not to misrepresent his concept of the complete aesthetic and noetic experience. As he points out, *rasa* has its counterpart in Greek thought and the idea of ritual purification is demonstrably widespread. Consequently one can draw together

the various elements of his analysis as he could have done, though possibly not exactly as he does it explicitly in his essays. As he says, "The Indian theory . . . does not in fact differ from what is implicit in the Far Eastern view of art, or on the other hand in any essentials from the Scholastic Christian point of view, or what is asserted in the aphorisms of Blake,"[14] or, one could add, what is set forth in the dialogues of Plato.

In the Indian theory of art contained in such documents as the *Sāhitya Darpaṇa*, often cited by Coomaraswamy, "the most important term is *rasa*," which he renders as "Ideal Beauty" in the definition of art, "Art is expression informed by ideal beauty."[15] The word *rasa* means literally "tincture" or essence and is often translated by Coomaraswamy as "flavour." Aesthetic experience is often "described as the tasting of the flavour (*rasâsvādana*)."[16]

As he observes, "The definition of aesthetic experience . . . given in the *Sāhitya Darpaṇa*, III, 2–3, is of such authority and value as to demand translation *in extenso*."[17]

Pure aesthetic experience is theirs in whom the knowledge of ideal beauty is innate; it is known intuitively, in intellectual ecstasy without accompaniment of ideation, at the highest level of conscious being; born of one mother with the vision of God, its life is as it were a flash of blinding light of transmundane origin, impossible to analyze, and yet in the image of our very being.[18]

This passage Coomaraswamy explicates at length, partly by quotation of additional sources that throw light upon it. In a sense, "knowledge of ideal beauty" is inborn in all men as Coomaraswamy has often suggested, notably in *Recollection, Indian and Platonic* where he discusses the widespread doctrine of the omniscience of the immanent Spirit, one of whose names is Beauty. In most men, however, this knowledge cannot be realized. It is only those men whose powers are more or less subject to the Spirit or Intellect, that can be free to respond strongly to the "attractive power of perfection" that lies in the beauty of a work of art. The average sensual man is so fixed to the world and to his imaginings that his reaction to the intellectual aspects of a work of art is incomplete; he cannot be carried away out of himself — that is, his involvement

with his psychophysical powers – into a vision of beauty and truth.[19] A man like the Hindu sage of the last century, Sri Ramakrishna, however, was such a developed spiritual type and so little attached to the world that he would go into *samādhi* – a state in which the knower and the known are united in a vision of bliss – at the mere sight of a flower. In some manner, the flower was for him a symbol of a higher reality – specifically, no doubt, the Great Mother to whom he was devoted. So free was he from "knots of the heart" that he would no sooner see the flower than he would perceive an aspect of the deity – the symbol and its referent are identical. He could taste the full savor of the flower. For him "the flower in the crannied wall" that evoked such speculations from Tennyson led, though not by meditation or discursive thought, to an intuitive and instantaneous vision of the divine reality of the universe. The Buddha, in his well-known "Flower Sermon," lifted a flower without saying a word; this gesture enlightened some of his disciples and became the origin of Zen Buddhism.[20]

Translating and paraphrasing from Sanskrit sources, Coomaraswamy writes,

"It is the spectator's own energy . . . that is the cause of the tasting, just as when children play with clay elephants"; the permanent mood . . . is brought to life as *rasa* because of the spectator's own capacity for tasting, "not by the character or actions of the hero to be imitated . . . , nor by the deliberate ordering of the work to that end. . . ." Aesthetic experience is thus only accessible to those competent. . . . Competence depends "on purity or singleness (*sattva*) of heart and on an inner character (*antaradharma*) or habit of obedience (*anuśīla*) tending to aversion of attention from external phenomena; this character or habit, not to be acquired by mere learning, but either innate or cultivated, depends on an ideal sensibility (*vāsanā*) and faculty of self-identification (*yogyatā*) with the forms . . . depicted. . . ." Just as the original intuition arose from a self-identification of the spectator with the presented matter. . . .[21]

As Coomaraswamy notes, some persons will always remain incapable of truly savoring the intelligible essence of works of art. It may be true, as Plotinus observes, that – potentially at least – "the soul includes a faculty peculiarly addressed to Beauty – one

95

incomparably sure in the appreciation of its own, never in doubt whenever any lovely thing presents itself."[22] However, in many or most persons this potentiality is far from being realized. Using the Hindu typology, which can be illuminating here, we can observe that the psychophysical types called *rajasic* (active, energetic) and *tamasic* (inert, slothful) are bound in their consciousness to the world and to their own bodies and they possess too little of the *sattvic* (from *sāttva*, the quality that illumines, clarity) component in their nature to be able to have that vision that works of art can generate in the more competent and gifted.[23] Eckhart writes, "That which is received is received and grasped by its receiver according to the mode of the perceiver; and so anything conceived is known and understood according to the mind of him who understands and not according to its own innate conceivability."[24] Many men will not be able to order the component parts or powers in their nature into harmonious subordination to their intellect; these then will be less able to respond to the ideal form of the work of art than those innately gifted or trained to competence.[25]

Coomaraswamy writes, "In accordance with the Indian theory of aesthetic experience, the accomplishment depends not on the accidents of the representation, but on the spectator's or hearer's own effort or energy."[26] He quotes Rabindranath Tagore concerning the rendition of Indian music, " 'Those of the audience who are appreciative are content to perfect the song in their own mind by the force of their own feeling.' "[27] Clearly, if one approaches works of art with this will — that he must perfect the work so far as he can — he will receive delight that the critical, lethargic, or merely aesthetic person can never find.

From the point of view of the *Laṅkâvatāra Sūtra*, writes Coomaraswamy, "the two chief hindrances" to a man's making effective intellectual use of a work of art "are *kleśâvarana* (sensual attachment) and *jñeyâvaraṇa* (mental or systematic hindrances), one might say affections and prejudices."[28] Because the physical and psychic powers of man are, as it were, knotted up or restlessly seeking objects to fix upon, they dissipate his capacity for intellec-

tual concentration and interfere with his response to the ideal form of the work. Like is attracted to like, as the ancient maxim has it; hence, so long as one *thinks* and *feels* and does not *know*, he does not achieve that supreme aesthetic experience. And because most men are not completely recollected all the time, the work of art must possess some characteristic that will help to arrest the flow of images, ideas, and passions and to reduce to quiescence the powers of the soul so that, for the duration of the aesthetic experience at least, one can approach that state of being where there is a self-identity with the theme. In such a state one is aware of nothing but the theme; he will, for the time, be what he knows and thus transcend his usual state of comparative ignorance. In short, a work of art must possess the power to rectify the personality.

Coomaraswamy, it has been noted, believes that so-called aesthetic contemplation cannot be taught; "all that can be done is to break down the barriers that stand in the way of realization."[29] If these barriers are to be broken down, the work of art must have, as it were, powers of shock and penetration. In a notable essay, "*Samvega*, 'Aesthetic Shock,'"[30] Coomaraswamy discusses that arresting and acute experience that men sometimes have in the presence of a great work of art. "The Pali word *samvega*," he observes, "is often used to denote the shock or wonder that may be felt when the perception of a work of art becomes a serious experience."[31] So far as the shock is, strictly speaking, merely "aesthetic" (that is, relating to affections), it falls short of evoking a total response; it is properly to the essential or intellectual aspects of the work that the pain or joy of the shock is to awaken one. For instance, the Buddhist's consideration of the themes of birth, old age, sickness, sufferings, and death may shock and distress him, but it should also lead him to "recollection of the Buddha, the Eternal Law and the Communion of Monks."[32] The icons of Buddhist art, serving as "reminders of the great moments in the Buddha's life and participating in his essence, are to be regarded as 'stations' at the sight of which a 'shock' or 'thrill' may and should be experienced by Monk or layman."[33] The sight of a violent and fatal automobile collision may arrest momentarily the more or less random flow of

97

images and thoughts in the spectators, but such an experience usually does not present an opportunity for contemplation. For one thing, it was not ordered to that end consciously by an artist; for another, distractions in such a context soon appear to dissipate the focus of concentration; lastly, there is an ambiguity about the larger significance of the event.

Coomaraswamy further elaborates his definition of *saṁvega*, which "refers to the experience that may be felt in the presence of a work of art, when we are struck by it, as a horse may be struck by a whip. It is, however, assumed that like the good horse we are more or less trained, and hence that more than a merely physical shock is involved; the blow has a *meaning* for us, and the realization of that meaning, in which nothing of the physical sensation survives, is still part of the shock." [34] Though the two phases of the shock — the blow and the awareness of meaning — are experienced almost together, it is the second phase that peculiarly characterizes the experience of men who are more than mere aesthetes. The power of a work of art to arrest and command Coomaraswamy describes in a notable passage:

In the deepest experience that can be induced by a work of art (or other reminder) our very being is shaken . . . to its roots. The "Tasting of the Flavour" that is no longer any one flavour is . . . , "the very twin brother of the tasting of God"; it involves . . . a self-naughting . . . and it is for this reason that it can be described as "dreadful," even though we could not wish to avoid it. For instance, it is of this experience that Eric Gill writes that "At the first impact I was so moved by the (Gregorian) chant . . . as to be almost frightened. . . . This was something alive . . . I knew infallibly that God existed and was a living God" (*Autobiography*, 1940, p. 187). . . . But this shock can be felt only if we have learned to recognize truth when we see it. Consider, for example, Plotinus' overwhelming words, "Do you mean to say that they have seen God and do not remember him? Ah no, it is that they see him now and always. *Memory* is for those who have forgotten" (*Enneads*, IV.4.6). To feel the full force of this "thunderbolt" (*vajra*) one must have had at least an inkling of what is involved in the Platonic and Indian doctrine of Recollection. [35]

Works that possess this power of the "thunderbolt" — "The 'thunderbolt' is a hard saying that hits you in the eye" [36] — can

arrest and focus one's consciousness to the exclusion of all else. As Coomaraswamy observes, "In the question, 'Did He who made the lamb make thee?' there is an incomparably harder blow than there is in 'Only God can make a tree,' which could as well have been said of a flea or a cut worm." [37]

※    ※    ※

The end of art is gnosis. And if the work of art is to serve effectively in revealing knowledge, "the mental and effective barriers behind which the natural manifestation of the spirit is concealed" [38] must be broken down, temporarily at least. There must be, as we have seen, a rectification of the personality. This transformation of one's nature comes from a purification or purgation of those elements that would interfere with the intellectual identification with the idea of the work. Now, one can speak of "beauty as the attractive power of perfection"; this beauty which is a result of the adequate representation of the idea or form of the work in the material has a particular affinity to the cognitive element in our nature. One can also speak of *rasa* and *saṁvega* in an effort to describe the highest aesthetic experience. The theory of katharsis is based upon still another figure of speech that is sometimes used in the analysis of the effect of great works of art. Katharsis, of course, does not suggest a mere emptying or purging. It implies rather a purifying, negating, or quieting of those passional and mental hindrances that keep men from the state described in a Sanskrit work: "When the consciousness is brought to rest in the form . . . , and sees only the form, then, inasmuch as it rests in the form, aspectual perception is dispensed with and only the reference remains; one reaches then the world-without-aspectual-perception, and with further practice attains to liberation from all hindrances, becoming adept." [39]

In a superb late essay, "A Figure of Speech or a Figure of Thought?," Coomaraswamy concisely sets forth his theory of katharsis. He claims that Plato's "heartsease" ( εὐφροσύνη ) and the "intellectual beatitude" of Indian rhetoric are immediate experiences, "congeneric with the tasting of God." [40] He continues,

99

This is, then, by no means an aesthetic or psychological experience, but implies what Plato and Aristotle call a Katharsis, and a "defeat of the sensations of pleasure (or pain)." Katharsis is a sacrificial purgation and purification, "consisting in a separation, as far as that is possible, of the soul from the body"; in other words, a kind of dying, that kind of dying to which the philosopher's life is dedicated. The Platonic katharsis implies an ecstasy, or "standing aside" of the energetic, spiritual and imperturbable from the passive, aesthetic and natural self; a "being out of oneself" that is a being "in one's right mind" and real Self,[41] that in-sistence that Plato has in mind when he "would be born again in beauty inwardly," and calls this a sufficient prayer.[42]

Coomaraswamy admits that it is difficult to know precisely what Aristotle meant by his well-known definition of the power of tragedy "by its imitation of pity and fear" to effect "a katharsis from these and like passions." He does, however, believe that Aristotle clearly meant that the effect of tragedy was a purification *from* the passions and not an indulgence in them. He points out also that for Aristotle tragedy was essentially a representation of actions and not of character. Accepting the doctrine of the primacy of action over characterization, he writes as follows:

[Plato's] katharsis is an ecstasy or liberation of the "immortal soul" from the affections of the "mortal," a conception of emancipation that is closely paralleled in the Indian texts in which liberation is realised by a process of "shaking off one's bodies."[43] The reader or the spectator of the imitation of a "myth" is to be rapt away from his habitual and passible personality and, just as in all other sacrificial rituals, becomes a God for the duration of the rite, and only returns to himself when the rite is relinquished, when the epiphany is at an end and the curtain falls. We must remember that all artistic operations were originally rites, and that the purpose of the rite (as the word implies) is to sacrifice the old and to bring into being a new and more perfect man.[44]

Several times in his work Coomaraswamy discusses katharsis, though he does not deduce all the psychological details of the process.

If one genuinely and profoundly responds to the thesis of a great work of art — which deals perennially with the subject of God, "whose only idiosyncrasy is being" — he identifies himself

with the subject of the work and ceases to be aware of himself as an individual. Each such experience reinforces a man in his realization of who he is; it tends to separate soul from the body — that is to say, one's consciousness is raised from concern with the body to a higher level. Now, a work of pornography may seem totally to absorb a reader; if it does, it will probably not bring him out of his individuality but rather immerse him in those forces and passions with which he frequently identifies himself in his unregenerate state. There is much more in Coomaraswamy and other Traditional thinkers that deals with the purifying effect of works of art, but in view of what has been said here and above, the main lines of the theory should be clear.

    ❁    ❁    ❁

According to the perennial Tradition, the perfection of man is in knowledge — immediate, intuitive, direct knowledge of reality or God. Works of art are among the best means developed by man for imparting principial knowledge. As we have seen, works of art are reminders; they are supports of contemplation. Their beauty, their power of shock and purification, their capacity for ordering the disparate elements of our natures — all these are qualities that make them very effective with persons with the innate ability or with the training to employ them as they are intended by the Traditional artist.

In yet another noteworthy passage Coomaraswamy describes the function of art:

Now since the contemplation and understanding of these works is to serve the needs of the soul, that is to say in Plato's own words, to attune our own distorted modes of thought to cosmic harmonies, "so that by an assimilation of the knower to the to-be-known, the archetypal nature, and coming to be in that likeness, we may attain at last to a part in that 'life's best' that has been appointed by the Gods to man for this time being and hereafter," or stated in Indian terms, to effect our own metrical integration through the imitation of the divine forms; and because, as the Upanishad reminds us, "one comes to be of just such stuff as that on which the mind is set," it follows that it is not only requisite that the shapes of

101

art should be adequate reminders of their paradigms, but that the nature of these paradigms themselves must be of the utmost importance. . . .[45]

It will be observed that Coomaraswamy repeatedly describes only the most intense or exalted aesthetic experiences — experiences that are more properly termed noetic than aesthetic. It is only those natively gifted or progressively initiated into the mysteries of Beauty — as Plato, for instance, suggests in the *Symposium* — who are capable of making maximum use of a work of art in perfecting their lives in knowledge. Others will react according to their condition. "It will be seen that everyone is thought of as making use of the work of art in his own way, the work of visual art, no less than a word, being a *kāma-dhenu* [the mythical cow which satisfies all desires], yielding to the spectator [or reader] just what he seeks from it or is capable of understanding."[46] All genuine myths and all traditional works of art, by the necessity of their nature, have levels of meaning and significance; all meanings are true but they are conceivable according to the nature or training of those that respond to them. Many Traditional works (e.g., sacred scriptures, such as the Bible with its "four senses," and compositions like the *Divine Comedy* to which Dante ascribes polysemous significance) can often be discovered to have at least four types of significance — literal, moral, allegorical, and anagogic.[47] Most men at best will only be informed and edified; the higher significance will be hidden from them, partly because of the artist's intent, for as St. Thomas Aquinas observes, "The very hiding of truth in figures is useful for the exercise of thoughtful minds, and as a defense against the ridicule of unbelievers. . . ."[48] Thoughtful minds and those gifted with insight will be able to respond to the parabolic or anagogic meaning which tends to lead upward to a vision or state of knowledge beyond the dualities of the ordinary human state of mind.[49]

Because man learns in large measure by imitation, as Aristotle, for one, has noted,[50] it is important for the generality of men — if not for all — that the artist observe this principle: "The imitation of anything and everything is despicable; it is the actions of God

and Heroes, not the artist's feelings or the natures of men who are all too human like himself, that are the legitimate theme of art."[51] Even if one is unable to achieve that gnosis which is the highest end of the aesthetic experience, he will be powerfully prompted to emulate the actions of the gods and heroes he has identified himself with as he has read, seen a play, or taken part in a rite.

It should be noted that Coomaraswamy follows the doctrine of the Tradition in holding that works of art should and will afford pleasure to those who make them use of them.[52] He writes, "The life of pleasure only, one of which the end is pleasure, is sub-human; every animal 'knows what it likes,' and seeks for it. This is not an exclusion of pleasure from life as if pleasure were wrong in itself; it is an exclusion of the pursuit of pleasure thought of as a 'diversion,' and apart from 'life.'[53] It is in life itself, in 'proper operation,' that pleasure arises naturally, and this very pleasure is said to 'perfect the operation.'[54] In the same way in the case of the pleasures of use or the understanding of use."[55] The work of art properly employed quiets the appetites and satisfies the will, focuses one's consciousness, and fulfills some real indigence (the desire to know) in us in a manner that gives delight and pleasure. This pleasure "perfects the operation" and renders the response whether aesthetic, moral, or noetic all the more effective; pain and disgust would distract and detract from its effectiveness.[56]

That beauty delights men — some, at least — is assumed. Beauty, as we have seen, is the attractive power of perfection; it attracts and it satisfies that longing to know reality or God, that restless urge that impels all men. Any properly made work of art will be beautiful, as we have noted. Even those imitations of things that are considered ugly will be beautiful to the extent they accurately embody the form of the ugly thing. "As St. Thomas says, *Sum. Theol.*, I, q.39, a.8, 'an image is said to be beautiful if it perfectly represents even an ugly thing,' and this accords with the (unstated) converse of St. Augustine's dictum that things are not beautiful merely because they please us. St. Thomas, *ibid.*, III, q.9, a.5c, says also . . . 'We delight in knowing evil things, although the evil things themselves delight us not.' . . ."[57] If beauty relates to the

cognitive faculty which delights and is perfected in knowledge, it is obvious that the work of art that imitates or expresses well the essential form of an ugly thing will delight the man who really desires to know. The descriptions of sin in Dante's *Commedia* surely embody the true nature of sin; they have been discovered to be beautiful even by aesthetes, who deal largely in sensations, and they are all the more beautiful to those who wish to understand.

❊    ❊    ❊

To what extent works of art effect their end has been discussed frequently by Coomaraswamy. Of particular interest for its grandeur of conception is his extraordinary collation of Meister Eckhart's dicta. Quoting, paraphrasing, summarizing, explicating, he sets forth these remarkable ideas:

So what is aesthetic experience, or, as Eckhart calls it, recollection, contemplation, illumination . . . , the culminating point of vision, raptures, rest? In so far as it is accessible to man as a rumor (95) or foretaste (479), passing like a flash of lightning (255), it is the vision of the world picture as God sees it, loving all creatures alike, not as of use, but as the image of himself in himself (360), each in its divine nature and in unity, as a conscious eye situated in a mirror (253, 384) might see all things in all their dimensions apart from time and space as the single object of vision, not turning from one thing to another (12) but seeing without light, in a timeless, image-bearing light, where "over all sensible things hangs the motionless haze of unity." That is a seeing of things in their perfection, ever verdant, unaged and unaging. . . .[58]

It is a supreme vision of this sort that Dante describes in the last canto of the "Paradiso." There are others as well who have tried to describe the nature of this experience, although nearly all recognize that it is impossible more than to suggest what it is. It may be that Dante's *Commedia* itself has with some fulfilled the grand purpose for which it was undertaken. It is reported that poems — often short ones — have been the occasion for the experience of *satori* (supreme enlightenment) by Zen Buddhists.[59]

To go on with Coomaraswamy's collation of Eckhart on the contemplative vision to which Traditional art is dedicated:

Again, it is compared to the seeing of a play, a play (Skr. *līlā*) played eternally before all creatures, where player and audience, sport and players, are the same, their nature proceeding in itself, in clear conception and delight (147, 148), or to an operation in which God and I are one, works wrought there being all living. This sharing of God's vision of himself in his "work," which in so far as we can have an "inkling" of it is what we mean by aesthetic experience, is likewise what we mean by Beauty as distinct from loveliness or liking, which have their drawbacks in their opposites. . . .

So much of pure aesthetic experience as is possible to anyone is his guarantee of ultimate perfection and of perfect happiness. It is as artist-scholar that man prepares all things to return to God, in so far as he sees them intellectually . . . and not merely sensibly. . . .[60]

In these and similar words Coomaraswamy has described the end for which works of art are often intended by Traditional artists (e.g., Dante and Blake); this is the ultimate end for which works of art can be employed as means. Although few even among those consciously aspiring to their perfection as men may achieve the supreme realization, much less experience it as a direct result of reading a poem or viewing a play, many men can advance in the perennial pilgrimage with the aid of objects of beauty designed to satisfy mediate ends and gradually to perfect them. To study deeply the *Divine Comedy*, to view *Hamlet* in the theater, to read Blake's "Tyger," to see a bronze statue of a dancing Shiva — these and the like may not of themselves be the occasion for that "lightning-flash" of gnosis, but they can and do give men profound insights into the true nature of things, the more so if the rest of a man's life is generally in accord with the informing spirit of these and similar works. As reminders and supports of contemplation they not only afford marvellous intuitions but also prepare men for those other contemplative experiences with which we are graced, especially if we still retain the sacred view of the cosmos. While works of art in themselves will not save the world or even many souls in any age, much less in our own, they will nonetheless form one important component in the economy of the Traditional existence, which is in all ways ordered to the perfection of persons.

🏮

# VI

# *Judgment and Criticism*

*All that can be done is to break down the barriers that stand in the way of realization.* A. K. COOMARASWAMY

IN COOMARASWAMY'S MANY ESSAYS can be discovered an explicit theory of literary judgment and criticism that is strictly coherent with his doctrine of art which, in turn, is grounded upon the perennial metaphysics. Works of art, according to Coomaraswamy, admit legitimately and necessarily of two kinds of judgments: (1) technical — in terms of the ratio

$$\frac{\text{intention}}{\text{result}}$$

and (2) moral — in terms of the use to which they may be put by the consumer. Although the two judgments are often not separated in life, they are logically distinct; hence, they must be rigorously distinguished lest one become confused about the domains of art and prudence.[1] These judgments are part of the critical task, but they are possibly not the most important function the critic can perform in our day. It is clear from an examination of Coomaraswamy's practice as well as his theory that he assumes that the critic of today has a subsequent and essentially creative function — that is, to interpret, explicate, and generally to prepare persons to respond to the work of art in a more or less complete manner and much as the artist would have wished.[2]

The critic and scholar attempts "to break down the barriers that stand in the way of realization"[3] of the ideal form that is properly the origin as well as the end of the work of art. "It is as an artist-

scholar that man prepares all things to return to God, in so far as he sees them intellectually . . . and not merely sensibly. . . ."[4] The critic's task then can be seen in the total pattern of man's endeavor; it is he, in part, who interprets the great works and prepares men in these latter days to respond to their life-giving substance. In his highest function it is the literary critic–scholar who initiates men into the mysteries of the great works of literature so that the spirit in the inspired letters may give life. It is by the study of the Scriptures (which we can take here, as elsewhere in this study, as more or less perfect types of literature)[5] and the pursuit of his natural vocation, as the *Gītā* says, that man approaches perfection. As we shall see, this both exalts and humbles the critic.

❊　　❊　　❊

Initially we can turn with profit again to Coomaraswamy's essay, "A Figure of Speech, or a Figure of Thought?," which contains in brief the essential substance of this present study, setting forth as it does quite a complete theory of literature. Here Coomaraswamy states the method of the two judgments of a work of art. He writes, "All the arts, without exception, are 'imitative': the work of art can be judged as such (and independently of its 'value') by the degree to which the model has been correctly represented; the beauty of the work is proportionate to its accuracy ($ὀρθότης$ = '*integritas sive perfectio*'), or truth ($ἀλήθεια$ = *veritas*). In other words, the artist's judgment of his own work by the criterion of art is a criticism based upon the proportion of essential to actual form, paradigm to image."[6] So far as the critic judges the execution of a work, he uses the same method as the artist;[7] his own prepossessions, reactions, or moral valuations are irrelevant to this judgment, which always concerns the "equality or proportion of the image to its model."[8]

After completion of his work, the artist will judge it according to its success in embodying what he intends; the critic will likewise judge according to the same principle.[9] If the poet has intended to write a lyric poem about the Edenic delight in a garden — as Andrew Marvell did — he will examine his completed work to

determine his success in the lyrical evocation of this experience. The critic in his role as judge of artistic accomplishment can do no other. If he wishes that the lyric had never been composed or if he prefers to have the experience treated in an epic or an ode, he is not judging the artistic perfection of the work; he is rather making another kind of judgment as moralist, consumer, or user of the work. He says, in short, that this kind of work does not suit his requirements.

This other judgment is important. By the artist it is made before he undertakes his work; by the critic it can usually be made only after the work has been completed. Drawing upon Plato, Coomaraswamy writes thus:

But we have also to consider the good of the man for whom the work is done, whether this "consumer" ($\chi\rho\acute{\omega}\mu\epsilon\nu\sigma$) be the artist himself or some other patron. This man judges in another way, not, or not only, by this truth or accuracy but by the artifact's utility or aptitude ($\dot{\omega}\phi\acute{\epsilon}\lambda\iota\alpha$) to serve the purpose of its original intention ($\beta o\acute{\nu}\lambda\eta\sigma\iota\varsigma$), viz. the need ($\acute{\epsilon}\nu\delta\epsilon\iota\alpha$) that was the first and is also the last cause of the work; accuracy and aptitude together making the wholesomeness ($\dot{\nu}\gamma\iota\epsilon\iota\nu\acute{o}\nu$) of the work that is its ultimate-rightness ($\dot{o}\rho\theta\acute{o}\tau\eta\varsigma$). The distinction of beauty from utility is logical, not real (*in re*).[10]

These two judgments, which are "united in the whole man and connoisseur,"[11] we shall now analyze separately in more detail.

❈    ❈    ❈

The technical judgment is always made properly in these terms, as stated variously by Coomaraswamy:

| intention | concept | forma | art in the artist |
|-----------|---------|-------|-------------------|
| result | product | figura | artifact |

As we have observed, this is the same kind of judgment that the artist is expected to make when he finishes his work, criticizes it, and trues it to his original plan.[12] If one cannot reconstruct or divine the original artistic intention, he cannot be sure that his technical judgment of the work is not entirely gratuitous and beside the point. A man does not usually believe that he can judge a

poem written in a language that he does not understand. And so far as one does not understand the meaning of a poem — and this meaning is what the poet *intends* to be understood as its meaning[13] — he must admit his inability to decide whether the work in question expresses poorly what the poet intended.[14] It would seem obvious, for example, that one cannot arraign Milton for poorly executing a love lyric, which he did not intend, when he wrote *Paradise Lost*. The principle formulated in Alexander Pope's familiar words and enunciated many times in the history of criticism would appear to be unexceptionable:

> A perfect Judge will read each work of Wit
> With the same spirit that its Author writ
>
> . . . . . . . . . . . . . .
>
> In every work regard the writer's End
> Since none can compass more than they intend.

Yet some critics still insist that a work of art should not be judged by the author's conscious intention because his real intentions are subconscious. And there are others who criticize the "intentional fallacy," claiming that the authors' intent can seldom if ever be determined with any degree of certainty.

In an interesting essay, "Intention,"[15] Coomaraswamy sets forth the critical principles proposed above and answers the objections to this point of view.[16] This essay is worth considering not only because it reveals Coomaraswamy in a polemical mood but because it states concisely a theory in criticism that still exercises many minds.[17] The polemics, as such, need not much concern us here. It should be noted, however, that Coomaraswamy vigorously and learnedly answers those who contend (1) that works cannot be judged in terms of intention because intention can seldom, if ever, be known with certainty, and (2) that the critic's task is "to evaluate the work itself" more in terms of "what the work ought to be" than with "what the author intended it to be."[18] Such propositions are offensive to Coomaraswamy because they tend to exalt the critics (especially the unqualified ones) beyond their rightful function.[19] It is likely that Coomaraswamy senses here the specious justification for anyone to set himself up as a critic.[20] So long as

the criticasters confine their activities to modern works of little worth it may not matter much, but Coomaraswamy in his long life as a scholar had seen the results of the bigoted, merely learned, and "profane" approach to the great works of art that he revered. (This may account for the icy politeness and tartness of his essay, which is in the form of an open letter.)

In answering his opponents, Coomaraswamy resorts characteristically to canonical sources both because their utterance is authoritative and also because they demonstrate the manner in which certain words and concepts have been used over the centuries. He writes thus:

In the Western world, criticism that takes account of intention begins, I think, with Plato. He says: "If we are to be the connoisseurs of poems we must know in each case in what respect they do not miss their mark. For if one does not know the essence of the work, what it intends and of what it is an image, he will hardly be able to decide whether its intention (*boulesis*) has or has not found its mark.[21] One who does not know what would be correct in it (but only knows what pleases him), will be unable to judge whether the poem is good or bad" (*Laws* 668C, with parenthesis from B). Here "intention" evidently covers "the whole meaning of the work"; both its truth, beauty or perfection and its efficacy or utility. The work is true to its model (the choice of the model does not arise at this point), and also adapted to its practical purpose — like St. Augustine's writing-stylus, *et pulcher et aptus*. These two judgments by the critic (1) as an artist and (2) as a consumer can logically be distinguished, but they are of qualities that coincide in the work itself.[22]

In his typical manner of basing an argument upon ultimate principles, Coomaraswamy cites the primordial myth which in its universality is exemplary for all actions, human and divine. "When God is said to have considered his finished work and found it 'good,' the judgment was surely made in these terms: what he had *willed*, that he had *done*. The ratio in this case is that of the *Kosmos noetos* to the *Kosmos aisthetikos*, invisible pattern to material imitation. In just the same way the human maker 'sees within what he has to do without'; and if he finds his product satisfactory, . . . it can be only because it seems to have fulfilled his intention."[23] The

normal artist intends that the consumer will be enabled to see within by the aid of what he (the artist) has done without. Likewise the critic must be able to see within what the artist has intended to do so that he may compare the work without with the original plan, artistic intention, or contemplated form.

Although opponents of the intentional method of criticism claim that it is virtually impossible ever to discover what the original intention of the artist was, Coomaraswamy maintains that this is not the case. He refers in "Intention" to several authors — since his opponents say that they are "concerned only with poetic, dramatic, and literary works"[24] — who have quite explicitly stated their intentions. He cites the very words of Avencebrol, Witelo, Dante, and Aśvaghosa. The well-known words of Dante about the *Commedia* are quoted again: "The purpose of the whole work is to remove those who are living in this life from the state of wretchedness and to lead them to the state of blessedness."[25] Although this is a moral and not artistic purpose, its implications for art can clearly be deduced. Dante, we are aware, believed that man reaches his final end in knowledge of reality or in union with God. Since this union is accomplished only in the absorption of the soul into God, man must know all things as they are known by and in God. Dante's method is clearly to depict a vision of the Three Worlds as they are in reality and to call men to this vision by the energy and beauty of his conception.

Although Coomaraswamy does admit that it is sometimes difficult to discern the author's intention, he contends "that the critic *can* know what was in the author's mind, if he wants to, and within the limits of what is ordinarily meant by certainty or 'right opinion.'"[26] He answers those who "deny that it is ever possible to prove from external evidence that the author intended the work to mean something that it doesn't actually mean"[27] by pointing out that outside of pure mathematics we do not, in our ordinary condition, possess absolute proof for anything; even the rising of the sun tomorrow is a conjecture or a hypothesis probably but not necessarily true. But if we are to divine the author's intention we must often work hard and not depend upon "mere sensibility."[28]

One must not only have a natural vocation to practice as critic, but he must also acquire competence by considerable self-discipline as well as by learning.

❧    ❧    ❧

Because it is of such crucial importance to Coomaraswamy's whole theory of judgment and criticism, we shall examine at greater length the method by which a critic can properly discharge his function. "Just as the original intuition arose from self-identification of the artist with the appointed theme, so aesthetic experience, reproduction, arises from a self-identification of the spectator with the presented matter; criticism repeats the process of creation."[29] We have only to refer again to the techniques by which the artist achieves his creative vision to understand in some measure what the critic must do. The critic's task will be easier because he can use the work of art as a support for his contemplative vision. And the better qualified he is innately and the better the work of art, the easier will be the process of reproducing intellectually the original form of the work, as it was conceived by the artist. As the artist must give himself up to create, so must the critic give himself up to judge and criticize.

About the proper critical approach Coomaraswamy writes, "To begin with, the critic must both know the author's subject and delight in it[30] — *sine desiderio mens non intelligit* —, yes, and believe in it — *crede ut intelligas.*"[31] He adds, "I assert, from personal experience, that one can so identify oneself with a subject and point of view that one can foresee what will be said next, and even make deductions which one afterwards meets with as explicit statements in some other part of the book or in a work belonging to the same school of thought."[32]

In a notable passage that deserves to be quoted at length in this context, Coomaraswamy writes about the proper discharge of the critic's function:

If, as Dante says, he who would portray a figure cannot do so unless he *be* it, or as we might express it, unless he *lives* it . . . it is no less certain that he who would . . . appreciate and understand an

112

already completed work, can only do it subject to the same condition, and this means that he must conform his intellect to that of the artist so as to think with his thoughts and to see with his eyes. Acts of self-renunciation are required of all those who aspire to "culture," that is, to be other than provincials. It is in this sense that *Wer den Dichter will verstehen, muss im Dichters Lande gehen.*[33]

As Coomaraswamy has written elsewhere concerning this dictum of Goethe, "Not necessarily, though often advantageously, a physical territory, but still another world of character and another spiritual environment."[34] To be such a traveler in strange lands demands great gifts of courage and love, for " 'it is a divine power that moves' . . . even the rhapsodist, or literary critic so far as he speaks well, though he is only the exponent of an exponent."[35]

Coomaraswamy knows that truly to understand and to judge alien works of art, an entire (if, possibly, only provisional) rectification of one's personality is required. An avowed materialist or atheist cannot *understand* Romanesque or Gothic art. Lacking the gift of belief which would predispose him to be amenable to the shaping influence of these Christian works, he could only view them in a manner conditioned by his own prepossessions, which by their very nature render him relatively impervious to religious theses that are at best difficult enough of comprehension.[36] Coomaraswamy believes that it would be a contradiction in terms to think that an atheist, for instance, could become, in a proper sense, a doctor of mediaeval art. He is likewise convinced that it is absurd not only to teach the "Bible as literature" but also to believe that one can teach or study Dante profitably as mere "literature."[37]

The application of Coomaraswamy's theory of critical competence can readily be extended; even to study Homer, Sophocles, or the Arthurian romances, for instance, from the point of view of the "nonbeliever" is to miss their real significance. This is not merely to make the unexceptionable observation that study and criticism are enhanced by knowledge of the age that produced the work in question. It is to state that unless one can surrender his prejudices and overcome his intellectual limitations, say, in a study of Homer, he would probably believe that the constant pre-

occupation with gods, fate, and miraculous events results in mere figures of speech quite unrelated to the deepest convictions of the Greeks concerning the nature of gods and man; at best he would ascribe such preoccupations to their superstitious and primitive natures. In another manner of speaking, Coomaraswamy states, "No one can 'write a fairy tale' who does not believe in fairies and is not acquainted with the laws of faery."[38] As Guénon has remarked in the same vein, "There is only one really profitable way of studying doctrines: in order to be understood they must be studied so to speak 'from the inside.' . . ."[39] And as Guénon has also noted, "inasmuch as a conception always contains something that surpasses its expression," even the initiates and duly accredited interpreters will be hard put to explicate the content of a traditional work of art.[40] Interpretation of scriptures (as the highest type of literature) and metaphysical and religious symbols should be attempted only by the qualified; the "profane" approach is worthless and destructive.

Coomaraswamy continues:

It may be remarked that the very word "understanding," in application to anything whatever, implies to identify our own consciousness with that upon which the thing itself originally depended for its being. Such an identification, *rei et intellectus*, is implied by the Platonic distinction of σύνεσις (understanding, or literally association) from μάθησις (learning) or, in Sanskrit that of *artha-jñāna* (gnosis of meaning) from *adhyayana* (study): it is not as a mere Savant (*paṇḍitah*), but as a Comprehensor (*evaṁvit*) that one benefits from what one studies, assimilating what one knows. Understanding implies and demands a kind of repentance ("change of mind"),[41] and so too a recantation of whatever may have been said on the basis of observation alone, without understanding.[42]

Coomaraswamy believes that only that which is correct or true is comprehensible. To accept an error as true is not to understand; it is to have an opinion or to be favorably disposed toward such an error, but it is not to understand *intellectually*. Hence, if one really understands a work of art — that is, apprehends the true form or archetype embodied in it — he cannot wish the work to

have been otherwise; to do so would be to deny "the art in the artist," the artist's very being. The critic may point out the discrepancy between the idea and the execution, for that is part of his legitimate function as critic. If he, however, objects to the existence of the artifact or disagrees with its thesis, it is not as the critic of art that he acts; in this case, he acts as consumer *post factum.* On the basis of these requirements for the critic it would appear that few men would have the capacity (1) to distinguish the true meaning of a work from mere opinion of its significance and (2) to refrain from allowing their prepossessions to interfere with their critical perceptions.

What emerges first from these statements is an awareness that the critic like the artist must be capable of contemplation (in the technical sense).[43] If he must go to the poet's land or become, for example, a Romanesque man, it is mainly to be able to accept and comprehend the particular idiom and world-view of the artist whose work he seeks to understand. Once he puts himself at the point of view of the artist, he can fully utilize the work of art as a support to his contemplation of its thesis. And unless he can recreate the original intelligible form, as did the artist, he cannot, like the artist, make a judgment about the adequacy of the representation of the form.

Now it is possible that the artist only poorly comprehended what he intended to imitate in his artifact — that he had a muddy vision or an infirm act of contemplation. It would seem that it is not this vision in all its imperfection that the critic will try to reproduce. He may need to identify himself with the artist, but this is mainly to accept the artist's characteristic mode of expression so that he can understand his meaning. The critic, employing the particular sensible symbols of the work as aids to the discovery of meaning, will try to determine as perfectly as he can the idea, intelligible form, or theme of the work. It may be that an artist depicts angels as plump children dressed in nightgowns and sporting little golden wings. The critic will surmise — provisionally, at least, for the purpose of his judgment of the adequacy of the portrayal — that the artist is sincerely attempting to render the angelic orders in a sen-

sible form. Now the critic will not merely try to duplicate the original conception of angels as plump children; it is rather that he will try to know or envision angels as they really are. Ideally he could follow the injunction of the master whom Eckhart represents as giving this advice to his pupil who had asked about the angels: Give yourself up to the contemplation of angels so that you can be them and know them as they really are. It is only when the critic knows angels as they are that he can judge the success of the artist's rendition of them.[44] In this case, of course, one might not even need to resort to contemplation; knowledge of and trust in the traditional portraiture of angels in the Christian tradition might suffice to demonstrate the inadequacy of this portrayal.

According to the formulae advocated by Coomaraswamy, we could analyze the critic's judgment thus:

$$\frac{\text{pictures of plump children with wings (result)}}{\text{angels as they really are (intention)}}$$

Due regard, of course, will be had for the characteristic Christian mode of iconography — so far as this differs from that of the Muslim, Judaic, or Hindu tradition. Other versions of this formula could likewise be used. If one judges, for instance, by "the art in the artist," it is the potentially perfect art within him rather than the lesser art that that he seems to command.

Such a judgment by the critic would seem to assume that the artist works by art and voluntarily and that he is inclined by justice to do his work faithfully, as St. Thomas Aquinas states; so far as he *is* an artist moved by his art (and not by cupidity, sentimentality, or other irrelevant motives) he must thus do his work. If the hypothetical artist here wished to depict angels as we have described for the purpose of appealing to popular taste these days, one would label this intention a moral one, a matter of will and not of intellect or art. Regardless of this impure moral intention, there is the artistic intention to depict angels — and that is what will be considered in the first judgment.

It is clear that Coomaraswamy's critical principles can best be applied in a conservative, Traditional social order with a more or less homogeneous culture. If artists intend to express themselves

116

and record any vagrant mood, impression, or thought, it may be difficult to make out their real intention. To say this is not to open criticism to the kind of thing that Coomaraswamy deplores — motive-mongering, psychologizing, and the like. It is to say that true criticism is made very difficult by the general condition of modern art. Clearly, Coomaraswamy believes that if a critic presumes to judge technically a certain work, regardless of its merit, he will rigorously seek to interpret it according to the ratio he sets forth; he will interpret *intention* or *concept* or *forma* or *art in the artist* in a respectful and literal manner.

The critic who is also an artist and hence also works willingly and by art will respect the concept, form, or art in the artist that is manifested in the work he undertakes to judge. So far as these inhere in the work, it is knowable; and so far as it is knowable, it participates in the divine beauty and being. If the alleged object of art has no formal basis or if the art in the artist had in no way contributed to a transformation of the material, the object would not exist as a work of art at all.

Although we can easily conceive of the good critic's approaching a great work in a respectful manner and trying to judge it according to the canons Coomaraswamy has made explicit, we may test his theory by judging whether it works in the case of the creation of a feeble art. Now suppose an ordinary sentimental man says, "I intend to describe in my poem what I felt and thought last night while looking at the moon." How can the critic apply his formula to such a poem? How can he know what this individual man thought and felt? He cannot, of course, except so far as the poem gives him a clue. A critic like Coomaraswamy or an elder of Plato's ideal state would not even judge such a poem scrupulously by the criterion of art; he would cast it out on moral grounds or because it was not conducive to harmonious and intelligent behavior or to the knowledge that is the end of all arts that are truly arts.[45] But if he were to judge it technically, he would have to make an effort to understand the poem, as Coomaraswamy points out. And understanding implies the ability "to identify our own consciousness with that upon which the thing originally depended for its be-

117

ing."[46] Now the knowing critic, an expert in these matters, would not try to get himself into the sentimental mood of our poetaster who thought he was happy and profound. He would rather try to divine the true state of the poet; this might be far from what the poet thought it to be. He might determine that what the being of the poem depended upon was an individual condition possibly similar to some of those described in Dante's "Inferno."[47] This is not to psychologize but to discern the gap between what the poet thought his condition was and what it really was. The *artist* — so far as he is an artist — works "'by intellect,' which is the same as 'by his art.'"[48] Our hypothetical poet would probably be working little by intellect and art, for art has fixed ends — intellectual ones — and ascertained modes of operation.[49] And "artificial things are said to be false absolutely and in themselves, in so far as they fall short of the form of the art;[50] whence a craftsman is said to produce a false work, if it falls short of the proper operation of his art."[51] And, if St. Thomas Aquinas seems to dislike most poetry, it is because it is emotional and naturalistic, hence not conducive to man's welfare.[52]

The above speculations may not be warranted applications of Coomaraswamy's critical theory; they do represent, however, an attempt to argue for its validity even in a social order far removed from what he considers normal. One thing is sure: to judge by the criterion of art in a day when art is subjective, devoted to the description and evocation of feelings and emotions, and little concerned with knowledge as an end is indeed difficult. Obviously Coomaraswamy's canon of judgment would work best in a Traditional society where there would be little ambiguity about the artistic intention of the artist because he would generally be handling well-known themes in an approved manner. Possibly Coomaraswamy's method of criticism could best be used today if the judgments were conditional: If the poet intended such-and-such, then —

✻ ✻ ✻

As we have seen, Coomaraswamy repeatedly takes pains to distinguish the realms of art and prudence.[53] From what has been

said above — especially in "Man, Society, and Art" — it is clear that Coomaraswamy believes that an artist should be a moral (rather than an immoral) man engaged in the production of artifacts that will be conducive to the welfare of his fellows. That is, as a citizen no artist should accept a commission and execute a work of art that is likely to be used for sinful purposes. "For example, the smith will be sinning as an artist if he fails to make a sharp knife, but as a man if he makes one in order to commit murder, or for someone whom he *knows* intends to commit a murder."[54]

The moral judgment of the critic *post factum* corresponds in purpose to the moral judgment of the artist as citizen *ante factum*. If the citizen-artist is a moral and wise man his judgment will be confirmed by the critic's. However, in a Traditional community with its castes or orders in the hierarchy — as, for instance, in Plato's *Republic* — the artist or craftsman is not really expected to make the moral judgment independently; he is not an expert in morals, politics, and philosophy, and he therefore cannot make finally, with any kind of sureness, the judgment dictated by prudence.

It will be observed in one's study of Coomaraswamy that he is little concerned with morals when he discusses the place of art in a Traditional society. In a Traditional social order craftsmen cannot make what they please. Their intellectual or spiritual superiors who are putatively aware of the significance of the arts in the total economy of man's life will censor the products made.[55] They recognize, as the craftsman may not, that "it is our duty to refer all our acts to the last end. . . ."[56] And they will understand that "the practical arts are directed to the speculative arts, and every human operation, to intellectual speculation, as its end. Now, in all sciences and arts that are mutually ordered, the last end seems to belong to the one from which others take their rules and principles. . . . The knowledge of God is the last end of all human knowledge and activity."[57] On this theme one could cite copiously from Plato, St. Thomas Aquinas, and many others as Coomaraswamy does, but it is probably not necessary here. It will suffice to say again that the

119

moral and formal nature of works of art in a Traditional society are rigorously controlled.[58] Artists and craftsmen are not allowed to introduce innovations which, all unknown to them, may be factors contributing to decay. Poetry and music are so important in forming the bodies and minds of citizens that they must be closely supervised lest changes in their themes and forms subtly corrupt.[59]

A Traditional social order, however, is a complex system of compensations. If the artist is restricted in one sense — and this by his intellectual superior — he is given great opportunity to achieve freedom from himself and those passional, appetitive elements that constitute his nature in large part. If a man has a genuine vocation to his craft or art and lives under conditions that encourage him to exercise his powers subject to the rule of the highest part (in himself or in the community), one will not need to be much concerned with his morals. If a man is happily absorbed in his vocation, his morals will tend to take care of themselves. He is more likely to be a moral man if he has a vocation that permits him to harmonize the elements within him than if he is poorly employed but otherwise concerned with doing good and refraining from bad deeds. More important, he is much more likely to reach a higher state of perfection as a man. "Man reaches perfection (or success) by his loving devotion to his own work."[60]

The purpose of this new discussion of the place of the artist in a Traditional society is to make this point: the more an artist (or critic) is called by his natural endowments to practice a particular art and the more he is given to obeying the spiritual authority (whether in himself or from without), the better will be his work as an artist and the less sin he will incur or cause by his work. The converse of this is also true: the less an artist (or critic) is naturally called to practice his art and the less he obeys his superiors (within or without), the worse will be his work and the more sin it will cause.

�֍    �֍    ✖

As we have noted, there is, besides the judicious, still another function of the critic. Coomaraswamy does not much discuss this

peculiarly creative function of cooperating with the artists — often long dead and gone — to make their works more effective. He hints at it when he says that art museums should not only have curators, but more important, should also have docents to explain the works exhibited and generally to prepare patrons to respond fully to them.[61] Coomaraswamy's own critical practice in itself, however, best exemplifies this function of the critic; from it a clear theory and method can be deduced.

Coomaraswamy knows that "aesthetic contemplation cannot be taught," and that "all that can be done is to break down the barriers that stand in the way of realization."[62] These barriers, as we have seen, are effectively broken down by the great works of art. But oftentimes rootless modern men, highly literate and basically ignorant, simply cannot be reached by these works. The task of the critic then is to remove some of the outer barriers or to bring up the great works of art within effective range so that they can function properly. It has been said that there are always some men who have the capacity to be moved, delighted, and perfected in knowledge by works of art. And in an age when the Tradition declines and men become more concerned with emotions and aesthetic surfaces than with knowledge, it becomes especially necessary that critic-scholars like Coomaraswamy give some preparation — often not needed by persons of similar capacity when the works were executed — for initiation into the mysteries and manifold meanings of the Vedas, Brahmanas, Upanishads, and the writings of Plato, Plotinus, St. Augustine, Rūmī, Dante, Eckhart, and Blake — to name several representative works and writers of a Tradition dedicated to imparting principial knowledge.[63] A critic like Coomaraswamy makes our minds amenable to their idiom, symbolism, depths of meaning, and profound life-giving qualities. Not only by his fruitful method but by his revelations he can also make us aware of the richness of our own English literature, possibly in ways little suspected.

Coomaraswamy, as we have suggested, had a genuine vocation to this labor. He had the quality of reverence, the faculty for belief, the magnanimity that, coupled with an immense learning and

121

a profound intelligence insatiable for the truth, enabled him to divine the meaning of many works of art of diverse provenience. The erotic art of India, the many-limbed statues of the Gods, the dark sayings of Heraclitus, the meanings hidden behind the veil of the strange verses of Dante, the daring flights of Eckhart, the manic effusions of Nietzsche — all these and much more that has repelled a good many persons he approached with that characteristic courage and intelligence of the hero who discovers secrets hid from the generality of mankind. In the words of Plato, he was one of "Love's disciples" — as are all, in their way, who labor rightly at their natural vocation. He was given to quoting the words from Plato that very well fitted himself: "Do we not know that as regards the practice of the arts the man who has this God for his teacher will be renowned and as it were a beacon light, but one whom Love has not possest will be obscure?"[64] As he observes, this is the "'cosmic Love' that harmonizes opposite forces, the Love that acts for the sake of what it has and to beget itself, not the profane love that lacks and desires."[65] Because he had this love and was capable of such acts of self-renunciation and discipline, he writes in a manner to inspire trust, if not immediate credence and understanding.

To write thus about Coomaraswamy is not to indulge in eulogy, but to make yet another statement about the qualities needed by the great critic, here represented in the person of Coomaraswamy himself. If there is anything instructive in his practice of criticism, it is his willingness to understand; in this he is markedly different from the scholars and critics who do not perceive their own lack of competence and who persist in treating some of the greatest achievements of man's artistry in terms of their own limitations and prejudices.

Already we have glanced briefly at Coomaraswamy's method of literary criticism in our discussion of "Sir Gawain and the Green Knight: Indra and Namuci." If this essay were to be examined more closely — that is, read and studied carefully — one could form a clear idea of the manner in which the scholar-critic breaks down some of the barriers that stand in the way of the realization of the

deep significance of works that the ignorant and aesthetic reader, as Coomaraswamy would label him, cannot begin to comprehend, especially if he has had an ordinary education and lives according to some of the common values of our age. For variety, let us turn briefly to the examination of another critical study of his that is a model of method, "Two Passages in Dante's *Paradiso*." [66]

He begins by adducing evidence for his conception of the perennial metaphysics that underlies many of the manifestations of human culture. He writes thus:

It has now for some time been fully recognized that Islamic analogies are of singular value for a study of Dante's *Divina Commedia*, not only in connection with the basic form of the narrative, but as regards the methods by which the theses are communicated. And this would hold good, entirely apart from the consideration of any problems of "influence" that might be considered from the more restricted point of view of literary history. It has been justly remarked by Wolfson that the mediaeval Arabic, Hebrew, and Latin "philosophical literatures were in fact one philosophy expressed in different languages, translatable almost literally into one another." . . . Without going too far afield in time or space — and one could go at least as far as Sumeria and China — it will suffice for present purposes to say that what is affirmed by Wolfson for Arabic, Hebrew, and Latin, will be of equal validity if Sanskrit be added to the list. [67]

After observing that he has repeatedly pointed out the "remarkable doctrinal and even verbal equivalences that can be demonstrated in mediaeval Latin and Vedic Indian traditional literature," [68] he cites a few again briefly to reinforce his original intention and to reveal the method by which true analogies can be drawn. These he asserts are merely samples of many others of the same sort. In each case he cites canonical Christian sources and then the Hindu equivalent with a brevity and persuasiveness that makes each example quite convincing. Among others he discusses the following: the doctrine of Christ's two births, eternal and temporal; the simultaneity of beginning and end in creation; the definition of a personal as opposed to an animal nature; the doctrine that " 'He who is' is the principal of all names applied to God"; [69] the Immaculate Conception; creation *ex nihilo* and the knowledge of God which

is the cause of all things; sin; the corruptibility of things under the sun; the creation of woman from the first man's rib; the being of creatures which depends on the Being which is God. As he observes, "Singular parallels might be referred to 'coincidence' which is merely to substitute description for explanation. If, however, we believe with St. Augustine that 'nothing in the world happens by chance'[70] (a proposition with which the scientist will scarcely quarrel) three explanations (and only three) of repeated and exact 'coincidences' are possible: either (1) there must have been a borrowing on the part of the later source, or (2) a parallel development, or (3) derivation from a common anterior source."[71]

He notes that "the commonly accepted formula of the existence of a gulf dividing Europe from Asia is thus fallacious in this sense, that while there is a division, the dividing line is traceable not as between Europe and Asia normatively considered, but as between mediaeval Europe and Asia on the one hand, and modern Europe on the other: in general and in principle, whatever is true for mediaeval Europe will also be found to be true for Asia, and vice versa."[72] The doctrines of mediaeval Europe and Asia he considers, each in its way, orthodox. He does not presume borrowings or influences. "We maintain . . . the relative independence of the Christian Tradition at any one time, whether that of Dionysius or that of Dante, at the same time that we relate all orthodox teaching, of which the Vedic expression itself is merely a late expression, to one common and . . . ultimately superhuman source; the problems are not essentially, but only accidentally, problems of literary history."[73] Up to this point in the essay he has set forth his basic assumptions and cogently demonstrated the method he employs. He believes that this may be enough to convince the reader that "it may not be unreasonable to look in Sanskrit as well as in Islamic texts for parallels to or even explanations, but not necessarily sources, of particular idioms of thought employed by Dante, none of whose ideas are novel, though he clothes the traditional teaching in a vernacular form of incomparable splendor, *splendor veritatis*."[74] He then chooses to explicate by his established method two passages that have "presented particular diffi-

culties to commentators relying only on European sources." These passages, he knows, are only two among the many in Dante permitting the same kind of analysis.

Coomaraswamy's interpretations of past ages and his arguments we shall not analyze here. His argument is too complex and sparingly worded to summarize; quotation *in toto* would be necessary to develop it properly. (When Coomaraswamy writes in this manner — with precision and economy as well as exemplary clarity — one feels that his ideas are set forth with such authority and inevitability that there can be no other way of expressing them.)

The first passage ("Paradiso," XXVII, 136–38) reads as follows:

> Cosi si fa la pelle bianca nera —
> Nel primo aspetto — de la bella figlia
> Di quel ch' apporta mane e lascia sera.

The version of P. H. Wicksteed is included: "So blackeneth at the first aspect the white skin of his fair daughter who bringeth morn and leaveth evening." After discussing this passage which deals with the relationship of Dawn to the Sun he writes:

We have presented the tradition as to Dawn in some little detail in order to remind the reader how dangerous it is, in connection with writers of this calibre and with such preoccupations as are Dante's and Eckhart's, who are not belle-lettrists though each is the "father" of a language, to attribute to individual poetic invention or artistry what are really technical formulae and symbols with known connotations. At the very least, our Vedic citations suffice to give a consistent meaning to Dante's and Eckhart's words. Both of these are always aware of much more than they tell. . . . It must also be remembered that the illustration of Christian doctrine by means of pagan symbols was not only from the mediaeval point of view legitimate, but even persisted in permitted practice until comparatively modern times of which an example can be cited in the work of Calderon. It is not unreasonable then to suppose that both Eckhart and Dante were acquainted with traditional [doctrines], perhaps initiatory and only orally transmitted, or perhaps only not yet traced in extant documents . . .[75]

The second passage ("Paradiso," XVIII, 110–11) that he explains — "from Him cometh to the mind that power that is form unto the nests" — is treated in the same manner as the first and just

125

as convincingly reveals the significance of lines that seem to have puzzled commentators. He brings out their precise value and reveals the depths of meaning where others have found only trivialities just guessed at. He ends by saying,

We think that it has been shown that the references of an exponent of orthodox Christian principles, writing at the end of and as it were resuming all the doctrine of the Middle Ages, can actually be clarified by a comparison with those of scriptures that were current half the world away and three millenniums earlier in time; and that this can only be explained on the assumption that all these "alternative formulations of a common doctrine" (*dharma-paryāya*) are dialects of one and the same language of the spirit, branches on one and the same "universal and unanimous tradition," *sanātana dharma, philosophia perennis*, St. Augustine's "Wisdom uncreate, the same now as it ever was, and the same to be for evermore."[76]

This article makes us aware of several important features of the kind of criticism that Coomaraswamy practices. In the first place, we see that literary criticism, like all legitimate pursuits in the Traditional way of life, is here dedicated primarily to making essential truth manifest — the kind of truth that, we are told, will make men free. The truth is one, as Coomaraswamy believes, though its dialects are many. The dialects and all their accidental aspects as we see them in diverse works of literature are not important save as modes of expression to enable various peoples to understand. The tracing of influences, the citing of bare "parallels" (to demonstrate "coincidences" at best and the scholar's learning at worst), analysis of techniques more or less separate from meaning and the ultimate significance of the matter set forth, reconstruction of historical setting, and discussion of aesthetic reactions — all these common pursuits of scholar-critics Coomaraswamy considers to be of relatively little importance. From his point of view, for example, Shakespeare's treatment of the problem of order, degree, hierarchy as opposed to the chaos that reigns "when degree is shaked" can really be understood in all its profundity, not solely by considering actual influences on Shakespeare's thought, but by studying works on the traditional doctrine of kingship — e.g., *Spiritual Authority and Temporal Power in the Indian Theory of Government*, and

Guénon's *Autorité spirituelle et pouvoir temporel,* and the many works cited therein.[77] In the light of these and similar works Shakespeare might be seen to be one of the very greatest political thinkers in the English language, as true and important today as ever. To study Shakespeare's plays in this manner is not primarily to study Shakespeare's plays by themselves or in relation to their time but to be concerned primarily with the pursuit of the truth by which one can live.

In the second place, Coomaraswamy's method is useful in exploring the original and residual values of the traditional myths and symbols that are grounded on the very order of things.[78] Sometimes these symbols are only partially understood even by those who use them. Yet they retain some of their power, for, as Coomaraswamy remarks, "Every traditional symbol carries with it its original values, even when used or intended to be used in a more restricted sense."[79] This is not to impute intention to authors who use them without complete understanding; it is, however, to suggest that works that do employ traditional symbols more or less correctly can have a greater use for the knowing reader as a support for contemplation than they might otherwise be deemed to have.[80] Although we are all familiar to a certain extent with the symbolism of the sea, a quintessential study, such as Coomaraswamy's "The Sea," makes us aware of depth of meaning we never before considered. For instance, the grandeur of a small poem of Herrick, "Eternitie," is revealed in a manner that few have suspected. To study this slender piece in the light not only of the essay "The Sea" but also of Coomaraswamy's *Time and Eternity* in which it is quoted is to understand that a "minor poet" can write a great poem when he uses traditional symbols that are evocative of resonances that can enchant one's soul.

Coomaraswamy's study "On the Loathly Bride" enables us genuinely to understand the significance of the recurring "motive of the transformation of the Loathly Lady or Serpent into the Perfect Bride"; new dimensions, for instance, are added to the episode of the marriage of Sir Gawain, familiar at least through our reading of the Wife of Bath's tale. From Coomaraswamy then we can

127

get not only a greater understanding of traditional symbols and motifs that constantly appear in the history of Western literature, but we can also learn a method of exploring the enduring significance of those figures of speech that are figures of true thought.

Thirdly, Coomaraswamy demonstrates a cogent and persuasive means of settling some of the confusing problems of literary criticism. The citing of analogues and parallels is common practice, but it is seldom accomplished with the kind of precision employed by Coomaraswamy when he shows the exact equivalences in expression and thought that often exist whenever the perennial themes of mankind are treated in a manner that is even only somewhat Traditional. For instance, the late Professor William P. Dunn, a scholar who has written a fine book on the religious philosophy of Sir Thomas Browne, admits that he is somewhat puzzled by the symbol that Browne employs to express "his conviction that nature is the union between the creator and the created." Browne says that nature is "that straight and regular line, that settled and constant course the wisdom of God hath ordained the actions of his creatures, according to their several kinds."[81] This symbol of Traditional thought Coomaraswamy has several times discussed with reference to dozens of uses of it in many literatures. The passage concerning the symbolism of the line or string quoted above, his treatise, "The Iconography of Dürer's 'Knoten' and Leonardo's 'Concatenation,'" and other references in his work to the "Thread-Spirit" (sūtrātman) help to illuminate Browne's use of the Traditional figure of the line of nature.[82]

❊    ❊    ❊

One of Coomaraswamy's main contributions to a theory of literary criticism is his cogent apology for the perennial method of criticism that rigorously distinguishes art and prudence. In making his distinctions between the two types of judgments — according to the criteria of art and morals — he develops explicit formulae which the scrupulous critic can employ — or understand what it means when he cannot. More significant, it would seem, is his advocacy of the ideal that the study of literature (in its broadest

sense) can be a genuinely important activity of man and a means to his perfection. It is not a pursuit for aesthetes and academicians, each with his limited preoccupations and preciousness, and it is not a subject to be foisted upon students because of its alleged "cultural value." Coomaraswamy tries to make us realize that "man shall not live by bread alone, but by every word that proceedeth out of the mouth of God." The words from His mouth are to be found in many places and many dialects. They nourish, however, only when they are understood in their proper meaning. Among the scholar-critics of our day, Coomaraswamy ranks among the first in preparing men to live by the words of truth he labored so hard to explain.[83]

## VII

# Conclusion

*Two loves make up these two cities: love of God maketh Jerusalem,
love of the world maketh Babylon. Wherefore let each one question
himself as to what he loved; and he shall find of which he is a citi-
zen.* ST. AUGUSTINE

In this study we have attempted to compose a primer of
Traditional literary theory largely from the works of A. K. Cooma-
raswamy. The major aim of this undertaking has been to study
what Coomaraswamy has said and to achieve some measure of un-
derstanding of the great Tradition he resumes with such exemplary
rigor and learning in his works. That in itself is enough to tax the
powers of some of us. In fact, if one recalls the dictum of St. Bona-
ventura, which applies perfectly to the efforts of the epigoni really
to grasp the significance of what Coomaraswamy has said — "Who-
ever would understand the writings of Paul must become of his
mind" — he can either become aware of the difficulty of his task
or rejoice that he is thus relieved of a fruitless labor. Whatever the
degree of our understanding, there has been sketched out here the
perennial theory of literature which Coomaraswamy has set forth
with unusual authority in his works.

The study has been relatively superficial for a variety of reasons,
suggested in part above and for the rest not too hard to surmise.
Only a hint of the depth and breadth of Coomaraswamy's scholar-
ship, the power and precision of his method, and the grandeur of
his conceptions has been revealed here. Lapses into syncretism and
lack of exactness in distinguishing modes of discourse or defining
ideas are not to be attributed to Coomaraswamy, who seldom

nods. And even all the relevant material from Coomaraswamy has not been included by quotation or summary. Little effort has been made to cite other writers of the same orientation, except a few known and respected by Coomaraswamy; to do otherwise, in view of Coomaraswamy's learning, would be supererogatory if not impertinent. We have, likewise, made few references to modern scholars, critics, and writers whose thought resembles that of Coomaraswamy to a greater or lesser degree. Thorough studies would be needed if one were to determine from the Traditional point of view how orthodox, for instance, are the literary theories of Milton, Goethe, Blake, Coleridge, T. S. Eliot, and any others, including our contemporaries, whom one would choose to examine.

There is yet another relevant and commonly discussed topic in Coomaraswamy's writings that has barely been suggested. Throughout his works he contrasts the perennial doctrine on a number of issues with the modern (post-Renaissance) view. His comments — frequently, strictures — on modern art and literature might help to clarify the perennial doctrine, but they have been left out in an effort to set down straightforwardly his theory of literature, difficult enough in itself to accept even provisionally for purposes of understanding, without introducing observations and criticism that might alienate and seem invidious. This is not to suggest that Coomaraswamy's view of modern art and literature is wrong. Indeed, so far as one understands and accepts Traditional doctrines, he will see that Coomaraswamy's judgments are generally just. He will become aware that, however much the world process requires the manifold offenses of modern art, he can and should eschew all those works that exacerbate the disorder of our souls.

After having written this much, we should probably try to assess the value of Coomaraswamy's theory of literature. Suggestions of its worth appear throughout. We can, however, recapitulate and explore briefly the fruitfulness of his doctrines. In the first place, Coomaraswamy's theory of literature (coherent as it is with the Philosophia Perennis) reveals the amazing unanimity of thought throughout the world concerning the arts. There has been discov-

ered in Coomaraswamy's works a perennial doctrine of art that has persisted for millennia, subscribed to by millions of men unknown to us, as well as by many of the greatest philosophers and artists of the race. For those who respect the greatness of the Buddha, Śankarâcārya, Plato, Aristotle, Plotinus, Dante, St. Thomas Aquinas, Eckhart, and Blake, for example, and revere some, at least, of the scriptures and myths of mankind, Coomaraswamy's thought may well seem invested with authority, rigor, and great explanatory power. And those who are conscious that the writings of many of the moderns do not speak to their condition satisfactorily can look to the thought of this scholar, who lived little known in America for thirty years, for the promise suggested in his own words: "When the salt of the 'established church' has lost its savour, it is rather from without than from within that its life shall be renewed."[1] Bringing the life-giving boons associated with the inspired stranger of myth and folk tale, Coomaraswamy not only opens up the riches of the world's literature that many may not have suspected, but he also gives us another perspective by which to look on "English literature as a road to wisdom."[2]

Secondly, as has been suggested, he has set forth a polar doctrine of the arts. This polar position may serve its uses in defining the hemisphere of discourse, so to speak, and the metaphysical axis of various theories of literature that are now current. There are a number of capable critics these days who appear to inhabit somewhat the same environment as Coomaraswamy, though most do not approach very nearly the polar fastnesses where he dwells. The usefulness of Coomaraswamy's theory *vis à vis* theirs may be to induce them to explore further some of the implications of their thought, to push certain of their ideas to possibly unsuspected conclusions, and especially to examine their own metaphysical presuppositions anew in the light of perennial doctrine. Against the model of Coomaraswamy's theory and method they could possibly test and true their own ideas.[3] There is probably slight indication that critics would welcome Coomaraswamy's thought for the service here suggested. Most well-educated modern scholars with a considerable mastery of the thought of modern Europe are not likely

to jettison this learning for the ancient wisdom Coomaraswamy purveys. The climate of his thought is as inhospitable in its way as the climate of the terrestrial poles, and it is likely that what Rabelais says of Plato will hold true for Coomaraswamy also: "Antiphanes compared Plato's philosophy to words spoken in some arctic country during a hard winter: no sooner spoken, they froze up and congealed in the chill air, without ever being heard."[4]

Thirdly, Coomaraswamy's theory has considerable power, as we have already seen, to illuminate some of the issues that concern contemporary critics. For instance, every one of the many topics included in *The Critic's Notebook* (a composite of quotations from modern critics), edited by Robert Wooster Stallman, is treated by Coomaraswamy; furthermore, Coomaraswamy's pronouncements are supported by his usual authorities, who may be able to clarify some of the issues by their characteristic emphases and insights. Almost at random one familiar with the history of English literature could think of many subjects and problems, besides those explicitly discussed in this study, that might be clarified by use of the comprehensive doctrine epitomized in Coomaraswamy's work. Here are a few: the seventeenth-century "dissociation of sensibility"; the Traditional metaphysical bases of Blake's thought and the precise value of his symbols so often misunderstood and unconvincingly interpreted; the concern with "nature," which was discovered around the seventeenth century and which preoccupied the minds of men increasingly in subsequent centuries; the equation of Beauty and Truth; the effect of universal literacy on literature; naturalism as a world-view and a technique; the Romantic theory of the "imagination"; the alienation of the artist; "originality" as a literary motive; the precise nature of "genius"; the importance of natural endowments (vocation) for the writer; the concept of "incantation" in poetry, and many others. For example, Keats's perceptive observation that the thought evoked by a poem should come, as it were, as a remembrance could be explained at length in terms of the theory of reminiscence that is ably treated by Coomaraswamy in his "Recollection, Indian and Platonic." And Thomas Carlyle's notion that the symbolic function of language is

133

to embody and reveal the infinite is amenable to considerable elaboration if one resorts to the precise formulations of Coomaraswamy concerning this concept. Essays on "courtly love" and "the cosmic dance" in other traditions, for example, because they are so reverently and learnedly handled, could possibly deepen one's understanding of the true substance of these motifs in English literature. Coomaraswamy's comment that William Morris will be the only English poet of the nineteenth century who will be valid five hundred years hence might send us to this poet's works with added appreciation.[5] To read Morris's *Sigurd the Volsung* aloud is possibly to realize that here is one of the very greatest literary epics in English or any other language; the peculiar effectiveness of Morris's language, his long line, and his sure handling of mythical motifs might make one aware of the essential justice of Coomaraswamy's remark. There are few long poems more moving. The sense of fatality that hangs over the heroic characters in a manner reminiscent of the *Mahābhārata*, the *Iliad, Beowulf*, and *Morte Darthur* gives it a power to exalt one as few works can.

Fourthly, it can be noted that Coomaraswamy's example could well have a benign effect upon graduate studies, which need to be rescued from the vanity, pedantry, and aestheticism that beset them. Lastly, we can observe that writers could learn from Coomaraswamy their responsibilities to a venerable Tradition and the immense demands this makes upon them. Even those lacking in energy and intelligence might gain considerable efficacy if they submitted themselves to the discipline and learning of the Tradition. When all is considered, however, there is little indication that many persons will profit from Coomaraswamy's examples or labors. At best, a few who are discriminating will maintain a seemly silence where before they might have written freely. At worst, Traditional ideas and symbols picked up from Coomaraswamy will be trampled under foot or exploited for trivial or malign purposes.

✵   ✵   ✵

For purposes of illustration let us examine a literary problem of some concern to critics these days — tragic katharsis — in an effort

to demonstrate the fruitfulness of Coomaraswamy's thought in clarifying issues that have aroused a good deal of speculation. With few specific citations we shall sketch out in general terms yet another theory of katharsis, scarcely exceptional except so far as it incorporates certain features of the doctrines to which Coomaraswamy subscribes.

It is the perennial doctrine of the two selves in man — the one, mortal, suffering, driven in "the storm of the world's flow" (Eckhart) and the other, the witness of life, immortal, serene, omniscient — that can provide a key to understanding the undoubted effectiveness of high tragedy in purifying man and in exalting him above his usual condition. Although we could consult dozens of passages in Coomaraswamy for a statement of this doctrine, let us turn again to one of his respected sources — the *Muṇḍaka Upanishad* — which embodies a most striking statement of the nature of the two selves and affirms the recognition of the Great Companion within as the supreme deliverance.

> Two birds, fast bound companions,
> Clasp close the self-same tree.
> Of these two, the one eats sweet fruit;
> The other looks on without eating.
>
> On the self-same tree a person, sunken,
> Grieves for his impotence, deluded;
> When he sees the other, the Lord, contented
> And his greatness, he becomes freed from sorrow.
>
> When a seer sees the brilliant
> Maker, Lord, Person, the Brahma-source,
> Then, being a knower, shaking off good and evil,
> Stainless, he attains supreme identity with Him.[6]

And since it is to Plato that we will go for a good part of this brief apology for tragedy, we can quote a few of Coomaraswamy's many apposite citations from Plato that allude to the doctrine of the two souls — mortal and immortal. Coomaraswamy says that the Immortal Soul mentioned in the *Timaeus* (69D, 90A–C) and the *Republic* (430, 604B) is the "real Self" of *Laws* (959B). Noting the "almost identical" formulations in the *Bhagavad Gītā* and the *Meno* Coo-

maraswamy quotes from the latter, "the Soul of Man is immortal and at one time reaches an end, which is called 'dying' and is 'born again,' but is never slain. . . . In the same way *Phaedo* (83B, C) 'the Self of (all) beings' (αὐτὸ τῶν ὄντων) and 'Soul of every Man' (ψυχὴ παντὸς ἀνθρώπου . . .) corresponds to the 'Self of all beings,' . . . in the Upaniṣads." He translates from the *Phaedo* (83B), "Philosophy . . . admonishing the soul to collect and assemble herself in her Self, and to trow in nothing but her Self, that she may know her Self itself, the Self of (all) beings."[7] More could be added, but only to corroborate the doctrine of the two selves found throughout Plato, as well as in other writers in the Tradition.

As has been observed, Coomaraswamy's suggestive analysis of mythical and religious rites is posited upon this doctrine of the two-fold nature of man. Rites are usually sacrifices. The participant in one of the archetypal rites commits ritual suicide or otherwise sacrifices himself; he slays or abandons, temporarily at least, his identity as an individual to become, so far as he is able, that higher being — God or Hero — whose actions he imitates. After the rite is over, he returns to his ordinary condition, though possibly much uplifted by his imitation of divine actions. Coomaraswamy recognizes that the great Traditional rites, which enact the primordial myths, are among mankind's most efficacious means for self-transcendence and self-realization. In the light of the Traditional doctrine of man's final end, works of art — literary as well as others — are deemed useful to the extent that they enable a man truly to know himself — or, as Coomaraswamy says, to lose or to find himself, these being the same.

High tragedy in Western civilization has long been acclaimed one of the grandest types of literary achievement, noble in form, profoundly moving, and peculiarly satisfying psychologically. Greek tragedy, it has been said, was developed from religious rites. Certainly the Greek tragedies of the fifth century B.C. were performed as part of a religious festival. During an age that saw the decline of the old religion, the rise of materialism, skepticism, and the commercial spirit, Greek tragedies — especially those of Aeschylus and Sophocles — seem in many ways to be exoteric, possibly

secular, rites; they effect in their way the ritual death, purification, and rebirth of men as religious rites do. (It is interesting to observe, as others have, that Elizabethan tragedy flourished in a similar period — at a time when the purifying sacraments of the church were being abandoned, in letter as well as in spirit. It seems as if men in the Elizabethan and Jacobean age were prompted to attempt to restore some kind of wholesomeness and stability to the psychological economy of mankind. Similarly the magnificent outward flowering of the High Middle Ages — the great Gothic cathedrals, the poetry of Dante, and the incandescent thought of Eckhart — seems to represent an earlier attempt of the forces of the Spirit to arrest the decline of spirituality in Europe. Some believe that if man is not somehow purified and renewed by rites and sacraments he often finds himself, for all his rationality, more and more possessed by the dark elements within him. Euripides' *Bacchae*, for example, lends credence to this idea most powerfully.)

Tragedy as a secular rite has been long recognized to have much the same function as sacred rites. Accepting this theory, let us examine the effect of tragedy upon the spectators. For the purposes of this excursus it may be economical as well as effective to rely mainly upon Plato and Aristotle, whose thought is quite relevant to the subject.

Now Plato, it is well known, banished the tragic poets from his ideal state. He does, however, admit that if dramatic poetry "can show good reason why it should exist in a well-governed society" (*Republic* 606, Cornford's translation), he will welcome it back. Although Plato may ultimately be justified in his proscription of the poets from a social order dedicated to the perfection of its members, one can make an excellent case for tragedy — in principle, at least — largely in Plato's own terms. First, one must recall that the primary theme of Plato's philosophy is autology, for he was concerned always with the achievement of that principial knowledge that is indistinguishable from being. Rites, in their way, seek to reaffirm the true being of man also. One can then argue that high tragedy as a kind of rite can possibly serve the same purpose.

Plato is aware that much poetry, tragedy included, arouses in

man those emotions that he had better learn to master rather than to indulge; each indulgence, whether at the spectacle of another's suffering or that of himself, has often the effect of exercising and reinforcing the resistance of man's affective parts to the rule of the intellect, the Godlike part within him. However, unless man wishes to blink the knowledge that sin and suffering exist in the world, he must learn to understand them as they are. And unless he wishes to live in ignorance of his mortal condition, he must somehow become aware of what he is. The injunction "know thyself" refers clearly to both selves.[8] Now Plato has noted that the good man dreams of what the bad man does; he recognizes in most men the presence of a source of sinful impulses beneath the level of consciousness.

If one is truly to know himself as he is, he must become aware of those untamed elements within him. One of the explicit requirements for the philosopher-king, the perfected man, is that he have no secret corner of illiberality left in him. Few themes are more persistent in Plato's work than the ignorance of man concerning himself and others; Plato was well aware of the evil that merely "good" — and ignorant — men can do. If it can be shown that a tragedy, for instance, could elicit certain undesirable emotions within man for a better purpose than mere indulgence, this might afford an occasion for considerable self-knowledge. A tragedy, by its very resemblance to a rite, can give such an occasion, though possibly not so effectively.

It is commonly accepted that one of the characteristics of tragedy viewed in the theater is its power to implicate the members of the audience in the action; we tend to identify ourselves by empathy with some or most of the characters. Identifying ourselves in part with them, we live and suffer, in a manner, as they do. But our favored position as spectators also enables us to stand above the characters with whom we have identified ourselves. We rise above the passional elements of life, which are probably in us to the extent that we are moved by the spectacle of them. If we are moved by pity and fear as spectators — to borrow from Aristotle's pertinent analysis — we are in an advantageous position to realize what the

presence of these emotions within us means. This is to know oneself in part.

Spectators of a Greek tragedy generally knew the plot of the story enacted before them; this held true also for most of the Elizabethan audience. In any case, the tragic setting and atmosphere with the specific expectations it arouses is unmistakable in both the Greek and Elizabethan theaters. The spectators would pretty well know what will happen to the characters. And the very nature of the enactment would lead them to identify themselves with some of the characters, to live and suffer with them. Simultaneously they would live *in* the characters and *above* them. They would experience the inexorable thrust of fate, which rules all things, as they do not in their ordinary life with its illusion of a certain kind of freedom. Empathically involved with the unwitting characters, they would yet be aware of what was going to happen. Foreknowing the disastrous consequence of the acts of those they identify themselves with, they would still be thrust on by the action to do, against their better judgment and will as rational beings, those very things that will insure their unhappiness. For as Aristotle says, "All terrible things are more terrible if they give us no chance of retrieving a blunder." In terms of the Aristotelian analysis, the audience will feel fear ("associated with the expectation that something destructive will happen to us")[9] and pity ("a feeling of pain caused by the sight of some evil, destructive or painful, which befalls one who does not deserve it, and which we might expect . . . to befall us soon")[10] but the nightmare realization of these emotions will be only partial. Another element in the spectators will brood, godlike and serene, over the spectacle. Goethe writes about the *Oresteia* of Aeschylus: "More than ever the web of this primeval tapestry makes me marvel. Past, present, and future are so felicitously interwoven that in beholding it you become a seer yourself —that is to say, one akin to God. And that, when all is said and done, is the ultimate triumph of poetry, covering its whole range."[11] Coomaraswamy observes, "Impartiality . . . is a subjective state of patience or detachment, as of one who looks upon whatever

139

pleasant or unpleasant things befall himself as one might look upon a play, present at but not involved in the hero's predicaments."[12]

As the "word of God is quick, and powerful, and sharper than a two-edged sword, piercing even to the dividing asunder of soul and spirit" (Heb. 4:12) — the mortal and immortal selves — so the emotional and intellectual impact of high tragedy tends to separate the soul (involved inexorably in the action) from the Spirit (or Intellect) that is above the conflict, impassible and serene. Associating ourselves with the characters of the tragedy, we are driven on to suffer and die, and as spectators we live untouched. In suffering we learn wisdom.

The "separation" of the soul from the body is what Plato calls katharsis or purification.[13] The philosophical enterprise is devoted to solving the problem of death, to knowing the Self, and to freeing the immortal soul from involvement in the body. The ritualistic death that we experience at a tragedy is a mimetic rehearsal of our death which the Fates have already determined; we are poignantly aware that we can die because we *do* die as the characters with whom we identify ourselves. And always our triumph over death — and an intimation of our true nature — is asserted by our continued serene existence throughout the action and after the close. Thus by participating in the tragedy, we face the problem of death and solve it by understanding that to our immortal part death is no more than life. We rehearse the death of the mortal part and we get a prescience of the good that is the end of our existence when we can, if we are perfected, become spectators of all time and existence.[14]

We learn the truth of Seneca's "Fate leads the willing and drags the unwilling"; for as long as we live with the characters who are forced by the myth to act as our foreknowledge might prevent us from acting, we understand how fate (destiny, nature, necessity) dictates the course of the psychophysical elements of our being. We learn acquiescence to fate. And we rise above the compulsions of necessity in our better part. As Plato observes, "The soul in her totality has the care of inanimate being everywhere and traverses the whole heaven in divers forms appearing — when perfect and

fully winged she soars upward and orders the whole world."[15] The Self of all selves within is the very principle that orders the universe. In the coincidence of will and knowledge that we can experience in the presence of great tragedy, we too understand what it is to know what will happen and to will it; we, accepting and exultant, order the action taking place before us. In the presence of tragedy we are afforded the occasion for transcending and forgetting our mortal self in the world, and we can receive there some intimation of the way in which that other Self views the play of existence.

This sketch contains nothing very remarkable, save possibly the introduction of the perennial doctrine of the two selves within man. It does, however, give a Traditional account of katharsis and the not uncommon ecstatic experience of men in the presence of high tragedy.

From Plato alone could be adduced much more evidence for the validity of the theory briefly adumbrated here. And if one included other sources — ancient as well as modern — he could develop a cogent and lengthy case for this view. From the works of Coomaraswamy alone one could draw an enormous amount of material in support of it; the essays which deal with the dual nature of man, the determinism of nature, recollection, the world as God's play, rites and ceremonies, autology as the end of man, aesthetic shock, katharsis, and the like, could well be consulted.

(It should probably be noted here that the defense of tragedy more or less in Plato's own terms may well be specious. Plato would doubtless object to our ever identifying ourselves with suffering tragic heroes; he would probably demand that if we are to identify ourselves in ritual mimesis with anyone, it should be the Gods and Heroes in whose character we could be raised above our mortal condition without being further immersed in it. However, if an argument for tragedy were to be advanced in rebuttal of Plato, it would probably need to be in the terms suggested here.)

This analysis of tragic katharsis has been undertaken mainly to show that to examine many critical problems from the vantage point of Coomaraswamy's thought is to see them in a new light, if

141

not more clearly and as a whole. Others can no doubt perform this service, but Coomaraswamy's advocacy of the Traditional doctrines and his characteristic use of analogies from other literatures enhance his ability to perceive ideas often little divined in familiar formulations.

❧　　❧　　❧

If these lucubrations prove anything conclusively, it may be the soundness of Mr. Murray Fowler's remark: "To interpret the thoughts of another is inevitably to court error. Happily what Coomaraswamy has said needs no mediator. . . ."[16] The interpretation and mediation performed herein are doubtless somewhat awry. Such functions, however, were not the most important ones of this study. We said at the outset that the only way out of the confusions of Babel is to learn once more "the one language" that prevails before the curse is laid upon men. Our intention then was to set forth a provocative portion of the vocabulary, grammar, and syntax of this "language" in a simple form and with especial reference to a Traditional theory of literature. The copious quotations, a handful from the great treasure amassed by Coomaraswamy, by themselves should very nearly justify the undertaking.

On the evidence of this effort there will be few to cry, "Babylon is fallen, is fallen." We can hope that here and there a person will be led to seek Coomaraswamy's works in the proper spirit. Among many, however, there will be the suspicion that Babel has not so much been razed to the ground as raised to greater heights. There is doubtless some truth in this suspicion. It is not that Coomaraswamy does not write in a pre-Babylonian tongue, nor is it solely that we have done him and his cause a disservice here by meddling with his works. It is rather that his clear words have been — and will continue to be — adopted by those aberrants who see themselves as Traditional thinkers, artists, and perfected men beyond the law without ever having submitted themselves to the style of a declined tradition, much less to the discipline of the perennial Tradition. The impious and poverty-stricken crew who rifle ancient temples for experiences and modish esoterica, who court "self-

realization" in abandoned sanctuaries, who surrender themselves to infernal forces under the guise of metaphysics and mysticism — these will doubtless throw the words of Traditional doctrine, so precisely and nobly set down by Coomaraswamy, into the universal murmuring. Indeed, this is all that most of us can do in this age of the Flight. As Max Picard has put it:

Since in the language of the Flight there is no articulation, speech becomes indistinct; one no longer knows where one word begins and another ends. Everything blends into one vast murmuring, existing before man has begun to speak and going on after he has ceased to speak. It is not so in the world of Faith, where the springing up of a word out of silence is in itself an act; but here, in the language of the Flight, there is no longer an interval between the silence and the word; there is no longer the risk of the leap from silence into the word; both are dissolved into the murmuring. To make poetry is no longer to make the silence sound, but to reduce mere talk to a murmuring. One can hurl everything into this murmuring; everything comes to resemble it. In this language man can dare to express the most dangerous things, for in the murmuring they look just like the most innocent; the new resembles the old, all things have already been murmured in the distant past, everything becomes stale.

Within this murmuring, where one thing can no longer be distinguished from another, there is no longer the possibility of a decision. Everything has been decided, for everything is dissolved in the murmuring. But in the world of Faith that which constitutes the honor and dignity of speech is this: that in speech man makes his decision.[17]

The greatness of Coomaraswamy is that he, living in the deathless age of Faith, has made his decision to speak with utmost purity and precision the languages of the Primal Word. If we are able to heed what he has to say, we may hopefully abandon the speech and attitude of the Flight.

And if we do escape from the Flight for a moment we might receive a revealing intimation from these lines:

> For we are but of yesterday, and know nothing,
> Because our days upon earth are a shadow:
> Shall not they teach thee and tell thee,
> And utter words out of their heart?

Then we who comprehend in part the precariousness of our condition and the shadowiness of our existence may turn to those who transmit the saving forms and noble style with which the Traditional man in all ages plays out his life in the world. And if we know that we know nothing we might hearken to the words spoken out of the heart of the great writers and thinkers of the universal Tradition. Although "literature" has a minor place in a Traditional society because of its relative lack of efficacy in ordering life, it nonetheless may have greater use in a profane age in which rites and arts are much declined. Even because many of us read so much and are so replete with ideas, opinions, and fancies generated by the many words we encounter that we approach satiety without satisfaction, we must continue to search for other words that in some measure appease that natural hunger for knowledge that drives men. Clearly we who read ought to choose those works that not only remind us of our actual condition and ultimate destiny but also provide means for the relief of the one and the realization of the other. To teach us and to tell us what and how to read few can do better than Ananda Coomaraswamy. After receiving from the study of his works a truly liberal education, one can turn to Plato, Dante, Eckhart, Shakespeare, Milton, and a great host of equal and lesser figures, as well as to Holy Writ, with an enhanced understanding that will perceive saving truths overlooked before.

Now, the final word does not come from Bildad, the friend of Job, who knows that "we are but of yesterday," nor does it come from Coomaraswamy or any Traditionalist, be he Plato, St. Thomas Aquinas, Dante, or René Guénon. The last word, as well as the first and only Word, comes from Him who reveals himself as He wills. To Job, who penetrated into the quiet eye of the whirlwind, was revealed the numinous presence which impoverishes all words. We who seek the stillness of the center need strength and guidance to withstand "the storm of the world's flow." In some part we can get this from those who transmit to the ages of men the perennial wisdom. Against the day of the gathering of the nations when all the earth will be devoured with the fire of His jealousy, and He

will turn to the people a "pure language that they may call upon the name of the Lord" (Zeph. 3:8–9), let us then hearken to whomever speaks in any dialect the "one language" that resounds with "the wisdom that is not created, that is as it has ever been and so shall be forever."

Now preye I to hem alle that herkne this litel tretys or rede that, if ther be any thing in it that liketh hem, that therof they thanken oure Lord Jesu Crist, of whom precedeth al wit and al goodnesse. And if ther be any thing that displese hem, I preye hem also that they arrette it to the defaute of myn unkonninge and nat to my wil, that wolde fayn have seyd bettre if I hadde had konninge. For oure Book seith, "Al that is writen is writen for our doctrine," and that is myn entente.                                                                *Chaucer*

*APPENDIX AND ABBREVIATIONS* ❊   ❊   ❊

# A Brief Life of Ananda Coomaraswamy

Ananda Kentish Coomaraswamy came from a distinguished family in Ceylon. His father was Mutu Coomaraswamy Mudaliar, who had the distinction of being the first Asian knighted by the English monarchy and the first Hindu to be called to the bar in England. In the reign of Queen Victoria (1863) he was admitted as a barrister of one of the Inns of Court. In 1876 Sir Mutu married Elizabeth Clay Beeby, an Englishwoman. Their only child was Ananda, who was born in Ceylon on August 22, 1877. When Ananda's mother became ill, he left Ceylon with her in 1878 to go to England. His father was to have followed shortly; but he, too, became ill and died in Ceylon in 1879, without seeing his son again.

Ananda Coomaraswamy was reared in England by his mother. At the age of twelve he went to Wycliffe College at Stonehouse in Gloucestershire where he remained for more than six years. Later he attended the University of London from which he received the degree of Bachelor of Science with First Class Honors in Geology and Botany. From 1903 to 1906 he rendered his first important public service when he returned to Ceylon to direct the first mineralogical survey of the country. During this survey he discovered a mineral of high specific gravity which he named thorianite. Important for his later development were his experiences at this period that led to an awakening interest in the arts and crafts of India and Ceylon and his growing concern with the problems of Indian nationalism.

In 1906 he received his doctorate in geology from the University

of London. The next ten years were spent, as far as one can tell, largely in England and India. His activities in India, where he is still remembered for his important contributions to the cause of nationalism, were in part political. By his writing, speaking, and other labors he did much to revive the faith of Indians in the greatness of their heritage. In 1910 he made an extended tour of northern India to gather a great quantity of paintings and drawings. In this year and the following he was in charge of the art section of the United Provinces Exhibits in Allahabad.

During all these years he published copiously, although not with the volume of his later life. Besides the early articles on geology, he wrote many essays and books on the arts, crafts, and politics of India and Ceylon, two of the most important being his *Mediaeval Sinhalese Art* (1908) and *Essays in National Idealism* (1909). In addition, he engaged in enterprises such as the following: he collected Indian songs of the Punjab and Kashmir; he translated the *Völuspa* out of the Icelandic of the *Elder Edda*; he compiled with Sister Nivedita (Margaret Noble) of the Ramkrishna Order the myths of the Hindus and Buddhists; he translated with Mirza Y. Dawud the *Suz-a-Gudaz* of Mohammad Riza Nau'i; he wrote a study of Buddhism, *Buddha and the Gospel of Buddhism* (London, 1916), still highly regarded.

In 1917 Coomaraswamy came to America to become Keeper of Indian Art in the Boston Museum of Fine Arts. He remained in the museum in much the same capacity for the rest of his life. He gathered there one of the greatest collections of Indian art outside of India. As time went by he turned away from his curatorial duties, more and more devoting his energies to study and writing. He refused promotion with its added cares and generally took a cavalier attitude toward the objects in his keeping and the whole enterprise of the museum. The last twenty years of his life were enormously productive. According to one bibliography (admittedly incomplete) published in *Ars Islamica* (Vol. IX, 1942), he published between 1917 and 1943 a total of 341 books and articles plus 40 book reviews. During these years he lectured frequently and carried on a large correspondence. Although he drove

himself so hard that he was in later years nearly always fatigued from his efforts, he was never so busy, it seemed, as to be unable to answer serious inquiries that came to him through the mail; with visitors to the museum he was generous in time and effort.

In 1948 he was to have resigned from the museum and leave for a hermitage in the Himalayas. On September 9, 1947, he died at his home in Needham, Massachusetts. He left behind the manuscripts of several completed works, one of which was "The Riddle of the Greek Sphinx." Although he had longed to be released from his labors, he had nevertheless continued until the end to project works that would have taken, as he once observed, a hundred years to complete.

# *Abbreviations*

*BL.: The Bugbear of Literacy*
*El.: Elements of Buddhist Iconography*
*Fig.: Figures of Speech or Figures of Thought*
*H. and B.: Hinduism and Buddhism*
"Rec.": "Recollection, Indian and Platonic"
"Relig. Basis": "The Religious Basis of the Forms of Indian So-
ciety," in *East and West and Other Essays*
"Sir G.": "Sir Gawain and the Green Knight: Indra and Namuci"
*Sp.A.: Spiritual Authority and Temporal Power in the Indian Theo-
ry of Government*
*Trans.: The Transformation of Nature in Art*
"Two Passages": "Two Passages in Dante's *Paradiso*"
*Why: Why Exhibit Works of Art?*

Works by Others

*Crisis:* René Guénon, *Crisis of the Modern World*
Curtius: Ernst Robert Curtius, *European Literature and the Latin
Middle Ages*
Eckhart: Pfeiffer (ed), *Meister Eckhart*, Vols. I and II.
*Hom.:* S. Durai Raja Singam (ed), *Homage to Ananda K. Coo-
maraswamy*
*IHD.:* René Guénon, *Introduction to the Study of Hindu Doctrines*
Keynes: Geoffrey Keynes (ed), *Blake's Poetry and Prose*
*Sp.P.:* Frithjof Schuon, *Spiritual Perspectives and Human Facts*
*TUR.:* Frithjof Schuon, *The Transcendent Unity of Religions*

*NOTES AND GLOSSARY*　✾　✾　✾

# *Notes*

The notes are generally arranged in groups of ten to keep the many brief references from adding unduly to the length of this work. The name of Ananda K. Coomaraswamy is sometimes abbreviated AKC.

## CHAPTER I. PROLOGUE

[1] Elder Olson, "An Outline of Poetic Theory," *Critics and Criticism* (abridged), R. S. Crane (ed), Chicago, 1957, p. 3. [2] "The metaphysical doctrine of universal language is . . . by no means to be thought of as asserting that a universal language was ever actually spoken by any people under the sun; the metaphysical concept of a universal speech is in fact the conception of a single sound, not that of groups of sounds to be uttered in succession, which is what we mean when we speak of 'a spoken language.'" AKC, "Nirukta = Hermeneia," *Viśva-Bharati Quarterly*, August 1936, p. 16. [3] Ananda K. Coomaraswamy observes, "The myth is always true (or else is no true myth). . . ." (*Figures of Speech or Figures of Thought*, London, 1946, p. 119. Hereafter cited as *Fig.*) [4] ". . . the scriptural style [is] always (as Clement of Alexandria remarks) 'parabolic'" (*Fig.* 121). [5] Cf. Heraclitus, *Frag.* 2. [6] ". . . if Ultimate Truth is one and only, the language of Truth necessarily consists of many dialects, adapted to the needs of different races and individuals. . . ." Marco Pallis in Foreword to René Guénon, *Introduction to the Study of the Hindu Doctrines*, London, 1945, p. 10 (hereafter cited as *IHD*). In *Time and Eternity*, p. 59, AKC quotes Wilbur M. Urban, *The Intelligible World*, New York, 1929, p. 471, "The metaphysical idiom of the Great Tradition is the only language that *is* really intelligible." [7] Throughout this work metaphysics and philosophy will be distinguished according to the formula of Frithjof Schuon, "What essentially distinguishes the metaphysical from the philosophical proposition is that the former is symbolic and descriptive, in the sense that it makes use of rational modes as symbols to describe or translate knowledge possessing a greater degree of certainty than any knowledge of a sensible order, whereas philosophy . . . is never anything more than what it expresses." (*The Transcendent Unity of Religions*, New York, 1953, p. 11. Hereafter cited as *TUR*.) [8] "All our sources are conscious of the fundamental identity of all the arts" (*Fig.* 11). [9] Although their differences may seem to be more striking to many than their similarities, AKC views thinkers like these as being in essential agreement. He respects them all as important representatives of the Perennial Tradition.

[10] V. Appendix A above. [11] V. esp. *Homage to Ananda K. Coomaraswamy*

155

(Part I – A 70th Birthday Volume, 1947, and Part II – A Memorial Volume, 1952), S. Durai Raja Singam (ed), Kuala Lumpur, Malaya, and the *Festschrift* volume, *Art and Thought*, K. Bharatha Iyer (ed), London, 1948. Also of interest is Gai Eaton, *The Richest Vein: Eastern Tradition and Modern Thought*, London, 1949, esp. Chap. 10, "Two Traditionalists." In view of the high praise tendered AKC in these works, it has not seemed necessary to justify some of the superlatives applied to him herein; all could easily be documented. [12] Quoted in *Homage to Ananda Coomaraswamy*, Part II, S. Durai Raja Singam (ed), n.p., 1952, p. iv (hereafter cited as *Hom.*). [13] Ananda K. Coomaraswamy, "Dr. Coomaraswamy's Talk at His Boston Dinner," *Journal of the Indian Society of Oriental Art*, Vol. XV, 1947, A. K. Coomaraswamy Commemoration Volume, Part I, p. 11. [14] AKC, *The Bugbear of Literacy*, London, 1949, p. 42 (hereafter cited as *BL.*). [15] *Das verlorene Paradies*, Munich, 1938, cited in *Fig.* 122. [16] From an article in *Zalmoxis*, II, 78, quoted in AKC, "Sir Gawain and the Green Knight: Indra and Namuci," *Speculum*, Vol. XIX, January 1944, p. 21. (Hereafter this article will be cited as "Sir G.") [17] *Fig.* 218. V. an interesting criticism from the Traditional point of view of scholars like Frazer in Mircea Eleade, *Images et Symboles*, Paris, 1952, pp. 231–35. [18] AKC, "The Religious Basis of the Forms of Indian Culture" (an address to the Students' Religious Association, Ann Arbor, January 1946), reprinted in AKC, *East and West and Other Essays*, Colombo, Ceylon, n.d. (hereafter cited as "Relig. Basis"). [19] In the West from Heraclitus on ("Most of what is divine escapes recognition through unbelief," *Frag.* 86) the importance of belief for understanding has been emphasized by Traditional thinkers. Cf. Isa. 7:9.

[20] Quoted from *Ātmā-Bodha* in *IHD.* 283. [21] *Meister Eckhart*, Franz Pfeiffer (ed), C. de B. Evans (trans), London, 1947, Vol. I, p. 42 (Hereafter Eckhart will be cited from this two-volume edition by reference in the text to volume and page.) [22] *Hom.* 4. [23] AKC, *Hinduism and Buddhism*, New York: n.d., p. 86. (This work hereafter cited as *H. and B.*) [24] *Hom.* xviii. [25] Cf., e.g., St. Thomas Aquinas, *Summa Contra Gentiles*, I, XXV. [26] Robert A. Parker, Introduction, *BL.* ix. [27] Josef Pieper, *The Silence of St. Thomas*, New York, 1957, p. 104. [28] AKC differs from many other modern Traditional writers in the extensiveness of his citations from diverse thinkers, both Traditional and otherwise. His quotations, which are sometimes composite in nature, seem never to be used to give a false impression of any writer. He is not interested in the writer as a personality or possibly even in his total system of thought. For instance, it is not Plato as Plato that he frequently cites. If he turns to Plato's works, it is with the purpose of marshaling apt and cogent expressions of the truth as he understands it. As for quoting out of context and hence misleadingly, this suspicion will probably have to be investigated by those who have the learning and zeal to do so.

## CHAPTER II. MAN, SOCIETY, AND ART

[1] V. Appendix B below. [2] René Guénon, *Crisis of the Modern World*, London, 1942, p. 44 (hereafter cited as *Crisis*). [3] *Conf.* VIII.10. [4] *Writings from the Philokalia on Prayer of the Heart*, E. Kadloubovsky and G. E. H. Palmer (trans), London, 1951, p. 133. [5] AKC, "Who is 'Satan' and Where is 'Hell'?" *The Review of Religion*, November 1947, p. 38. Cf. Hermes Trismegistus, ". . . man, unlike all other living creatures upon earth, is twofold. He is mortal by reason of his body; he is immortal and has all things in his power;

yet he suffers the lot of a mortal, being subject to destiny. He is exalted above the structure of the heavens; yet he is born a slave of Destiny." (*Hermetica*, Lib. I.15, Walter Scott (ed), Oxford, 1922, p. 123.) Much of the Hermetic literature is part of the Philosophia Perennis and could be cited extensively in a work like this, especially concerning the nature and final end of man, the creative process, vocation, inspiration, and katharsis. [6] Thomas Hobbes, *Leviathan*, E. H. Plumptre (trans), Chicago, 1949, pp. 76–77. [7] Boethius, *The Consolation of Philosophy*, W. V. Cooper (trans), New York, 1943, p. 18. [8] Plotinus, *Enneads*, Stephen MacKenna (trans), London, 1926, V.8.7 (hereafter cited as *Enneads*). [9] *Himalayas of the Soul: Translations from the Sanskrit of the Principal Upanishads*, J. Mascaró (trans), London, 1945, pp. 79–80. (*Māṇḍūkya Upanishad*, III.1.)
[10] AKC, "On the One and Only Transmigrant," Supplement to the *Journal of the American Oriental Society* (issued with Vol. LXIV, No. 2, April–June 1944), p. 40. [11] Ananda K. Coomaraswamy and I. B. Horner, *The Living Thoughts of Gotama The Buddha*, London, 1948, p. 18 (quotation is from AKC's introductory chapters). [12] Patanjali, *How to Know God: The Yoga Aphorisms of Patanjali*, Swami Prabhavananda and Christopher Isherwood (trans), New York, 1953, pp. 54–55. [13] St. Thomas Aquinas, quoted in Josef Pieper, *The Human Wisdom of St. Thomas*, New York, 1948, p. 6. [14] *Enneads*, I.6.8. and I.2.6. [15] *De vis. Dei*, Chap. IX, quoted in *Fig.* 107. [16] *Paradiso*, XXXIII, 85–87, Philip H. Wicksteed (trans). [17] *Readings from the Mystics of Islam*, Margaret Smith (trans and ed), London, 1950, p. 62. [18] AKC has often treated in his works the problem of the nature and final end of man. Among the best are these: "Who is 'Satan' and Where is 'Hell'?" "On Being in One's Right Mind"; *Spiritual Authority and Temporal Power in the Indian Theory of Government*; "Ātmayajña: Self-Sacrifice"; "The 'E' at Delphi"; "The Sun-kiss"; "'Akiṁcaññā': Self-naughting"; "The Indian Doctrine of Man's Last End"; *Hinduism and Buddhism*; "Recollection, Indian and Platonic"; "On the One and Only Transmigrant"; "The Religious Basis of the Forms of Indian Culture." See Selected Bibliography below for exact references. [19] ". . . those institutions are traditional which find their ultimate justification in their more or less direct, but always intentional and conscious dependence upon a doctrine which, as regards its fundamental nature, is in every case of an intellectual [i.e., metaphysical] order . . ." (*IHD.* 89).
[20] The Hindu way of life and theory of government, with reference to many parallels, has been analyzed in several works of Coomaraswamy, two of the most notable being "The Religious Basis of the Forms of Indian Society" and the longer *Spiritual Authority and Temporal Power in the Indian Theory of Government* (hereafter cited *Sp.A.*). Still another great essay, "What is Civilization?," is devoted to the universal doctrine without special emphasis upon particular national manifestations. [21] *H. and B.* also contains a concise statement of Hindu social theory. Other works on the theory of the Traditional society much admired by AKC are these: Marco Pallis, *Peaks and Lamas*, New York, 1949, Sister Nivedita, *The Web of Indian Life* (1st ed. 1904), and René Guénon, *Autorité spirituelle et pouvoir temporel*, Paris, 1947. [22] "Relig. Basis" 13. [23] *H. and B.* 13. [24] "Relig. Basis" 17–18. [25] *Ibid.* 20. [26] Cf. AKC, "A Pilgrim's Way," *Journal of the Bihar and Orissa Research Society*, Vol. XXIII, 1937, pp. 452–71. [27] *Fig.* 11. [28] AKC, *The Transformation of Nature in Art*, Cambridge, Massachusetts, 1935, p. 9 (hereafter cited as *Trans.*). [29] "The artist is not a special kind of man, but every man who is not an artist in

some field, every man without a vocation, is an idler." AKC, *Why Exhibit Works of Art?*, London, 1943, p. 24 (hereafter cited as *Why*). [30] "Relig. Basis" 28. [31] *Bhagavad Gītā*, Chaps. IV and V, summarized in "Relig. Basis" 28–29. [32] "Relig. Basis" 28–29. [33] If one labors in his vocation, concerning himself only with his work and nothing extraneous, he is less likely to claim (as a personality) to be the doer of the work, for which he will be more or less inspired. When we do something less or other than that which we are called by our nature and station to perform, we are likely to claim to be the doer of the work, for we will be self-conscious — that is, conscious of those powers with which we associate our personalities. A man totally absorbed in his work is not conscious of "I." This doctrine has illuminating implications, not here explored, for the writer in the modern world where thousands without gifts take to the typewriter and even those who are gifted seem possessed. [34] "Relig. Basis" 42. [35] "The anonymity of the artist belongs to a type of culture dominated by the longing to be liberated from oneself. All the force of this philosophy is directed against the delusion 'I am the doer.' 'I' am not in fact the doer, but the instrument; human individuality is not an end but only a means. The supreme achievement of individual consciousness is to lose or find (both words mean the same) itself in what is both its first beginning and its last end. . . . All that is required of the instrument is efficiency and obedience; it is not for the subject to aspire to the throne; the constitution of man is not a democracy, but the hierarchy of body, soul, and spirit. Is it for the Christian to consider any work 'his own,' when even Christ has said that 'I do nothing of myself'? or for the Hindu, when Krishna has said that 'the Comprehensor cannot form the concept "I am the doer" '? or the Buddhist, for whom it has been said that 'To wish that it may be known that "I was the author" is the thought of a man not yet adult.' " (*Why* 41.) [36] "Relig. Basis" 44–45. [37] *Arthaśāstra* I.6, quoted in *Sp.A.* 86. [38] 205C. [39] *Fig.* 11–12.

[40] *Trans.* 75. [41] "The divine Logos accompanies all the arts, itself teaching men what they must do for their advantage; for no man has discovered any art, but it is always God" (Epicharmus of Syracuse [*Frag.* 57]). Centuries later we find the same concept in quite the same words: "In Calderon . . . the divine Logos is not only a painter, but also architect, musician, poet. In him all arts have their common origin and their primal idea." Ernst Robert Curtius, *European Literature and the Latin Middle Ages*, Willard R. Trask (trans), New York, 1953, p. 568 (hereafter cited as Curtius). [42] Paracelsus, *Selected Writings*, Jolande Jacobi (ed), Norbert Guterman (trans), Bollingen Series XXVIII, New York, 1951, p. 177. [43] *Poetry and Prose of William Blake*, Geoffrey Keynes (ed), London, 1948, p. 802 (hereafter cited as Keynes). [44] *Republic* 406C. The theory of knowledge in the Tradition is that man learns by recollection of the truth which is virtually present within him. AKC has treated this problem with his characteristic brevity and learning in an important monograph, "Recollection, Indian and Platonic," Supplement to the *Journal of the American Oriental Society*, No. 3, April–June 1944 (hereafter cited as "Rec."). [45] *Sum. Theol.* I, 117, 1c. [46] Quoted in *Why* 73. [47] *De Trin.* VI.10, quoted in *Why* 56. [48] *Trans.* 25. [49] *Summa Contra Gentiles*, III, 17.

[50] *Philebus* 63; cf. *Republic* 409–10; *Timaeus* 88B,C, quoted in *Fig.* 36. [51] *Timaeus* 80B, translated in *Fig.* 13. [52] Keynes 582. [53] Keynes 639. [54] *Enneads*, V.1.4. [55] Keynes 610. [56] Quoted in *Fig.* 102.

## CHAPTER III. THE CREATIVE PROCESS

[1] "It is solely and exclusively traditional art . . . transmitted with tradition and by tradition, which can guarantee the adequate analogical correspondence between the divine and cosmic orders on the one hand, and the human or 'artistic' order on the other. As a result, the traditional artist does not limit himself simply to imitating Nature, but to 'imitating Nature in her manner of operation' (St. Thomas Aquinas, *Sum. Theol.* I, qu. 117, a.) and it goes without saying that the artist cannot, with his own individual means, improvise such a 'cosmological' operation. It is by the entirely adequate conformity of the artist to this 'manner of operation,' a conformity which is subordinated to the rules of tradition, that the masterpiece is created; in other words, this conformity essentially presupposes a knowledge, which may be either personal, direct and active, or inherited, indirect and passive . . ." (*TUR.* 86). [2] Cf. "In Calderon the divine logos is musician, poet, painter, architect. The 'Logos as poet' inspired his sacred play *El Divino Orfeo.* There the system of Scripture (*divinas letras*) and the wisdom of antiquity (*humanos letras*) are related by 'consonance,' even though they are severed in religion. How often prophets and poets agree when hidden truths are touched upon! The text of the Eternal Wisdom and the harmony of the world are linked by proportion and number. God is the musician who plays on the 'instrument of the world.' Christ is the divine Orpheus. His lyre is the wood of the Cross. By singing he draws human nature to himself. This is the 'Christus musicus' of Sedulius, and behind both stands the Orphic Christ of Clement." (Curtius, 244.) [3] *Satapatha Brāhmana* VII. 2.1.4. [4] *Trans.* 62. [5] "The artist's theoretical or imaginative act is said to be 'free' because it is *not* assumed or admitted that he is blindly copying any model extrinsic to himself, but expressing himself, even in adhering to a prescription or responding to requirements that may remain essentially the same for millennia. It is true that to be properly expressed a thing must proceed from within, moved by its form: and yet it is not true that in practicing an art that has 'fixed ends and ascertained means of operation' the artist's freedom is denied; it is only the academician and the hireling whose work is under constraint. It is true that if the artist has not *conformed himself* to the pattern of the thing to be made he has not really known it and cannot work originally. But if he has thus conformed himself he will be in fact expressing *himself* in bringing it forth. Not indeed expressing his 'personality,' himself as 'this man' So-and-So, but himself *sub specie aeternitatis*, and apart from individual idiosyncrasy." (*Why* 36.) The artist is free to the extent that he obeys his own true nature. He is merely servile (slavish, even) when he obeys his impulses or influences from without that make him debase his art. He is properly servile in the second phase of the creative process when he faithfully copies the freely conceived interior vision. [6] AKC, "Athena and Hephaistos," *Journal of the Indian Society of Oriental Art*, Vol. XV, 1947, 1. (The Greek words in this article are transliterated as quoted.) [7] *Sum. Theol.*, I–II, q.a.3c. [8] Before the creative process can begin, the artist must choose a subject or accept the subject of another's choice. The responsibility for the choice is the artist's, not as artist, but as man. It is a matter of prudence and not of art. No matter whose commission he accepts, he must, as a responsible member of the community, decide whether both the making and the subsequent use of a given work will add to the sum of his own or another's mortality. [9] *Sum. Theol.*, I, q.91.a.3c.

[10] "The icon-painters were monks who, before setting to work prepared

themselves by fasting, prayer, confession and communion . . ." (*TUR.* 95). This book, which is probably the most masterly exposition of certain phases of the Tradition, has an excellent chapter on art (Chap. IV, "Concerning Forms in Art") that corroborates what is said herein and throws additional light on various aspects of the problems with which we deal. "The Indian actor prepares for his performance by prayer. The Indian architect is often spoken of as visiting heaven and there making notes of the prevailing forms of architecture, which he imitates here below." (*Why* 32.) [11] *Fig.* 151. [12] Strictly speaking, His will, of course, is always done in our work, though often, as it were, against our personal will; it is when His will and ours jump together that He appears to work without our interference. [13] AKC has translated and commented at length upon a detailed Buddhist prescription for this preliminary phase. V. "The Intellectual Operation in Indian Art" (*Fig.* 145–60). [14] St. Thomas Aquinas, *De coelo et mundo*, II, 4, 5. [15] *Fig.* 41. [16] Cf. Blake, "Natural Objects always did & now do weaken, deaden & obliterate Imagination in Me" (Keynes 821). Works of art that merely copy natural objects must a fortiori have a worse effect upon the Imagination, "The Real Man" (*ibid.* 820) within us. [17] *Why* 37. [18] *Fig.* 153. [19] "Whosoever is to 'imitate the actions of Gods and Heroes, the intellections and revolutions of the All,' the very selves and divine paradigms or ideas of our useful inventions, must have known these realities 'themselves (αὐτά) and as they really are' (οἶα ἐστιν): for 'what we have not and know not we can neither give to another nor teach our neighbor' " (*Fig.* 24–25).

[20] *Timaeus* 28A,B, Jowett's translation. [21] *Republic* 500E. [22] *Laws* 890D. [23] An artist making a copy of the aspect of nature is like a machine making copies from a master pattern; his art is completely servile, not truly creative. According to Plato such an artist makes only a copy of a copy. [24] *Sophist* 236C. [25] *Fig.* 37. Cf. *Republic* 373B, 377E, 392–97, 402, *Laws* 667–99, *Statesman* 306D, *Cratylus* 439A, *Timaeus* 28A,B, 52B,C, *Sophist* 234C, 236C, Aristotle *Poetics* I.1.f. . . . [26] *Laws* 667–68. "So whenever a man states that pleasure is the criterion of music, we shall decisively reject his statement; and we shall regard such music as the least important of all . . . and prefer that which possesses similarity in its imitation of the beautiful. . . . Thus those who are seeking the best singing and music must seek, as it appears, not that which is pleasant, but that which is correct; and the correctness of imitation consists, as we say, in the reproduction of the original in its own proper quantity and quality" (Plato, *Laws* 668B,C, Bury's trans.). [27] *Fig.* 38. AKC often employs composite quotations, but never with an intent to misrepresent any writer who is, in any case, of little interest as a person compared to *what* is said. [28] AKC, *Time and Eternity*, Ascona, Switzerland, 1947, p. 65. [29] "Harmonies unheard in sound create the harmonies we hear and wake the soul to the consciousness of beauty, showing it the one essence in another kind: for the measures of our sensible music are not arbitrary but are determined by the Principle whose labour it is to dominate Matter and bring pattern into being" (*Enneads*, I.6.3).

[30] *Enneads*, V.9.11. [31] *Enneads*, IV.4.2. [32] Cf. I Chron. 28:11–12, 19; Acts 7:44; Heb. 8:5. [33] *De dec. praeceptis*, II, quoted in *Fig.* 141. [34] *Moses*, II. 74–76, translated in *Fig.* 158. [35] Meister Eckhart: "God is creating the whole world now, this instant (*nû alzemâle*). Everything God made six thousand years ago, God makes now instantly (*alzemâle*) . . . where time has never entered in, and no shape was ever seen. . . . He makes the world and all

things in this present Now (*gegenwürtig nû*). . . ." Quoted in *Time and Eternity*, p. 117. [36] "The art of God is the Son 'through whom all things are made'; in the same way the art in the human artist is his child through which some one thing is to be made. The intuition-expression of an imitable form is an intellectual conception born of the artist's wisdom, just as the eternal reasons are born of the Eternal Wisdom. The image arises naturally in his spirit, not by way of an aimless inspiration but in purposeful and vital operation 'by a word conceived in intellect.' . . . All things are to be seen in this eternal mirror [God's intellect, as it were] better than in any other way: for there the artist's models are all alive and more alive than those that are posed when we are taught in schools of art to draw 'from life.' If shapes of natural origin often enter into the artist's compositions, this does not mean that they pertain to his art, but they are the material in which the form is clothed; just as the poet uses sounds, which are not his thesis, but only means" (*Why* 34). [37] For a discussion of the doctrine of exemplarism see AKC, "Vedic Exemplarism," *Harvard Journal of Asiatic Studies*, Vol. I, 1936, pp. 44–64, 281. [38] "The word of creatures is said to be in God as the word of his products is in a craftsman. Now, the word of his products in a craftsman is merely the plan he has with respect to them." St. Thomas Aquinas, *Truth*, R. W. Mulligan (trans), Chicago, 1952, q.4, a.4. [39] *Sum. Theol.*, I, q.45, a.6.
[40] *Ibid.*, I, q.14, a.8. [41] *De red. artium ad theologiam* 12, quoted in "Athena and Hephaistos," p. 2. [42] *Fig.* 72–73. [43] "Reality . . . subsists there where the intelligible and sensible meet in common unity of being, and cannot be thought of as existing in itself outside or apart from, but rather *as*, knowledge or vision, that is, only in act. All this is also implied in the Scholastic definition of truth as *adequatio rei et intellectum*. Aristotle's identity of the soul with what it knows, or according to St. Thomas, 'knowledge comes about in so far as the object known is within the knower' (*Sum. Theol.*, I, q.59, a.2), in radical contradiction to the conception of knowledge and being as independent acts, which point of view is only logically, and not immediately valid." (*Trans.* 11.) [44] *Sum. Theol.*, I, q.17, a.1. [45] *Trans.* 61–95. [46] *Trans.* 62. [47] Eckhart I, 253. [48] Eckhart I, 461. [49] Eckhart I, 402.
[50] Eckhart I, 402, quoted in *Trans.* 68–69. [51] *Trans.* 70. [52] Eckhart I, 35, quoted in *Trans.* 69. [53] *Sent.* I, d.36, g.2, a.2 ad I, quoted in *Fig.* 76. [54] *Sum. Theol.*, I, q.117, a.1, quoted in *Fig.* 76. "For nature in Aristotle is not the outward world of created things; it is the creative force, the productive principle of the universe. . . . In the *Physics* (ii.2.194a21) the point of the comparison is that alike in art and in nature there is a union of matter ($ὕλη$) with constitutive form ($εἶδος$), and that the knowledge of both elements is requisite for the natural philosopher as for the physician and architect." S. H. Butcher, *Aristotle's Theory of Poetry and Fine Art*, New York, 1951, 4th ed, pp. 116–17. Cf. *Fig.* 67 for an explanation of St. Thomas Aquinas's use of the term "nature" in his statement, "Art imitates nature in her manner of operation." Cf. also to Eckhart whom AKC quotes repeatedly in this context, "To find nature herself (*māyā, prakṛti, avabhāva*) all her likenesses have to be shattered, and the farther in the nearer the actual thing" (I, 259, here quoted with Sanskrit synonyms in *El.* 89). [55] "Rec." 17. "The World-picture is the Eternal Mirror," cf. Augustine, *De Civ. Dei*, lib. xii, c. 29, *speculum eternum mentes se videntium ducit in cognitionem omnium creatorum* (here "mens" = *manas* = *daiva cakṣu*, "the angelic eye," as in *Chāndogya Up.*, VIII, 12,5), and Chuang Tzū, "The mind of the sage, being at rest, becomes the Mirror of the Universe" (*El.* 80).

THE TRADITIONAL THEORY OF LITERATURE

⁵⁶ Eckhart I, 195. ⁵⁷ Eckhart I, 18–19. "The just seeks nothing in his work; only thralls and hirelings ask anything for work, or work for any why. If thou wouldst be informed with, transformed into, righteousness, have no ulterior purpose in thy work. . . . Believe me, the idea of God in thee, if thou dost work with that in view, means death to all thy works. . . . If God is to make aught of thee or in thee, thou must first come to naught; so enter into thine own ground and work; works wrought by thee there are all living." (Eckhart I, 149–50.) As the priest by the ritual sacrifice of the Mass transforms the wafer into the body of Christ — the wafer *is* Christ, it is bread with a meaning, there is a *real* presence of the Truth and Light by which men live — so the great artist sacrifices himself (conquers himself or commits, as a man, symbolic suicide) so that there may be a *real* presence in his work of art. So far as he expresses his personal views of things, the Truth will not shine forth in his product. ⁵⁸ *Trans.* 76. ⁵⁹ *Trans.* 77.
⁶⁰ Eckhart I, 222. ⁶¹ Eckhart I, 80. ⁶² Eckhart I, 216. ⁶³ A skilled imager was transported to the Trayastrimśas heaven by Mandgalyâyana, and after contemplating there the features of the Buddha, who was preaching the Law to his mother, the artist was brought back to earth and carved the figure in his likeness" (*El.* 6). "The artist is first of all required to remove himself from human to celestial levels of apperception; at this level and in a state of unification, no longer having in view anything external to himself, he sees and realizes, that is to say becomes, what he is afterwards to represent in wrought material" (*Fig.* 178). ⁶⁴ *Trans.* 78. ⁶⁵ *Convivio,* Canzone III, 53–54, and IV, 105–106, quoted in *Trans.* 176. ⁶⁶ A work that would have appealed to AKC in its examination of the creative process is *The Art of Letters: Lu Chi's "Wen Fu,"* A.D. 302, translation and commentary by E. R. Hughes, New York, 1951.
⁶⁷ "The notion of a creator working *per artem,* common to the Christian and all other orthodox ontologies, already implies an artist in possession of his art, the foremeasure (*pramāṇa*) and providence (*prajñā*) according to which all things are measured out; there is, in fact, the closest possible analogy between the 'factitious body' (*nirmāna-kāya*) or 'measure' (*nimitta*) of the living Buddha, and the image of the Great Person which the artist literally 'measures out' (*nirmāti*) to be a substitute for the actual presence. The Buddha is in fact born of a Mother (*mātṛ*) whose name is Māyā (Nature, Art, or 'Magic' in Behmen's sense of 'Creatrix') with a derivation in each case from *mā,* to 'measure.' . . . There is, in other words, a virtual identification of a natural with an intellectual, metrical, and evocative generation. The birth is literally an evocation; the Child is begotten, in accordance with a constantly repeated Brahmana formula, 'by Intellect upon the Voice,' which intercourse is symbolized by the rite; the artist works, as St. Thomas expresses it, 'by a word conceived in intellect.' We must not overlook, then, that there is also a third and verbal image, that of the doctrine, coequal in significance with images in flesh or stone: 'He who sees the Word sees Me.' . . . These visible and audible images are alike in their information, and differ only in their accidents. Each depicts the same essence in a likeness; neither is an imitation of another, the image is stone, for example, not an imitation of the image in the flesh, but each an 'imitation' (*anukṛti,* mimesis) of the unspoken Word, an image of the 'Body of the Word' or 'Brahma-body' or 'Principle,' which cannot be represented as it is because of its perfect simplicity." (*Fig.* 164–65.) ⁶⁸ *Fig.* 19. ⁶⁹ *Trans.* 1–57.
⁷⁰ *Trans.* 5–6. ⁷¹ *Trans.* 7. ⁷² *Fig.* 145. ⁷³ *Trans.* 202. ⁷⁴ Keynes, 525. ⁷⁵ Keynes,

821. [78] Although AKC cites widely from the classics, the Fathers, and School-men, he has by no means set down all the references that support his theory of artistic creation. Richard McKeon in his book, *Thought, Action, and Passion*, Chicago, 1954, Chap. IV, "Imitation and Poetry," discusses the very subject of this chapter and cites additional writers whose theory squares essentially with the perennial doctrine. V. also McKeon's "Literary Criticism and the Concept of Imitation in Antiquity," in *Critics and Criticism*, R. S. Crane (ed), Chicago, 1952, pp. 147–75. [77] *Fig.* 25. [78] Cf. "When they called upon the Muses, who were 'present and knew all things' to tell them what they, as common mortals, could learn only by hearsay, it is likely that their meaning was more serious than we ordinarily suppose." F. M. Cornford, *Principium Sapientiae*, Cambridge, England, 1952, p. 79. [79] John 8:28.

[80] *Purgatorio*, XXIV, 51–54. [81] *Phaedrus* 260E. [82] *Timaeus* 90A. [83] *Greater Hippias* 288D. [84] *Fig.* 26. [85] "Democritus' words are preserved by Clement: 'Truly noble poetry is that which is written with the breath of divine inspiration (μετ' ἐνθουσιασμοῦ καὶ ἱεροῦ πνεύματος).'" Cornford, *Principium Sapientiae*, p. 66. "The final result is that 'we' are the authors of whatever is done amiss, and therefore not really 'done' at all; while of whatever is actually done, God is the author. Just as in our own experience, if I make a table that does not stand, I am 'no carpenter,' and the table is not a table; while if I make a real table, it is not by my self as this man but 'by art' that the table is really made, 'I' being only an efficient cause. In the same way the Inner Person is distinguished from the elemental self as promoter . . . from operator. . . . The operation is mechanical and servile; the operator being only free to the extent that his own will is so identified with the patron's that he becomes his own 'employer.' . . . 'My service is perfect freedom.'" (*H. and B.* 37.) [86] *Symposium* 197A. [87] *Fig.* 27. [88] *Ibid.* Although some critics see this passage in the total context of Plato's thought and regard, therefore, the inspiration here mentioned as fifth-rate, AKC, in a different sense regarding the passage in the total context of Plato's thought, treats it as a type of inspiration, true, *mutatis mutandis*, for any art. [89] *Phaedrus* 244D, 245A, in *Fig.* 40.

[90] *Fig.* 40. [91] *Sum. Theol.*, I, q.20, a.2. [92] H. S. Sullivan, "Introduction to the Study of Interpersonal Relations," *Psychiatry*, Vol. I, 1938, quoted in AKC, "Who is 'Satan' and Where is 'Hell'?," *Review of Religion*, November 1947, p. 37. [93] *Sum. Theol.*, I, q.17, a.1. [94] "In the practical matter of putting down their paintings in ink on paper Zen artists discovered that the principle of *muga* (it is not I that am doing this) opens the gate for the necessary essential truth to flow in. When the self does not control the drawing, meaning must. This principle runs all through Zen teachings especially where action is involved. It it is related to the Taoist mistrust of the human intervention which clogs the channels of the Way." Langdon Warner, *The Enduring Art of Japan*, Cambridge, Massachusetts, 1952, p. 100. [95] Eckhart I, 19, 150, 278. [96] Cf. *TUR.*, ". . . forms, even the most unimportant, are the work of human hands in a secondary manner only; they originate first and foremost from the same suprahuman source from which all tradition originates, which is another way of saying that the artist who lives in the traditional world devoid of 'rifts,' works under the discipline of a genius which surpasses him; fundamentally he is but the instrument of this genius, if only from the fact of his craftsman's qualification" (86). [97] "Through the mouth of Hermes the divine Eros began to speak' [*Hermetica*, Asclepius, prologue]. We must not conclude from the form of the words that the artist is a passive instrument,

like a stenographer. 'He' is much rather actively and consciously making use of 'himself' as an instrument. Body and mind are not the man, but only his instrument and vehicle. The man is passive only when he identifies himself with the psychophysical ego letting it take him where it will: but in act when he directs it." (*Why* 37.) [98] "Without Unceasing Practice nothing can be done. Practice is Art. If you leave off you are Lost." (Keynes, 582.) [99] The artist who has not mastered himself will perform an infirm act of contemplation. If his nature is not harmonious and if the component parts are not quiescent but rather independently assertive of their desires, the interior image that he conceives will be distorted. All are familiar with distractions and the effect on thought of one's unresolved psychological conflicts. The artist who has not mastered the practice of his art will execute poorly. But the one who is able to be quiet and really to become (*pro tem.*, possibly) that which he conceives in his intellect and who has furthermore mastered the means of his art, will better be able to bring the interior vision into outward manifestation. Approaching divine spontaneity, the discrepancy between the vision and manifestation will become smaller. ("No sooner said than done.") Plato describes how men are subject to the contrary pulls of the affections and adjures men to grasp "The sacred and golden cord of reason" (*Laws* 645A). And as he says, "Law and art are children of the intellect" ($\nu o \hat{u} s$) (*Laws* 890D). Quoting from Chinese sources, AKC describes artists who have reached "divinity": one painter paints a mountain with a door in it and then disappears forever through the door and another paints on the walls dragons that fly away. (*Trans.* 22.)

[100] *Trans.* 19. "The Ancients applied the term *habitus* ($\xi \xi \iota s$) to qualities of a distinct and separate kind, essentially permanent conditions perfecting in the line of its own nature the subject they inform. Health and beauty are habits of the body . . . ; other habits have for subject the faculties or powers of the soul, and as these naturally tend to action, the habits related to them perfect them in their very dynamism, are *operative* habits: such are the intellectual and moral virtues. We acquire the last-mentioned kind of habit by exercise and customary use. . . . Art is a habit of the practical intellect." Jacques Maritain, *Art and Scholasticism*, London, 1947, pp. 8–9. [101] *Fig.* 31–32. [102] *Trans.* 23. [103] In a book that AKC would have admired for its exposition of the Traditional doctrine of art, Eugen Herrigel, *Zen in the Art of Archery*, New York, 1953, describes his study of archery for six years under a Japanese master. At one time the author became so frustrated at his lack of success in releasing the arrow according to the traditional rules that he devised a different technique, apparently much more immediately successful. When his master discovered this "improvement" he refused to teach Herrigel any longer. The implication is clear: if a man is to learn to shoot a bow in a state of nondifferentiation when he is not aware of himself as the archer any more than as the bow, arrow or target, he must learn not only to give up egoism and self-consciousness but also to follow those rules tried and tested by great masters. This book cannot be too highly recommended to those who find that AKC speaks to their condition; it reveals very explicitly how mastery of the "lesser mysteries" (of one's art or craft) can lead to initiation into the "greater mysteries" (of spiritual growth and gnosis, of Eros, and the Kingdom of Heaven). [104] *Trans.* 23–24. [105] Cf. Maritain, *Creative Intuition in Art and Poetry*, p. 48. "To make fun of the rules, in proclaiming the liberty of art, is just an excuse provided by foolishness to mediocrity. 'It is clear,' Baudelaire

wrote, 'that systems of rhetoric and prosodies are not forms of tyranny arbitrarily devised, but a collection of rules required by the very organization of the spiritual being. . . .' " [106] One of the critical problems of modern aesthetics concerns the precise nature of the process by which the inwardly contemplated image is given embodiment in the appropriate material. Modern theory would seem to suggest the inadequacy of Traditional doctrine, which, it is claimed, is facile and verbal, pretty well blinking the real problem of refusing to treat it in phenomenological terms. However, Platonic, Christian, and Hindu doctrine — to mention only three — maintains that it is the Soul, Spirit, Atman that moves; it is the sole principle of motion in the universe. Whatever an artist executes, well or poorly, is moved by this Principle, which is, as it were, within him. And when the artist in his psychophysical nature has attained a high degree of mastery, the immanent Spirit will more perfectly bring into manifestation the form of the interior image. Such a description of the creative act as one finds, for instance, in Meister Eckhart would be considered phenomenological as well as metaphysical. Rules enable the artist to create in a certain form; rules result in an idiom, language or style which is necessary for communication to men of a certain time. [107] *Trans.* 39. This assumes a stable culture or, at least, one in which Traditional themes and techniques are living and meaningful. When the Tradition declines, the great artists are forced to change the rules and techniques. Because they are aware in part that "the letter killeth and the spirit giveth life," they wish to free the spirit from the dead hand of the past. Blake, an exponent of the Tradition if there ever was one, puts these words in the mouth of Los: "I must create a system or be enslav'd by another Man's. I will not Reason & Compare: My business is to Create." (*Jerusalem* I. Keynes, 442.) When Blake saw that the salt was losing its savor, he tried to restore meaning to the perennial myths. Blake may be difficult to understand at times, but his ideas, whatever their outward form, are generally Traditional. It is when writers employ private techniques, rules, and symbolisms that have a basis in a limited personal experience that they become really unintelligible or fruitlessly ambiguous without detailed biographical exegesis. [108] *Fig.* 28. There is a possibility of "demonic creation." The so-called demons — the opposite of the Daimon — are the unresolved or unmastered elements in the artist's nature. Many of the bards discussed by William Henry Schofield in *Mythical Bards and the Life of William Wallace* (Harvard Studies in Comparative Literature, Vol. V., Cambridge, 1920) would seem to be of the demonic type. Both St. Augustine and St. Thomas Aquinas deal with this problem when they discuss the activities of "magicians" who can create as miraculously as their spiritual betters. AKC, passim, refers to those artists of great skill who are not contemplative in the conception of their works or who are possessed by "inferior forces." [109] *Fig.* 11.

[110] *Symposium* 205C. [111] *Fig.* 140. [112] *De. an.* III.8, quoted in *Fig.* 114. [113] *Enneads* IV.3.30, quoted in *Fig.* 154. [114] Eckhart I, 80. [115] *Convivio*, IV, 10. [116] *Paradiso*, XVIII, 85, quoted in *Trans.* 176. [117] Eckhart I, 112. [118] Eckhart I, 114. [119] A. K. Coomaraswamy and Sister Nivedita, *Myths of the Hindus and Buddhists*, New York, 1914, pp. 23–24.

[120] Cornford, *Principium Sapientiae*, pp. 76–77. Cf. *Writings from the Philokalia on Prayer of the Heart*, E. Kadloubovsky and G. E. H. Palmer (trans), London, 1951, p. 237. The monks Callistus and Ignatius, "Directions to Hesychasts": "If any one assumes that visions, images, and revelations of

the prophets were fantasies and belonged to the natural order, let him realize that he is far from the right mark and truth. For the prophets of old and the holy recluses of our times had visions such as they had, not according to some natural order or law, but in a manner that is divine and above nature. Their visions were created and imprinted in them by the ineffable power and grace of the Holy Spirit, as Basil the Great says: 'The prophets received images in their mind pure and undistracted; and they heard the word of God as though uttered within them.' And: 'Prophets saw visions by the action of the Spirit, Who imprinted images in minds sovereign over themselves.' And Gregory the Theologian says: 'The Holy Spirit acted first in angelic and heavenly powers; then in the fathers and prophets some of whom saw God or knew Him; others foresaw the future when their sovereign mind received such images from the Spirit, as made them contemporaries of the future as though it were the present.'" [121] "What Milton prayed for was as much the vision of the seer as the inspiration of the poet, the knowledge of a Spirit which 'from the first was present,' a revelation which, as he believed, was to be found not only in the canonical books, but in the Wisdom literature, the Cabala, and 'thrice great Hermes.' This Spirit, he declared, was wont to inspire his

> prompted song else mute
> And bear through highth or depth of natures bounds
> With prosperous wing full summ'd to tell of deeds
> Above Heroic, though in secret done,
> And unrecorded left through many an Age,
> Worthy t' have not remain'd so long unsung.

The lines above quoted reproduce, in every feature, that claim to hidden knowledge of the past, as well as of the present and the future, which . . . is regularly advanced by the seers and poets of the heroic and post-heroic ages in many different lands." Cornford, *Principium Sapientiae*, pp. 78–79. [122] *Fig.* 176. [123] Cf. *The Creative Process: A Symposium*, Brewster Ghiselin (ed), New York, 1955.

### CHAPTER IV. THE WORK OF ART

[1] *Philebus* 63, quoted in *Fig.* 36. [2] Referred to in AKC, "Eckstein," *Speculum*, Vol. XIV, January 1939, p. 66. [3] *Sum. Theol.*, I, q.91, a.3. [4] *Summa Contra Gentiles*, III, XXV. [5] AKC and Stella Block, "The Appreciation of Art," *Art Bulletin*, Vol. VI, 61. Cf. "Let us tell . . . the painful truth, that most of these works of art are about God, whom we never mention in polite society" (*Why* 20). [6] *Fig.* 252. [7] *Why* 11. [8] "The more an image is 'true to nature,' the more it lies" (*Trans.* 129). This dictum applies to naturalistic writing also. [9] *Why* 31–32.

[10] "The 'tracks' by which He is to be found are primarily the symbolic expressions of the ritual sacrifice and hymns, 'seen' and 'worded' by the poetic genius (*Rg Veda*, IX, 73, 9; X, 71, 3, etc.); and in just the same way any symbol . . . constitutes a 'track' by means of which He may be 'followed after,' the symbol (*pratīka*) being employed, not for its own sake, but as a call to action" (*El.* 16–17). Cf. McKeon, *Thought, Action, and Poetry*, pp. 123–25 and 245 for an analysis of the use of the figure of the "tracks" or "footprints" in St. Augustine and St. Bonaventura. Also Sister Emma Jane Marie Spargo, *The Category of the Aesthetic in the Philosophy of Saint Bonaventure* (Franciscan Institute, St. Bonaventure, N.Y., 1953), esp. Chap.

166

VI. [11] *Fig.* 115. [12] *Fig.* 187–88. [13] *Trans.* 121–38. [14] *Trans.* 126–27. [15] *Trans.* 121. [16] *Fig.* 198. [17] "There has often been brought out the common valency of the Christian rose and Indian lotus as representations of the ground of all manifestation, the support of being when it proceeds or seems to proceed from being to becoming." AKC, "Two Passages on Dante's *Paradiso*," *Speculum*, Vol. XI, July 1936, p. 331. [18] *Trans.* 124–25. [19] *Sum. Theol.*, I, q.1, a.10, partially quoted in *Fig.* 74.
[20] "The theological point of view is but a particularisation of the meta-physical point of view, implying a proportional alteration. . . . Every theological truth may be conceived in terms of the metaphysical truth corresponding to it, of which it is but a kind of translation, though this does not mean that there is an effective equivalence between the two orders of conception . . ." (*IHD*. 126). [21] "It is the basis of Plato's criticism of naturalistic poets and painters that they know nothing of reality but only the appearance of things, for which their vision is over keen; their imitations are not of the divine originals, but are only copies of copies [*Republic* 601]. And seeing that God alone is truly beautiful, and all other beauty is by participation, it is only a work of art that has been wrought, in its kind ($\iota\delta\acute{\epsilon}\alpha$) and its significance ($\delta\acute{\upsilon}\nu\alpha\mu\iota\varsigma$), after an eternal model that can be called beautiful" (*Fig.* 19). [22] *Fig.* 135. [23] *Ibid.* [24] *Ibid.* 134–44. [25] *Fig.* 136. [26] *Ibid.* [27] ". . . every symbol, in so far as it must essentially serve as a support to contemplation, is also endowed with a very real efficacy; and the religious sacrament itself, in so far as it is a sensible sign, does indeed play a similar part as support of the 'spiritual influence' which will turn the sacrament into an instrument of immediate or deferred psychical regeneration; just as in the parallel case the intellectual potentialities included in the symbol are able to awaken either an effective or simply a virtual conception, according to the receptive capacity of each individual" (*IHD*. 132). [28] *Fig.* 115. [29] V. *Fig.* 137–40, 144, for a more complete discussion of "participation."
[30] *Fig.* 137–38. [31] *Convito*, III, 12, quoted in *Fig.* 115. [32] V. AKC, "The Sun-kiss," *Journal of the American Oriental Society*, Vol. LX, 1940, pp. 46–47. [33] *El.* 63. [34] *Sp.P.* 39. [35] *Ibid.* 39–40. [36] *Fig.* 216–38. [37] *Fig.* 222. [38] "Proverbs of Hell," Keynes, 183–84, quoted in *Fig.* 235. [39] Keynes, 182.
[40] *Sp.P.* 47–48. [41] "The sensible forms, in which there was at first a polar balance of the physical and metaphysical, have been more and more voided of content on their way down to us; so we can say, this is an 'ornament' " (Walter Andrae translated in *Fig.* 253). "It can be noted, however, that every traditional symbol carries with it its original values, even when used or intended to be used in a more restricted sense" (*El.* 8). [42] *Commentary on the Vedānta Sutras*, I. 1, 20, quoted in *Trans.* 24. [43] Keynes, 184. So far as a statement is intelligible or "makes sense" it is true. And it may be correct to say, as St. Augustine does, that "There is no truth but contains the whole of truth" (quoted in Eckhart I, 228). Yet some expressions are clearer, more efficient reminders of the truth than others, though ultimately all fall short of the truth. This is, no doubt, what Heraclitus referred to when he said, "All things are true and all are false" (quoted in Aristotle, *Metaphysics*, IV. 8, 1012a 35). [44] *Fig.* 188. [45] *Fig.* 121–22. [46] V. AKC, "The Iconography of Dürer's 'Knoten' and Leonardo's 'Concatenation,'" *Art Quarterly*, Vol. VII, pp. 109–28, for a more extensive and learned treatment of this symbolism. [47] *Fig.* 114–22. [48] *Fig.* 116–17. [49] *Fig.* 171.
[50] *Sum. Theol.*, I. 1.9 quoted in *Why* 50–51. [51] *Fig.* 122. [52] "Sir G." 19. [53] V.

Mircea Eliade, "Mythology and the History of Religions," *Diogenes*, No. 9, 1955, 101. "The principal function of myths is thus to determine the exemplary models of all rites and of all significant human activities (eating, procreation, work, etc.)." [54] *Fig.* 252. From Andrae, *Die ionische Säule, Bauform oder Symbol?* [55] *Fig.* 232. [56] Quoted in "Sir G." 8, from an article by Murray Fowler. [57] *Fig.* 193. [58] *Fig.* 164. [59] *Speculum*, Vol. XIX, January 1944, pp. 2–23.

[60] "Sir G." 2. [61] *Ibid.* [62] "In the total form of the original story it may be assumed that the two opponents were friends, fought, and were reconciled. That is, indeed, precisely the relationship of God to Satan — often called the 'Serpent' — as completely stated only in those Traditions, notably the Islamic, in which an ultimate apokatastasis of the fallen Angel is foreseen. We have elsewhere pointed out the parallel recognizable in any performance of the mystery of St. George and the Dragon: the opponents, having been friends, and perhaps even brothers, in the green room (the other world), appear on the stage (of this world) as mortal enemies, but are friends again when they return to the obscurity from which they first emerged. So in Egyptian mythology, Horus and Seth are both friends and enemies." ("Sir G." 4.) [63] "Sir G." 23. [64] *From Ritual to Romance*, 1929, p. 176, quoted in "Sir G." 23. [65] "Sir G." 21–22. [66] *Fig.* 119. [67] AKC and Sister Nivedita, *Myths of the Hindus and Buddhists*, New York, 1914, p. 24. [68] *Why* 44. [69] For evidence of the decline of myth see Nathan G. Starr, *King Arthur Today: The Arthurian Legend in English and American Literature*, Gainesville, 1954.

[70] *Fig.* 118–19. [71] *Fig.* 216. "The content of folklore is metaphysical. Our failure to realize this is primarily due to our own abysmal ignorance of metaphysics and of its technical terms." (*Fig.* 216.) [72] *Fig.* 220. [73] *Fig.* 231. [74] *Sum. Theol.*, I, q.1, a.10. [75] *Confessions*, XII, xxxi. [76] *Sum. Theol.*, I, q.1, a.9. [77] *Why* 51. [78] Quoted in *IHD*. 147. [79] *IHD*. 67.

[80] Quoted from *Freedom and the Spirit* in *Fig.* 122. [81] *Fig.* 96. [82] *Fig.* 85–99. [83] *Fig.* 85. [84] *Fig.* 86. [85] *Fig.* 97. [86] *Fig.* 96. [87] Typical of AKC's method, which is somewhat unusual, in what would seem, in the realm of modern academic scholarship, is the detailed etymological and hermeneutic explanation of key words to derive from them their utmost significance, especially as this relates to metaphysical knowledge. (Hermeneutic explanation, he observes, may or may not coincide with the actual pedigree of a word. For example, Dionysius Areopagiticus relates καλός "beauty" to the verb καλέω "I call"; Divine Beauty, he says, summons all things into one whole: such an explanation is a hermeneia, if not an etymological account of the relationship.) Like Plato of the *Cratylus* and the Indian thinkers of the Purva Mīmāṁsa, which deals with the traditional science of language, AKC believes that the relation between sounds and meaning is not an accidental but essential one; sound and meaning of words as originally used — so far as can be determined — are inseparably associated, being in language an image of the Supreme Identity of essence and nature. (V. AKC, "Nirukta — Hermeneia," *The Viśva-Bharati Quarterly*, August 1936.)

AKC's thesis in his essay "Ornament" is that ornament is an integral factor of the beauty of a work of art, necessary to its efficacy. Typically, he analyzes the Sanskrit word *alaṁkāra*, "ornament" with reference to rhetorical ornament or to jewelry or trappings. He finds the word composed of *alaṁ*, "sufficient," or "enough," and *kṛ* to "make." (In older Sanskrit *alaṁ* was *araṁ*, *l* and *r* often being interchangeable.) He writes, "Analogous to the transitive

*araṁ-kṛ* are the intransitive *arambhū,* to become able, fit for, and *araṁ-gam,* to serve or suffice for. The root of *araṁ* may be the same as that of Greek αραρίσκω, to fit together, equip or furnish. *Araṁ* with *kṛ* or *bhū* occurs in Vedic texts in phrases meaning preparedness, ability, suitability, fitness, hence also that of 'satisfying' (a word that renders *alaṁ-kṛ* very literally, *satis* corresponding to *araṁ* and *facere* to *kṛ*), as in *Rgveda Saṁhita* VII.29.3 'What satisfaction (*araṁkṛti*) is there for thee, Indra, by means of our hymns?' *Alaṁ-kṛ* in the *Atharva Veda* (XVIII.2) and in the *Śatapatha Brāhmana* is employed with reference to the due ordering of the sacrifice, rather than to its adornment, the sacrifice indeed being much less a ceremony than a rite; but already in the *Rāmāyana,* a 'poetical' work, the word has usually the meaning to 'adorn.'" (*Fig.* 87–88.) Without going into the further detail of which he is capable in such context, Coomaraswamy states that it is clear that once the meaning of "adornment" referred to "the furnishing of anything essential to the validity of whatever is 'adorned,' or enhances its effect, empowering it" (*ibid.*). The root significance of classical Sanskrit words *bhūsana* and *bhūs* (meaning "ornament") and the Greek word κόσμημα ("ornament" or "decoration," usually of a dress, from κόσμος, "order") AKC discusses at even greater length in the same fashion. Before finishing he brings in Latin and Chinese analogues and builds up with considerable learned detail the traditional usage of ornament. The method here employed is so curious to modern minds and so integral to the traditional method as employed by AKC as to warrant the quotations and brief development devoted to it. Throughout AKC's whole discussion one is aware of the fact that he grounds his whole analysis upon Traditional metaphysical presuppositions. His method always displays a scrupulousness and awareness of metaphysical principles seldom matched in modern scholarship. [88] *Fig.* 91. [89] *Fig.* 95.

[90] *Aitareya Brāhmana* VIII.27. [91] *Sp.A.* 55. [92] Plato writes about the dangerous and degenerative effect of prose writings as compared to those poetical compositions set to the lyre (*Laws* 810B). [93] *Enneads,* V.9.11. [94] *Ibid.,* I.6.3. [95] *Aitareya Āranyaka* II.3.6, quoted in *Sp.A.* 53. [96] *Sp.A.* 53. [97] AKC discusses another formulation of a theory of poetry as follows: "According to the . . . School of Manifestation . . . the essential or soul of poetry is called *dhvani,* 'the reverberation of meaning arising by suggestion. . . .' In grammar and logic, a word or other symbol is held to have two powers only, those of denotation . . . and connotation . . . ; for example *gopāla* is literally 'cowherd,' but constantly signifies *Krṣna.* The rhetoricians assume for a word or symbol a third power, that of suggestion . . . , the matter suggested, which we should call the real content of the work, being *dhvani.* . . . *Dhvani,* as overtone of meaning, is thus the immediate vehicle of single *rasa* and means to aesthetic experience . . . The School of Manifestation is so called because the perception . . . of *rasa* is thought of simply as the manifestation of an inherent and already existing intuitive condition of the spirit, in the same sense that Enlightenment is virtually ever-present though not always realized." (*Trans.* 53.) [98] Cf. the *logos* of Heraclitus mentioned above. [99] AKC and Genevieve W. Foster, "Primordial Images," *PMLA,* Vol. LXI, June 1946, p. 601.

[100] V. Julius Portnoy, *The Philosopher and Music,* New York, 1954, passim, for quotations, references, and discussion of Greek and medieval music and the music of the spheres. [101] *Sp.A.* 56. [102] 659E, quoted in *Sp.A.* 55. [103] *Timaeus* 47D,E, AKC's translation. [104] *Timaeus* 80B, translated in *Sp.A.* 55–56. [105] *Timaeus* 90D, R. G. Bury's translation. [106] *Philebus* 63 in *Fig.* 36. [107] Music or poetry

that is deficient in energy and rhythm will not have the proper physical effect demanded of all truly correct and useful works of art. The affective elements within man — the "many-headed monster" of the *Republic* — have to be "enchanted" by the power and harmony of the poetry and music. The myth of Orpheus, who enchants wild beasts, trees, and plants, is no mere fancy but significant of the divinely inspired musician's powers of subduing the elemental forces of the universe which operate in man as well as in the rest of nature. [108] Quoted in *The Limits of Art*, Huntington Cairns (ed), Washington, 1948, p. 974. [109] Cf. AKC, "Note on the Iconography of the Cock on the Column," *Art Bulletin, Vol.* XXI, 1939, 375–82.

[110] *Sp.A.* 59–60. [111] "All possessions not at the same time beautiful and useful are an affront to human dignity" (*Why* 49). [112] *Fig.* 69. [113] *Ibid.* [114] *Ibid.* [115] *Ibid.* [116] *Fig.* 83. [117] *Sum. Theol.*, III, q.33, a.4c. [118] *Ibid.*, I, q.4, a.4. [119] AKC, *The Dance of Shiva*, Bombay, 1948.

[120] *Fig.* 44–84. [121] V. also AKC, "Beauty and Truth," Chap. V in *Why*. [122] *Fig.* 44. [123] AKC's translation. [124] *Fig.* 45. [125] Translated in *Fig.* 57. [126] Ulrich Engelberti in *Fig.* 48. [127] *Sum. Theol.*, I. q.5, a.1. [128] Ulrich in *Fig.* 46. [129] *Fig.* 46–47.

[130] *Sum. Theol.*, I. q.39, a.8, quoted in *Fig.* 78. [131] *Fig.* 63. [132] *Sum. Theol.*, I, q.39, a.8c, translated in *Fig.* 63. [133] *Fig.* 63–65. [134] *Fig.* 67. [135] *Fig.* 73. [136] Enneads, I.6.3. [137] *Fig.* 77. [138] *Why* 39. [139] *Ibid.*

[140] *Fig.* 179. [141] Quoted in Aldous Huxley, *The Perennial Philosophy*, New York, 1944, p. 127.

## CHAPTER V. THE FUNCTION OF WORKS OF ART

[1] Since art pertains to essential knowledge as an end rather than to expressing emotions,Coomaraswamy came to believe that the term *aesthetic* should be abandoned because it leads us to associate art primarily with "the delectation of the senses" (*Why* 16) and the excitation of the emotions. He quotes Plato, "I cannot fairly give the name of 'art' to anything irrational" (*Gorgias* 465A, quoted in *Fig.* 35). Nevertheless, Coomaraswamy often uses the term, especially in his earlier writings, for lack of a better. [2] *Fig.* 12. [3] It would seem that the *rasika* identifies himself with the archetype of any work of art to which he responds when he is so concentrated in attention, so absorbed, so oblivious to other things, so free from conscious or unconscious concerns with anything else, that he knows or is aware of only the archetype; so far as he *is* at this moment, he is the archetype. [4] *Fig.* 160. [5] *Why* 17. [6] *Timaeus* 47D,E, in *Fig.* 13. [7] *Ibid.* [8] *Fig.* 13–14. [9] *Timaeus* 90D, R. G. Bury's translation.

[10] Matt. 4:4. [11] *Why* 31. [12] *Epist. ad Can Grande.* [13] For a summary treatment of Indian aesthetics which touches upon the problem of katharsis — as well as *rasa*, imitation, the soul of poetry, etc. — see *History of Philosophy Eastern and Western*, S. Radhakrishnan (ed), London, 1952, Vol. I, pp. 472–87. [14] *Trans.* 56. [15] *Trans.* 46–47. [16] *Ibid.* [17] *Trans.* 48. [18] *Trans.* 48–49. [19] Many, of course, will remain unmoved by works of truth and beauty such as AKC constantly refers to as being great. "Neither will they be persuaded, though one rose from the dead" (Luke 16:31) — as AKC would observe.

[20] *Sp.P.* 134. [21] *Trans.* 50–51. [22] *Enneads* I.6.3. [23] *Prakriti* (the universal substratum, support of all manifestation) "possesses three *gunas*, or constitutive qualities. . . . The three *gunas* are: *sattva*, conformity to the pure essence of Being . . . , which is identified with intelligible light or Knowledge and is represented as an upward tendency; *rajas*, the expansive impulse, in accord-

ance with which the being develops itself in a given state . . . ; and lastly, *tamas*, obscurity, assimilated with ignorance and represented by a downward tendency." René Guénon, *Man and His Becoming According to the Vedānta*, London, 1945, p. 52. [24] Eckhart I, 341.

[25] In a somewhat difficult but illuminating passage AKC sets forth the essence of Indian psychology, which is a special form of the "psychology" of the Tradition. It is here quoted with omission of some of the Sanskrit words and references. "The functional powers are called Spirations, Lives, or Breaths after the central Spiration [cf. "The Spirit of God moved across the face of the waters" (Gen. 1:2)], Life or Breath of which they are participations and on which they depend . . . and 'Indra's energies' . . . with reference to [the God] Indra identified with the central Breath. . . . In us these Breaths act as one, so that 'we' can refer to, see, hear and think of a given object simultaneously ( . . . cf. I Cor. 12:4f); the passible Ego or 'Elemental Self' . . . is accordingly a 'host of beings.' . . . The true relation of these Breaths or Storms ( our 'stormy passions') to their Head is that of subjects to a King, loyal unto death; but if they are allowed to run wild in pursuit of their natural objects, serving themselves and not their King, 'we' are distracted by this body of fallen Angels within us. Self-integration is a matter of orientation." "Measures of Fire," *O Instituto*, Coimbra, Portugal, Vol. 100, 1942, p. 391.

Since the end of man is to subject the powers to the hegemony of their rightful sovereign, a work of art dedicated to this end must somehow quiet the "stormy passions" or render the "host of beings" within us amenable to rule. One of the reasons that a work of art must serve both physical and spiritual needs is to make some impact upon the unruly psychophysical powers which are relatively impervious to the Word except when they have been soothed, shocked, arrested, as, for instance, by the power of a work of art.

As AKC has written, "The content of the Gandharvas, the high Gods of Love and Music ( in Plato's broad sense of the word) is with the unregenerate powers of the soul whose natural inclination is the pursuit of pleasures. What the Gandharvas offer the Voice ["Mother of the Word"] is their sacred science, the thesis of their incantation; what the mundane deities offer is 'to please her.' The Gandharvas' is a holy conversation . . . , that of the mundane deities an appetising colloquy. . . . Only too often the Voice, the expressive power, is seduced by the mundane deities to lend herself to the representation of whatever may best please them and be most flattering to herself; and it is when she thus prefers the pleasant falsehoods to the splendour of the sometimes bitter Truth that the High Gods have to fear lest she in turn seduce their legitimate spokesman, the Sacrifice himself; to fear, that is to say, a secularisation of the sacred symbols and the hieratic language, the depletion of meaning that we are only too familiar with in the history of art, as it descends from formality to figuration, just as language develops from an original precision to what are ultimately hardly more than blurred emotive values." (*Fig. 31*, cf. *Sp.A.*, passim, for a detailed treatment of the aristocratic principle in all phases of human endeavor. )

[26] *El.* 79. [27] *Trans.* 28. [28] *Trans.* 199. [29] *Trans.* 199. [30] *Fig.* 200–207. [31] *Fig.* 200. [32] *Fig.* 201. [33] *Fig.* 204. "The image merely as such is of no value; all depends on what he does who looks at it, what is expected of him is an act of contemplation such that when he sees before him the characteristic lineaments, it is for him as though the whole person of the Buddha were present. . . . Aesthetic and religious experience are here indivisible; rising to the level of reference intended, 'his heart is broadened with a mighty understanding.' "

(*El.* 7.) [34] *Fig.* 204. [35] *Fig.* 205–206. [36] *Daśarūpa,* I.64, quoted in *Fig.* 207. [37]*Fig.* 206. [38] *Trans.* 55. [39] *Trans.* 167–68.
[40] *Fig.* 14. [41] Some of the most perceptive, searching and thoroughly orthodox treatises upon the function of art in perfecting man are those of the Sufis, the exponents of Islamic esoterism. A work that contains several selections concerning the effect of listening to music and poetry is *Muhammad's People: A Tale by Anthology,* Eric Schroeder (trans and ed), Portland, Maine, 1955. Poetry and music are used by qualified Sufis under the directorship of a master to induce states of religious ecstasy which are intellectual and not emotional in nature. [42] *Phaedrus* 279C quoted in *Fig.* 14. [43]"What is meant by the purification of the Soul is simply to allow it to be alone; (it is pure) when it keeps no company, entertains no alien thoughts; when it no longer sees images, much less elaborates them into veritable affections. Is it not true purification to turn away towards the exact contrary of earthly things? Separation too is the condition of a soul no longer entering the body to be at its mercy; it is to stand as a light set in the midst of trouble but unperturbed through all. Purification is the awakening of the soul from the baseless visions, the refusal to see them; its separation consists in limiting its descent toward the lower, accepting no picture thence, in banning utterly the things from which it is separated, when, risen above the turbid exhalations of sensuality and superabundance, though not free of the flesh, it has so reduced the body that it may be tranquilly carried." *Enneads,* III.6.5. [44] *Fig.* 14–15. [45] *Why* 10. [46] *Trans.* 108. [47] Origen, for instance, believes in a threefold interpretation of the Bible: (1) the literal meaning for the masses, (2) the moral or psychic level, and (3) the pneumatic or spiritual dimension for the qualified. [48] *Sum. Theol.,* I, q.1, a.9. [49]"As Dante expresses it, 'Behold the teaching that escapes beneath the veil of its strange verses.' The vocabulary of art, sensible in itself, is necessarily built from the elements of sensible experience, the source of all rational knowledge; but what is thus constituted is not intended to resemble any natural species, and cannot be judged by verisimilitude or by the ear's or eye's sensation alone; it is intended to convey an intelligible meaning and beyond that to point the way to the realization in consciousness of a condition of transcending even the images of thought, and only by self-identification with the content of the work, achieved by the spectator's own effort, can be regarded as perfect experience without distinction of 'religious' and 'aesthetic,' logic and feeling" (*El.* 35).
[50] *Poetics* 4. [51] *Why* 11. [52] "Delight or satisfaction may be either aesthetic (sensible) or intellectual (rational). Only the latter pertains to 'life,' the nature of which is to be in act; the satisfactions that are felt by the senses being not an act, but a habit or passion ('Witelo,' *De intelligentiis,* XVIII, XIX): the work of art then only pertains to our 'life' when it has been *understood,* and not when it has only been *felt.* The delight or satisfaction which pertains to the life of the mind arises 'by union of the active power with the exemplary-form to which it is ordered' ('Witelo,' *ib.,* XVIII). The pleasure felt by the artist is of this kind; the exemplary-form of the thing to be made being 'alive' in him and a part of his life. . . . Analogous to the artist's providential satisfaction in possession of the exemplary-form of the thing to be made is the spectator's subsequent delight in the thing that has been made (as distinguished from his pleasure in the use of it). This second and 'reflex delight' . . . is what we really mean by that of a 'disinterested aesthetic contemplation,' though this is an awkward phrase, because 'disinterested aesthetic' is a contradiction in

terms. The reflex delight is no more in fact a sensation than was the former delight in a thing not yet made; it is again a 'life of the intellect' . . . depending upon 'the union of the active power with the exemplary-form to which it is ordered' ('Witelo,' *ib.*, XVIII). . . . With this second identification of an intellect with its object, and consequent delight or satisfaction, the artifact, dead matter in itself, comes to be 'alive' in the spectator as it was in the artist; and once more it can be said that the love of the thing becomes a love of one's (true) self. It is in this sense, indeed, that 'it is not for the sake of the things themselves, but for the sake of the Self that all things are dear.' (*Bṛhadāraṇyaka Upaniṣad*, IV, 5.)" (*Fig.* 82–83.) [53] "The last end of Man is God. . . . We must therefore posit as man's last end that by which especially man approaches to God. Now man is hindered by the aforesaid [carnal] pleasures from his chief approach to God, which is effected by contemplation, to which these same pleasures are a very great hindrance, since more than anything they plunge man into the midst of sensible things, and consequently withdraw him from intelligible things." St. Thomas Aquinas, *Summa Contra Gentiles*, Chap. XXVII. Plato, also, envisages a state in which man is impervious to the promptings of both pleasure and pain; he, like Aquinas, decries naturalistic art which merely serves to fix man in sensible things and draw him away from intelligible things. [54] St. Thomas, *Sum. Theol.*, I–II. q.33. a.4, following Aristotle. [55] *Why* 26. [56] "It is clearly recognized that aesthetic pleasures are natural and legitimate, and even essential; for the good cannot be an object of appetite unless it has been apprehended . . . and 'pleasure perfects the operation' . . ." (*Fig.* 66–67). [57] *Fig.* 78. [58] *Trans.* 93. [59] V. an interesting discussion of the effectiveness of literature in giving men insights into their own nature and the nature of things, R. H. Blyth, *Zen in English Literature and Oriental Classics*, Tokyo, 1948. [60] *Trans.* 94–95.

## CHAPTER VI. JUDGMENT AND CRITICISM

[1] "Let us . . . beware of confusing art with ethics. 'Noble' is an ethical value, and pertains to the a priori censorship of what ought or ought not to be made at all. The judgment of works of art from this point of view is not merely legitimate, but essential to a good life and the welfare of humanity. But it is not a judgment of the work of art as such. The bomb, for example, is only bad as a work of art if it fails to destroy and kill to the required extent. . . . It will be obvious that there can be no moral judgment of art itself, since it is not an act but a kind of knowledge or power by which things can be well made, whether for good or evil use: the art by which utilities are produced cannot be judged morally, because it is not a kind of willing but a kind of knowing" (*Why* 28). [2] V., e.g., Guénon, *L'Ésotérisme de Dante*, Paris, 1949, for this searching type of criticism. [3] *Trans.* 199. [4] *Trans.* 95. [5] Divinely revealed works in the Hindu tradition are termed *shruti* — that is, heard or directly intuited — and those of lesser authority are termed *smriti* — that is, remembered. All works of literature can be ranked according to their authority in revealing the Word. [6] *Fig.* 16. [7] "The most general Scholastic definition of sin, of any kind, is as follows, 'Sin is a departure from the order to the end' (St. Thomas, *Sum. Theol.*, I–II, q.21, a.1c and a.2. ad 2) and in connection with artistic sin, St. Thomas goes on to explain that it is a sin proper to the art 'if an artist produce a bad thing while intending to produce something good; or produce something good, while intending to produce something bad.'"

173

("Two Passages in Dante's *Paradiso*," pp. 329–30.) [8] *Fig.* 19. [9] "The perfection of the object is something of which the critic cannot judge, its beauty something he cannot feel, if he has not like the original artist made himself such as the thing itself should be; it is in this way that 'criticism is reproduction' and 'judgment the perfection of Art'" (*Why* 30).

[10] *Fig.* 19–20. [11] "As 'Prudence is the norm of conduct' (*recta ratio agibilium*, *Sum. Theol.*, II–i, q.56, a.3) so 'Art is the norm of workmanship' (*recta ratio factibilium*) . . . 'The artist (*artifex*) is commendable as such, not for the will with which he does a work, but for the quality of the work' (*ibid.*, q.57, a.3); 'Art does not presuppose rectitude of the appetite' (*ibid.*, a.4); 'Art does not require of the artist that his act be a good act, but that his work be good. . . . Wherefore the artist needs art, not that he may lead a good life, but that he may produce a good work of art, and have it in good care' (*ibid.*, II–i, q.57, a.3, ad 1)" (*Fig.* 70). [12] This *intention* is one of art and not of prudence; it is what the artist *intends* to make and not what he intends the work to accomplish when it is finished. [13] AKC quotes Wilbur M. Urban at the head of his essay, "Intention," thus: "My meaning is what I *intend* to communicate, to some other person" (quoted from *The Intelligible World*, p. 190, in *Fig.* 123). [14] What Plato has to say of the rhapsode applies to the literary critic, "No man can be a rhapsode who does not understand the meaning of the poet. For the rhapsode ought to interpret the mind of the poet to his hearers, but how can he interpret him well unless he knows what he means." (*Ion* 530C.) [15] *Fig.* 123–33. [16] V. Monroe C. Beardsley and W. K. Wimsatt, Jr., "Intention," *Dictionary of World Literature*, new revised ed., Joseph T. Shipley (ed), New York, 1953. V. also W. K. Wimsatt, Jr., *The Verbal Icon: Studies in the Meaning of Poetry*, Lexington, Kentucky, 1954, Chap. I, "The Intentional Fallacy," pp. 3–18, written in collaboration with Monroe C. Beardsley. [17] Cf. Elmer Edgar Stoll, "Intentions and Instinct," *Modern Language Quarterly*, Vol. XIV, No. 4, December 1953; F. W. Bateson, *English Poetry, A Critical Introduction*, London, 1950, esp. Chap. I, "The Primacy of Meaning"; as well as others mentioned by Wimsatt and Beardsley in their article in *Dictionary of World Literature*. [18] *Fig.* 123. [19] "The critic of ancient or exotic art, having only the work of art before him, and nothing but the aesthetic surfaces to consider, can only register reactions, and proceed to a dimensional and chemical analysis of matter, and psychological analyses of style. His knowledge is of the sort defined as accidental, and very different from the essential and practical knowledge of the original artist and patron. One can in fact only be said to have understood the work, or to have any more than a dilettante knowledge of it, to the extent that he can identify himself with the mentality of the original artist and patron." (*Why* 75.)

[20] "Literary judgment is the last fruit of long experience . . ." (Longinus quoted by Curtius, 398). [21] For this reason it is often the master craftsman in a traditional social order — a man who has to a large extent perfected himself by his priestly dedication to his art — who is the best judge according to the criterion of art. [22] *Fig.* 124–25. [23] *Fig.* 125–26. [24] *Fig.* 125. [25] *Fig.* 128. [26] *Fig.* 130. [27] *Fig.* 129. [28] *Fig.* 130. [29] *Trans.* 51.

[30] "It is a matter at the same time of faith and understanding: the injunctions *Crede ut intelligas* and *Intellige ut credas* ('Believe, that you may understand' and 'Understand, in order to believe') are valid in both cases — i.e., whether we are concerned with the interpretation of folklore or with that of

the transmitted texts" (*Why* 140). [31] *Fig.* 130. [32] *Fig.* 131. A dedicated and disciplined musician, for instance, playing the works of Bach from an imperfect modern edition can intuitively correct the score to the original as Bach wrote it. [33] *Fig.* 71. [34] *Fig.* 130. [35] *Fig.* 27. [36] "A religious art is never an end in itself, but always a means of communication; it can only be called 'good' or 'bad' in so far as it actually expresses and conveys a given 'idea'; rational judgment of a given work can only be based on a comparison of the substance with its determining form. How then can one who ignores ideas or form embodied in a work of art be qualified to 'criticize' it? All that such an one can do is to say that he knows nothing of art, but knows what he likes." (*El.* 50–51.) [37] *Fig.* 72. [38] *Fig.* 71. [39] *IHD.* 67.

[40] Schopenhauer, a literary critic of sorts, could say of a Latin translation of a mediaeval Persian translation of the Sanskrit Upanishads: "It has been the most rewarding and the most elevating reading which (with the exception of the original text) there can possibly be in the world. It has been the solace of my life, and will be of my death." And yet he could also say of *essentially* the identical doctrine set forth in the Koran, "this wretched book," that "I have not been able to discover one single valuable thought in it." One of these scriptures suited his temperament and one did not and this fact he made the grounds of his judgment of them. [41] V. AKC, "On Being in One's Right Mind," *Review of Religion*, Vol. VII, 1942, pp. 32–40, for an analysis of the word "metanoia" (literally "change of mind") translated "repentance" in the New Testament. [42] *Fig.* 71. [43] "The man incapable of contemplation cannot be an artist, but only a skilful workman; it is demanded of the artist to be both a contemplative and a good workman" (*Why* 37). This dictum applies equally to the critic as artist. [44] On the basis of this reasoning the literary critic of Dante's *Commedia* must be able to visit the Three Worlds. [45] ". . . while all arts are imitative, it matters so much what is imitated, a reality or an effect; for we become like what we think most about; 'One comes to be of just such stuff as that on which the mind is set' (*Maitri Upanishad*, VI.34)" (*Fig.* 41). [46] *Fig.* 71. [47] Dante describes the real condition of men, not what they think they are. [48] *Sum. Theol.*, I. q.14, a.8, q.16, a.1, q.39, a.8, and q.45, a.7, quoted in *Fig.* 72. [49] "The imitation of anything and everything is despicable; it is the actions of Gods and Heroes, not the artists' feelings or the natures of men who are all too human like himself, that are the legitimate theme of art. If a poet cannot imitate the eternal realities, but only the vagaries of human character, there can be no place for him in an ideal society, however true or intriguing his representation may be." (*Why* 11.)

[50] So far as the art in the artist is the active principle directing the work, the artist has being; so far as he is impelled by natural forces, he can be called a person or an artist only conventionally, according to AKC. [51] *Sum. Theol.*, I. q.17, a.1. [52] ". . . The Doctor Universalis set no very high value on poetry" (Curtius, 218). One of the greatest poets of the Middle Ages, St. Thomas Aquinas, contemned worldly poetry that could not serve as a means to man's final end. But compare Thomas Aquinas: "The reason, however, why the philosopher may be likened to the poet is this: both are concerned with the marvellous." *Commentary on the Metaphysics*, 1,3., quoted in Josef Pieper, *Leisure, The Basis of Culture*, New York, 1952, p. 88. [53] "Man's activity consists in either a making or a doing. Both of these aspects of the active life depend for their correction upon the contemplative life. The making of things is governed by art, the doing of things by prudence. An absolute distinction

of art from prudence is made for purposes of logical understanding: but when we make this distinction, we must not forget that the man is a whole man, and cannot be justified as such merely by what he makes; the artist works by 'art and willingly.' Even supposing that he avoids artistic sin, it is still essential to him as a man to have had a right will, and so to have avoided moral sin. We cannot absolve the artist from this moral responsibility by laying it upon the patron, or only if the artist be in some way compelled; for the artist is normally either his own patron, deciding what is to be made, or formally and freely consents to the will of the patron which becomes his own as soon as the commission has been accepted, after which the artist is concerned only with the good of the work to be done: if any other motive affects him in his work he has no longer any place in the social order." (*Why* 23–24.) [54] *Fig.* 70. [55] At the second council of Nicea in the eighth century, it was stipulated that "'art' (i.e., 'the perfection of the work') alone belongs to the painter, while ordinance (the choice of the subject) and disposition (the treatment of the subject from the symbolical as well as the technical or material points of view) belongs to the Fathers. . . . This amounts to placing all artistic initiative under the direct and active authority of the spiritual leaders of Christianity." Frithjof Schuon, "Concerning Forms in Art," in *Art and Thought*, London, 1947, p. 10. [56] *Sum. Theol.*, I–II, q.21, a.4. [57] *Summa Contra Gentiles*, III, XXV. [58] "There can be no good use without art: that is, no good use if things are not properly made" (*Why* 25). [59] *Laws* 810. [60] *Bhagavad-Gītā*, IV. [61] *Why* 8–19. [62] *Trans.* 199. [63] Cf. Marco Pallis, *Peaks and Lamas*, pp. 72–74, for a lucid discussion of the qualifications of a "Translator" of Traditional doctrine. V. also *H. and B.*, p. 49. [64] *Symposium* 197A, translated in *Fig.* 27. [65] *Ibid.* [66] *Speculum*, Vol. XI, July 1936. [67] "Two Passages" 327. [68] *Ibid.* [69] "Two Passages" 329. [70] Q.Q. CXXXIII, 24. [71] "Two Passages" 330. [72] *Ibid.* [73] "Two Passages" 332. [74] *Ibid.* [75] "Two Passages" 334. [76] "Two Passages" 338. [77] E. M. W. Tillyard's little book, *The Elizabethan World Picture*, London, 1945 and 1950, discusses many of the themes that AKC treats in the larger context of world literature. Tillyard's study, among others, makes one understand how long the perennial philosophy persisted, even after the Renaissance, which generally represented a turning away from Traditional values. Without detracting from the worth of Tillyard's performance, one could note that the method that Coomaraswamy would employ in making such a study would enhance understanding of other dimensions of themes treated by Tillyard. As Coomaraswamy says, "Whoever wishes to understand the real meaning of these figures of thought that are not merely figures of speech must have studied the very extensive literatures of many countries in which the meaning of symbols are explained, and must himself have learned to think in these terms" (*Fig.* 121). [78] ". . . he who possesses true understanding is always the person who is able to see beyond the words, and it may be said that the 'spirit' of any doctrine is of an esoteric nature, while the 'letter' is exoteric. This is notably the case with all the traditional texts, which moreover usually present a plurality of meanings of varying profundity, corresponding to as many different points of view; but, instead of seeking to penetrate these meanings, people commonly prefer to devote themselves to barren exegetical researches and 'textual criticism,' following the methods laboriously worked out by the most modern scholarship . . ." (*IHD*. 162). [79] *El.* 8.

[80] ". . . what we have most to avoid is a subjective interpretation of adequate symbolism and most to desire is a subjective realization. . . ." (*Fig.*

176

188.) [81] William P. Dunn, *Sir Thomas Browne*, Minneapolis, 1950, pp. 98–100. [82] V. also AKC, *"Kha* and Other Words Denoting 'Zero' in Connection with the Metaphysics of Space," *Bulletin of the School of Oriental Studies,* Vol. VII, 1934, pp. 487–97. [83] V. *Hom.* (Part II), passim, for corroboration of this statement.

## CHAPTER VII. CONCLUSION

[1] *H. and B.* 47. [2] Samuel A. Nock, *English Literature as a Road to Wisdom,* Human Affairs Pamphlets, Hinsdale, Illinois, 1949. [3] This is not to suggest that there are no tenable half-way houses between the metaphysics of the perennial Tradition and the cult of feeling, nescience, and unintelligibility. "Ultimate Truth is one and only," as Marco Pallis writes, but "the language of truth consists of many dialects, adapted to the needs of different races and individuals . . ." (*IHD.,* Foreword, p. 10). [4] *Gargantua and Pantagruel,* IV, LV, Le Clercq's translation. [5]"In the 19th century the outstanding (literary) figure — perhaps the only one who will be valid 500 years hence — is William Morris, whom, I think, you cannot deal with too lovingly. . . ." Unpublished letter to David White, July 11, 1946. In this letter he also states, "George Macdonald's *Phantastes* is the only modern fairy tale worth considering — and it *is.*" The extravagance of AKC's judgments here may perhaps be accounted for by the fact that he was writing a letter, not to be published, directing a young student to possible topics for study. [6] *Muṇḍaka Upanishad,* 3.I.1, in *The Thirteen Principle Upanishads,* translated from the Sanskrit by Robert Ernest Hume, 2nd ed, revised, Oxford University Press, printed in India, 1951. [7] *Rec.* 13–14. [8] V. the analysis of the dictum, "Know Thyself," in AKC, "The 'E' at Delphi," *Review of Religion,* Vol. V, 1941, pp. 18–19. [9] *Rhetoric,* II, 5. 1382b 29.

[10] *Ibid.* II. 1385b 13. [11] *Goethe: Wisdom and Experience,* selections by Ludwig Curtius (trans and ed), with Introduction by Hermann J. Weigand, London, 1949, pp. 246–47. [12] *Gotama The Buddha,* p. 32. [13] *Phaedo* 65–69. [14] *Republic* 486. [15] *Phaedrus* 246, Jowett's translation. [16] *Hom.* 12. [17] *Max* Picard, *The Flight from God,* Chicago, 1951, pp. 115–16.

# Glossary

AESTHETIC(s): (a) The branch of philosophy dealing with the creation and nature of works of art as well as responses thereto. Often used in this commonly accepted sense by AKC, though quite reluctantly for lack of a better term. (b) The concern with the affective, sensible, "naturalistic" aspects of works of art, as opposed to their intellectual qualities; the preoccupation of "aesthetes." Often used in this pejorative sense by AKC, especially in later works, as a term indicating concern with "surfaces."

ART: (a) An operative habit; the capacity for making (or doing) according to the prompting of the Intellect (q.v.). Art always remains in the artist or workman. (b) That which is produced by art; sometimes used in this sense by AKC for "work of art" or artifact.

ESOTERISM: Doctrine or practice relating to the inexpressible elements of Tradition (q.v.), which only the qualified can conceive for themselves; contrasted with the exteriorization of Tradition, as the spirit (that gives life) is with the letter of a doctrine.

FORM, FORMAL: (a) Coincident with idea, image, species, similitude, reason; intellectual and non-material cause of a thing's being what it is; essential or substantial form (v. p. 38 above). (b) Actual form, shape, aspect; accidental, as different from essential form.

INTELLECT, INTELLECTUAL: The faculty in soul, "which is uncreated and uncreatable" (Meister Eckhart), capable of knowledge in which the known is assimilated to the knower.

METAPHYSIC(s): Knowledge of the universal; unique, intuitive, direct principial knowledge, non-dual, indeterminate, affirming fundamental identity of knowing and being; the indefinable basis of knowledge.

MYTH: Narrative or dramatic embodiment of metaphysic. (V. Chap. IV, pp. 66–74 above.)

ORTHODOXY: Unbroken accord with the principles of the Traditional metaphysic.

178

PHILOSOPHIA PERENNIS: The enduring and common metaphysical basis of a variety of religious and philosophical forms. (V. Chap. I above.)

PRINCIPIAL KNOWLEDGE: Metaphysical knowledge (q.v.).

SPIRIT, SPIRITUAL: The Holy Spirit; Divine Spirit; Immanent Spirit in man. Often used in this work as a synonym of Intellect (and intellectual).

TRADITION, TRADITIONAL: (a) The perennial metaphysic (q.v.). (b) Any human activity based upon conscious application of the principles of the perennial metaphysic to contingent circumstances.

*SELECTED BIBLIOGRAPHY AND INDEX*    ❁    ❁    ❁

## Selected Bibliography

The following books and articles by AKC are the ones that have been consulted most in the preparation and writing of this study. Other bibliographies (all incomplete) that may be consulted by those interested in other aspects of AKC's thought are the following: (1) "The Writings of Ananda K. Coomaraswamy" (compiled by Helen E. Ladd), *Ars Islamica,* IX (1942), 125–142; (2) "Reference Lists of Contributing Authors: Ananda K. Coomaraswamy," *Psychiatry,* VIII (1945), 373–77; (3) "A Bibliography of Gurudev Ananda K. Coomaraswamy's Writings" (compiled by S. Durai Raja Singam), mimeographed, Kuantan, Malaya.

In some cases below the chapters of books much consulted have been listed for the convenience of the reader.

"'Ākimcaññā': Self-naughting," *New Indian Antiquary,* III (1940), 1–16.

"The Appreciation of Art" (with Stella Bloch), *Art Bulletin* (College Art Association of America), VI (1923), 61–64.

"Art, Man and Manufacture," *Our Emergent Civilization.* Science of Culture Series, Vol. IV, Ruth Nanda Anshen (ed). New York, 1947.

*The Arts and Crafts of India and Ceylon.* Edinburgh and London, 1913.

"Athena and Hephaistos," *Journal of the Indian Society of Oriental Art,* XV (1947), A. K. Coomaraswamy Commemoration Volume, 1–6.

"Ātmayajña: Self-sacrifice," *Harvard Journal of Asiatic Studies,* VI (1942), Nos. 3 and 4, 358–98.

*Buddha and the Gospel of Buddhism.* New York, 1916.

*The Bugbear of Literacy.* London, 1949. I. Am I my Brother's Keeper? II. The Bugbear of Literacy. III. Paths That Lead to the Same Summit. IV. Eastern Wisdom and Western Knowledge. V. East and West. VI. "Spiritual Paternity" and the "Puppet Complex." VII. Gradation, Evolution, and Reincarnation.

"'The Conqueror's Life' in Jaina Painting: Explicitur Reductio Haec Artis Ad Theologiam," *Journal of the Indian Society of Oriental Art,* III (1935), 127–44.

*The Dance of Shiva.* Bombay, 1948. I. What Has India Contributed to Human Welfare? II. Hindu View of Art: Historical. III. Hindu View of Art: Theory of Beauty. IV. That Beauty is a State. V. Buddhist Primitives. VI. The Dance of Shiva. VII. Indian Images With Many Arms. VIII. Indian Music. IX. Status of Indian Women. X. Sahaja. XI. Intellectual Fraternity. XII. Cosmopolitan View of Nietzsche. XIII. Young India. XIV. Individuality, Autonomy and Function.

"The Darker Side of Dawn," *Smithsonian Miscellaneous Collection*, XCIV (1935), No. 1, 1–18.

"Dr. Coomaraswamy's Talk at His Boston Dinner," *Journal of the Indian Society of Oriental Art*, XV (1947), 11–12.

"The 'E' at Delphi," *Review of Religion*, V (January 1941), 18–19.

*East and West and Other Essays*. Colombo, Ceylon, n.d. I. East and West. II. The Religious Basis of the Forms of Indian Society. III. Indian Culture and English Influence.

"Eckstein," *Speculum*, XIV (1939), 66–72.

*Elements of Buddhist Iconography*. Cambridge, Massachusetts, 1935.

*Essays in National Idealism*. Colombo, Ceylon, 1909.

*Figures of Speech or Figures of Thought*. London, 1946. I. Figures of Speech or Figures of Thought. II. The Mediaeval Theory of Beauty. III. Ornament. IV. Ars Sine Scientia Nihil. V. The Meeting of Eyes. VI. Shaker Furniture. VII. Literary Symbolism. VIII. Intention. IX. Imitation, Expression, and Participation. X. The Intellectual Operation in Indian Art. XI. The Nature of Buddhist Art. XII. Saṁvega, Aesthetic Shock. XIII. An Early Passage on Indian Painting. XIV. Some References to Pictorial Relief. XV. Primitive Mentality. XVI. Notes on Savage Art. XVII. Symptom, Diagnosis, and Regimen. XVIII. Walter Andrae: On the Life of Symbols.

"For What Heritage and To Whom are the English-Speaking Peoples Responsible?" *The Heritage of the English-Speaking Peoples and Their Responsibility*, addresses at the conference, October 1946, Kenyon College, 48–65.

"Headless Magicians; and an Act of Truth," *Journal of the American Oriental Society*, LXV (1945), 215–17.

*Hinduism and Buddhism*. New York, n.d.

"The Iconography of Dürer's 'Knoten' and Leonardo's 'Concatenation,'" *Art Quarterly*, VII (1944), 109–28.

"The Indian Doctrine of Man's Last End," *Asia*, XXXVII (1937), 380–81.

"Is Art a Superstition or a Way of Life?" *American Review*, IX (1937), 186–213.

"Lilā," *Journal of the American Oriental Society*, LXI (1941), 98–101.

*Living Thoughts of Gotama the Buddha* (with I. B. Horner). London, 1948.

"Measures of Fire," *O Instituto* (Coimbra, Portugal), Vol. 100 (1942), 386–95.

*Mediaeval Sinhalese Art*. 2nd ed. New York, 1956.

*Myths of the Hindus and the Buddhists* (with Sister Nivedita). New York, 1914.

*A New Approach to the Vedas: An Essay in Translation and Exegesis*. London, 1933.

"Nirukta = Hermeneia," *Viśva-Bharati*, n.s., II (1936), Part 2, 11–17.

"Note on the Iconography of the Cock on the Column," *Art Bulletin*, XXI (1939), 375–82.

"A Note on the Stickfast Motif," *Journal of American Folklore*, LVII (1944), 128–31.

"On Being in One's Right Mind," *Review of Religion*, VII (1942), 32–40.

"On the Loathly Bride," *Speculum* XX (October 1945), 37–50.

*Patron and Artist. Pre-Renaissance and Modern* (with A. G. Carey). Norton, Massachusetts, 1936.

"Play and Seriousness," *Journal of Philosophy*, XXXIX (1942), 550–52.

"Primordial Images" (with Genevieve Foster), *Publications of the Modern Language Association*, LXI (1946), 601–603.

*Recollection, Indian and Platonic* and *On the One and Only Transmigrant.* Supplement to the *Journal of the American Oriental Society.* No. 3. April–June, 1944.

"The Sea," *India Antiqua*, Jean Phillipe Vogel Presentation Volume, E. J. Brill (ed). Leyden, 1947. Pp. 89–94.

"Sir Gawain and the Green Knight: Indra and Namuci," *Speculum* XIX (January 1944), 104–25.

"The Source of, and a Parallel to, Dionysius on the Beautiful," *Journal of the Greater Indian Society*, III (1936), 36–42.

*Spiritual Authority and Temporal Power in the Indian Theory of Government.* American Oriental Series, XXII. American Oriental Society. New Haven, 1942.

"The Sun-kiss," *Journal of the American Oriental Society*, LX (1940), 46–67.

"Symbolism," *Dictionary of World Literature.* Joseph T. Shipley (ed). New York, 1943.

"The Symbolism of Archery," *Ars Islamica*, X (1944), 105–19.

*Time and Eternity.* Ascona, Switzerland, 1947.

*The Transformation of Nature in Art.* Cambridge, Mass., 1935. I. The Theory of Art in Asia. II. Meister Eckhart's View of Art. III. Reactions to Art in India. IV. Aesthetic of the Sukranītisāra. V. Parokṣa. VI. Ābhāsa. VII. Origin and Use of Images in India.

"Two Passages in Dante's *Paradiso*," *Speculum*, XI (July 1936), 327–38.

"The Vedānta and the Western Tradition," *American Scholar* (1939), 223–47.

"Vedic Exemplarism," *Harvard Journal of Asiatic Studies*, I (1936), 44–64, 281.

"Who is 'Satan' and Where is 'Hell'?" *The Review of Religion*, XII (1947), 76–87.

*Why Exhibit Works of Art?* London, 1943. I. Why Exhibit Works of Art? II. The Christian and Oriental, or True, Philosophy of Art. III. Is Art a Superstition, or a Way of Life? IV. What is the Use of Art, Anyway? V. Beauty and Truth. VI. The Nature of Mediaeval Art. VII. The Traditional Conception of Ideal Portraiture. VIII. The Nature of "Folklore" and "Popular Art." IX. Beauty of Mathematics: A Review.

185

# *Index*

The text as well as substantive material in the notes is indexed below.

187